Fairfield Porter:

ART IN ITS OWN TERMS

Selected Criticism
1935-1975

Fairfield Porter:

ART IN ITS OWN TERMS

Selected Criticism
1935-1975

EDITED AND WITH AN INTRODUCTION

BY RACKSTRAW DOWNES

Taplinger Publishing Company
NEW YORK

AR
704
P845

First published in the United States in 1979 by
TAPLINGER PUBLISHING CO., INC.
New York, New York

Copyright © 1979 by Mrs. Fairfield Porter
Introduction © 1979 by Rackstraw Downes

Library of Congress Cataloging in Publication Data

Porter, Fairfield.
 Fairfield Porter: art in its own terms.

 Includes index.
 1. Art—Essays.
I. Downes, Rackstraw.
N7445.2.P67 704.9'2 78-57598
ISBN 0-8008-2586-1
ISBN 0-8008-2587-X pbk.

DESIGNED BY PHILIP GRUSHKIN

Printed in the United States of America

9 8 7 6 5 4 3 2 1

CONTENTS

LIST OF PLATES 9

ACKNOWLEDGMENTS 13

INTRODUCTION 19

I. CONTEMPORARY ARTISTS

Willem de Kooning 36
Richard Stankiewicz 38
Giacometti 41
The Education of Jasper Johns 44
Joseph Cornell 49

II. CONTEMPORARY STYLES

American Non-Objective Painting 54
New Images of Man 59
Happenings 61
Abstraction in Sculpture 63
Constructivism 65
Recent American Figure Painting 69

III. ART, NATURE, AND REALITY

Perfection and Nature 74
The Immediacy of Experience 79

Intellect and Comedy *81*

Reality and the Museum *84*

What Is Real? *87*

A Realist *90*

Non-Objectivity and Realism *91*

Kinds of Beauty *95*

Realism Transcends System *98*

Against Idealism *102*

IV. TRADITION AND OTHER TOPICS

Abstract Expressionism and Landscape *107*

Impressionism and Painting To-Day *111*

The Oriental in American Art *114*

Taste and Energy *117*

Tradition and Originality *121*

Attitudes to the Past *124*

Tradition and Revolt *127*

California and New York *130*

Sculpture and the Material *132*

Humor in Sculpture *136*

Art and Rubbish *137*

Is Photography an Art? *140*

Communication and Moral Commitment *143*

Experiencing Art *146*

V. THE PAST TODAY

Cézanne *150*

	Whistler, Morisot, Corinth	*152*
	France and America in the Nineteenth Century	*156*
	Italy and France in the Renaissance	*159*
	Restoration	*164*

VI. THE SHORT REVIEW

	The Short Review	*167*
	Vuillard, Bonnard	*169*
	Rodin, Matisse	*172*
	Dufy, Pougny, Berend	*175*
	Two Primitives	*176*
	Dubuffet, Klee	*178*
	Inness, O'Keeffe	*179*
	De Kooning	*180*
	Leslie, Ferren, Schueler	*181*
	Hartl	*184*
	Freilicher, Kahn	*185*
	Noguchi, Armitage, Kohn	*188*
	Lichtenstein	*190*
	From the Short Reviews	*191*

VII. PORTRAITS OF AMERICANS

	Homer	*196*
	Sargent	*201*
	Prendergast	*204*
	Marin	*209*
	Graham	*214*

VIII. BOOKS AND CRITICS

Poets and Painters in Collaboration *220*

Rhys Carpenter on Greek Sculpture *225*

Alberti and Leonardo on Painting *228*

Selden Rodman's Apology for Art *230*

Clement Greenberg on "American-type" *233*
 Painting: A Letter to the *Partisan Review*

Rosenberg and Hess on de Kooning *236*

Wyndham Lewis on Picasso: *239*
 A Letter to the *Kenyon Review*

IX. ART AND POLITICS

Murals for Workers *241*

The Purpose of Socialism *245*

Class Content in American Abstract *249*
 Painting

X. ART AND SCIENCE

Art and Knowledge *258*

Art and Scientific Method *265*

Albert York *269*

Technology and Artistic Perception *271*

Two Statements *281*

INDEX *283*

LIST OF PLATES

PAGE

1. FAIRFIELD PORTER: *Trees in Bud.* 1975.
 Oil on board. 18″x 22″. Collection of Mrs. Fairfield Porter. 21

2. FAIRFIELD PORTER: *Field Flower, Fruit and Dishes.* 1974.
 Oil on masonite. 18″x 22″. Collection of Mr. and Mrs. Lee M.
 Fuller, Jr. Photo courtesy of Hirschl and Adler Galleries. 24

3. FAIRFIELD PORTER: *Morning from the Porch.* 1974.
 Watercolor. 22″x 30″. Collection of Heckscher Museum,
 Huntington, L.I., N.Y. Courtesy of Hirschl and Adler Galleries. 33

4. WILLEM DE KOONING: *September Morn.* 1958. Oil on
 canvas. 63″x 49½″. Photo courtesy of Sidney Janis Galleries. 39

5. RICHARD STANKIEWICZ: *Playground.* 1959.
 Steel/iron. 18″x 22″x 12″. Photo courtesy of Zabriskie Gallery. 40

6. ALBERTO GIACOMETTI: *Figure from Venice VI.* 1956.
 Bronze. 52½″ high. Photo courtesy of Pierre Matisse Gallery. 43

7. JASPER JOHNS: *Two Flags.* 1960. Pencil and graphite wash.
 29½″x 21¾″. Photo courtesy of Leo Castelli Gallery. 47

8. JOSEPH CORNELL: *Ostend-Dover.* c. 1958. Construction.
 7″x 12″x 5″. Photo courtesy of Alan Stone Gallery. 51

9. JEAN ARP: *Constellation.* 1932. Wood relief.
 20½″x 22⅛″. Photo courtesy of Sidney Janis Gallery. 76

10. DAVID SMITH: Sculptures in the field at his Bolton Landing studio.
 Photo by David Smith; reproduced courtesy of M. Knoedler & Co. 78

11. GIORGIO MORANDI: *Still Life.* 1953. Oil on canvas.
 8″x 15⅝″. The Phillips Collection, Washington, D.C. 82

12. NICHOLAS VASILIEFF: *Red Pitcher.* 1957. Oil on canvas.
 42″x 56¹⁄₁₆″. Wadsworth Atheneum, Hartford, Connecticut. 83

13. ISABEL BISHOP: *Subway Scene.* 1957-58. Egg tempera and oil on
 composition board: 40″x 28″. Whitney Museum of American Art. 88

14. ALEX KATZ: *Ten O'Clock.* 1959.
 Oil on canvas: 57½″x 50½″. Collection of the artist. 90

15. ELMER BISCHOFF: *Two Figures with Vermilion Light.* 1959. Oil on
 canvas. 60″x 60″. Private collection. Photo, Staempfli Gallery. 93

16. ROBERT GOODNOUGH: *Summer III.* 1959.
 Oil on canvas. 54″x 68″. Photo courtesy of Tibor de Nagy Gallery. 94

9

17. ROBERT ENGMAN: Untitled sculpture. 1957. Aluminum.
36″ x 36″ x 18″. Formerly coll. of Yale University, destroyed by fire.
Photo courtesy of the artist. 96

18. PAUL GEORGES: *Self-Portrait.* 1959.
Oil on canvas. 51″ x 35″. Collection of David Spelman. 97

19. REMBRANDT: *Indian Warrior with a Shield Leaning on a Stick.*
c. 1654-56. Pen and brown ink on oriental paper. 7″ x 3$^{15}/_{16}$″.
(After a miniature by an Indian artist of the Mughal Court.)
The Pierpont Morgan Library. 100

20. JOSEPH FIORE: *Medomak II.* 1959. Oil on canvas. 49″ x 39″.
Collection of the Chase Manhattan Bank. Photo courtesy of the artist. 116

21. EDWIN DICKINSON: *Boyar House, Sheldrake.* 1939.
Oil on Canvas. 29″ x 24″. Photo courtesy of Graham Galleries. 118

22. MARK ROTHKO: *No. 18.* 1948. Oil on canvas.
67¼″ x 55⅞″. Collection of the Art Department, Vassar College. 119

23. ROBERT MOTHERWELL: *Black on White.* 1961. Oil on canvas.
78¾″ x 163¼″. The Museum of Fine Arts, Houston.
Museum Purchase. 122

24. ELAINE DE KOONING: *The Loft Dwellers.* 1961. Oil on canvas.
65½″ x 88″. Collection of Chaim and Norma Shatan. 123

25. SEYMOUR REMENICK: *St. Peter's and St. Paul's, Philadelphia.* 1959.
Oil on canvas. 8″ x 18″. Collection of Mrs. Katherine Beach.
Photo courtesy of the artist. 126

26. JOHN BUTTON: *Warehouse.* 1959. Oil on canvas. 45½″ x 40″.
Collection of Virgil Thompson. 127

27. PIERRE BONNARD: *Dining Room on the Garden.* 1934. Oil on
canvas. 50″ x 53⅜″. The Solomon R. Guggenheim Museum. 129

28. REUBEN NAKIAN: *Venus.* 1952. (Destroyed.) Plaster. 60″ high. 134

29. PETER AGOSTINI: *Clothesline.* 1960.
Plaster. 59″ x 58″ x 17″. Photo courtesy of Zabriskie Galleries. 135

30. WILLIAM KING: *Lady Godiva.* 1952. Wood. 60″ high.
Photo courtesy of Terry Dintenfass Gallery. 138

31. ELIOT PORTER: *Sick Herring Gull.* Photograph courtesy of artist. 142

32. JACK TWORKOV: *Brake II.* 1960. Oil on canvas. 65″ x 77″.
Collection of Mr. and Mrs. John L. Eastman.
Photo courtesy Nancy Hoffman Gallery. 145

33. BERTHE MORISOT: *Portrait of a Child with a Hat.* 1883.
Pastel, 19¼″ x 15″. The Baltimore Museum of Art, The Cone
Collection—formed by Dr. Claribel Cone and Miss Etta Cone
of Baltimore, Maryland. 154

34. LOVIS CORINTH: *The Black Hussar.* 1917. Oil on canvas.
87⅞″ x 47½″. The Baltimore Museum of Art.
Photo courtesy of Allan Frumkin Gallery. 155

35. EDOUARD VUILLARD: *The Newspaper.* c. 1898. Oil on board,
13¼" x 21½". The Phillips Collection, Washington, D.C. *171*

36. AUGUSTE RODIN: *Cambodian Dancer.* 1906.
Pencil, watercolor wash. 12³⁄₁₆" x 9¼".
The Maryhill Museum of Art, Goldendale, Washington. *173*

37. HENRI MATISSE: *Two Negresses.* 1908. Bronze. 18½" high.
The Baltimore Museum of Art, The Cone Collection—formed by
Dr. Claribel Cone and Miss Etta Cone of Baltimore, Md. *174*

38. LOUIS VIVIN: *Le Palais de Justice à Paris.* c. 1935. Oil.
21" x 28¾". Private Collection. Photo courtesy of Perls Galleries. *177*

39. ALFRED LESLIE: *Christ the Door.* 1951. © Alfred Leslie.
Oil on pieces of canvas stapled together, with paper collage.
53½" x 48½". Collection of the artist. *181*

40. JOHN FERREN: *Untitled.* 1953. Oil on Orlon. 16" x 20".
Photo courtesy of A. M. Sachs Gallery. *182*

41. LEON HARTL: *Flowers.* c. 1953. Watercolor. 30" x 24".
Collection of Mrs. Fairfield Porter. *184*

42. JANE FREILICHER: *Early New York Evening.* 1953.
Oil on canvas. 52" x 32". Collection of the artist. *186*

43. WOLF KAHN: *Dead Bird.* 1953. Oil on canvas. 24" x 25".
Collection of Nell Blaine. *187*

44. ISAMU NOGUCHI: *Dish.* 1950. Bizen ceramic.
c. 12" diameter, 2½" high. Photo courtesy of the artist. *189*

45. JOHN MARIN: *Mt. Chocorua No. 1.* 1926. Watercolor and charcoal.
17¼" x 22". Fogg Art Museum, Harvard University.
Purchase—Prichard Fund. *212*

46. ALBERT YORK: *Twin Trees.* c. 1962. Oil on masonite. 10⅞" x 10½".
Private collection. Photo courtesy of Davis and Long Galleries. *269*

ACKNOWLEDGMENTS

Some of the material in this book has been slightly edited or excerpted, and titles supplied or altered in some cases. Otherwise it is reprinted by kind permission of the original publications or present copyright holders as listed below:

"Willem de Kooning," *The Nation,* June 6, 1959.
"Richard Stankiewicz," in *School of New York: Some Younger Artists,* ed. B. H. Friedman (New York: Grove Press, 1959).
"Giacometti," *The Nation,* February 6, 1960.
© "The Education of Jasper Johns," *ARTnews,* February 1964.
"Joseph Cornell," first published in *Art and Literature,* no. 8 (Spring 1966).
"American Non-Objective Painting," *The Nation,* October 3, 1959.
"New Images of Man," *The Nation,* October 17, 1959.
"Happenings," *The Nation,* October 24, 1959.
"Abstraction in Sculpture," *The Nation,* November 21, 1959.
"Constructivism," *The Nation,* May 28, 1960.
"Recent American Figure Painting," first published as "Recent Painting USA: the Figure," © *Art in America* 50, no. 1 (1962).
"Perfection and Nature," *The Nation,* March 12, 1960.
"The Immediacy of Experience," *The Nation,* January 9, 1960.
"Intellect and Comedy," *The Nation,* January 21, 1961.
"Reality and the Museum," *The Nation,* May 20, 1961.
"What Is Real?" *The Nation,* May 21, 1960.
"A Realist" (excerpted), *The Nation,* October 1, 1960.
"Non-Objectivity and Realism," *The Nation,* January 23, 1960.
"Kinds of Beauty," *The Nation,* March 19, 1960.
"Realism Transcends System," *The Nation,* April 23, 1960.
"Against Idealism," first published in *Art and Literature,* no. 2 (Summer, 1964).
"Abstract Expressionism and Landscape," unpublished; appears by permission of Mrs. Fairfield Porter.
"Impressionism and Painting To-Day," *The Nation,* April 2, 1960.
"The Oriental in American Art," *The Nation,* November 5, 1960.
"Taste and Energy," *The Nation,* February 25, 1961.
"Tradition and Originality," *The Nation,* April 29, 1961.
"Attitudes to the Past," *The Nation,* February 13, 1960.
"Tradition and Revolt," *The Nation,* February 11, 1961.

"California and New York," *The Nation,* December 19, 1959.

"Sculpture and the Material," *The Nation,* December 24, 1960.

"Humor in Sculpture," *The Nation,* April 30, 1960.

"Art and Rubbish," *The Nation,* October 15, 1960.

"Is Photography an Art?" *The Nation,* June 18, 1960.

"Communication and Moral Commitment," *The Nation,* March 18, 1961.

"Experiencing Art," *The Nation,* September 10, 1960.

"Cézanne," *The Nation.* November 28, 1959.

"Whistler, Morisot, Corinth," *The Nation,* December 3, 1960.

"France and America in the Nineteenth Century," *The Nation,* June 10, 1961.

"Italy and France in the Renaissance," *The Nation,* April 8, 1961.

"Restoration," *The Nation,* July 4, 1959.

"The Short Review," *It Is,* no. 2 (1958).

© Vuillard, *ARTnews,* May 1954.

© Bonnard, *ARTnews,* April 1956.

© Rodin, *ARTnews,* February 1959.

© Matisse, *ARTnews,* January 1959.

© Dufy, *ARTnews,* October 1953.

© Pougny, *ARTnews,* April 1952.

© Berend, *ARTnews,* Summer 1952.

© Regensburg, *ARTnews,* November 1956.

© Vivin, *ARTnews,* February 1954.

© Dubuffet, *ARTnews,* February 1952.

© Klee, *ARTnews,* November 1955.

© Inness, *ARTnews,* November 1953.

© Aphorisms: a selection of aphorisms drawn from Porter's short reviews, *ARTnews,* 1951-59.

© O'Keeffe, *ARTnews,* May 1955.

© De Kooning, *ARTnews,* November 1955.

© Leslie, *ARTnews,* February 1952.

© Ferren, *ARTnews,* May 1953.

© Schueler, *ARTnews,* March 1957.

© Hartl, *ARTnews,* March 1958.

© Freilicher, *ARTnews,* May 1952.

© Kahn, *ARTnews,* November 1953.

© Noguchi, *ARTnews,* December 1954.

© Armitage, *ARTnews,* April 1954.

© Kohn, *ARTnews,* March 1959.

© Lichtenstein, *ARTnews,* January 1952.

"Homer," first published as © "Homer: American vs. Artist: A Problem in Identities," *ARTnews,* December 1958.

"Sargent," first published as © "Sargent: An American Problem," *ARTnews,* January 1956.

"Prendergast," first published as © "The Prendergast Anomaly," *ARTnews,* November 1966.

"Marin," first published as © "The Nature of John Marin," *ARTnews,* March 1955.

EDITOR'S NOTE

I would like to thank all those who took a helpful interest in this book while it was in preparation. Above all I am extremely grateful to Anne Porter for her contribution; she made available all unpublished material, and her understanding, knowledge, and quiet faith in the project was essential to it. I should also like to thank the many friends of Fairfield Porter who shared their recollections of him or lent me letters they had received or were in their possession: Donald Allen, Ellen Auerbach, Nell Blaine, Rudolph Burckhardt, Robert Dash, Lucien Day, Edwin Denby, Arthur Giardelli, Jane Freilicher, Thomas B. Hess, Wolf Kahn, Alex Katz, Elaine de Kooning, Willem de Kooning, Ted Leigh, John MacWhinnie, John Bernard Myers, Ron Padgett, Edith Schloss, Neil Welliver, Claire Nicholas White, and Jane Wilson. Several people made helpful suggestions at various stages; I should like to thank David Shapiro for sharing his own knowledge of Porter's writings, and Kenneth Koch for detailed comments on the introduction; also David Kermani, Jim Long, and Harriet Shorr, and Prescott Schutz of the Hirschl and Adler Galleries. I am indebted to the Archives of American Art for many facts and quotations in the introduction taken from their fine Porter interview conducted by Paul Cummings; to James Schuyler, who compiled a Porter chronology which the artist himself checked and annotated; to Robert Williams for library research; and to the individual artists and photographers, the galleries and museums and their staffs, who helped with assembling the illustrations: special thanks to the willingly peripatetic Bob Brooks. Finally, for continual attention and encouragement I should like to thank Rosemarie Beck, Roger Jellinek, and master-anthologizer Robert Phelps; and for special patience, Pamela Berkeley.

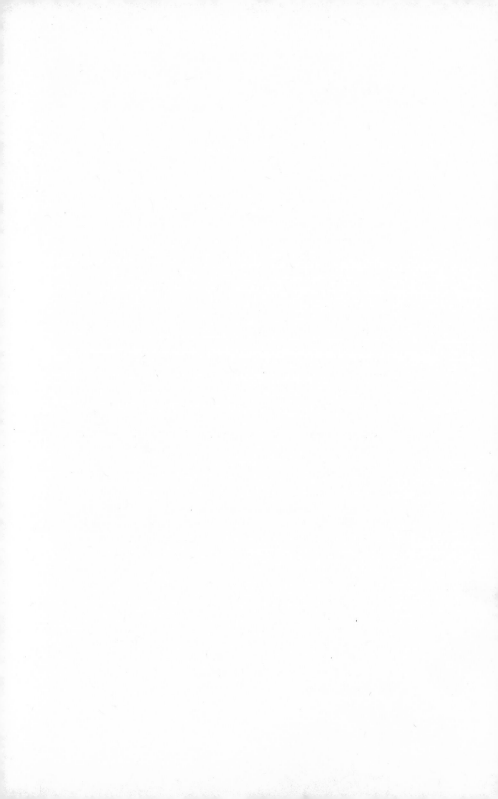

INTRODUCTION

I

When Fairfield Porter died in 1975 he was known as one of the best painters in America. His own opinion was that he was stronger as a critic. Whatever one's thoughts on that comparison, it can certainly be said that no practicing painter of distinction has ever made so complete a map of the art of his contemporaries—a map to which he himself invented the key, which is also the key to his own mind and art. This book of his writings, which is mainly about the art of his own time, is the complement to Fromentin's *Masters of Past Time*. In another respect, the philosophical depth with which an artist tried to probe the nature not just of his own art but of all art, Porter's writing is alone in its field.

His painting did not seem to fit any of the more publicized categories of a category-loving period; he was regarded as an independent. But Porter's independence took a different form from the known instances in art. He was not a resentful eccentric like Blake, nor a recluse like Morandi: far from it. He exhibited regularly and eagerly in the artistic capital, and his work affected other painters; he went assiduously to exhibitions of all kinds of art whether to review them or not, and he was famous among his fellow artists for suddenly inviting himself to their studios to see the progress they were making. And it would be hard to name a more attentive and respectful listener—not a quality for which artists are noted.

In the critical disputes of his time his was one of the sharp minds, and this is where independence became an issue. It was not that Porter liked contention: he loved art, and felt it was deeply important that critics, who mediate between art and its public, should represent it truthfully. Mainly he was at odds with a criticism which, ignoring the evidence that actually surrounded it, purported to deduce art's future from its immediate past; and so control it, as Porter put it, by imitating "the technique of a totalitarian

19

party on the way to power." If Porter's painting looked out of line to some people, it was the influence of this criticism that gave it that complexion, more than anything else.

He disliked the criticism but loved the art which surrounded him.* W. B. Yeats said "there can be no great art without a great criticism"; the converse also seems to be true. Alberti had the early Florentines, Baudelaire had Delacroix, Ruskin had Turner, Fry had Cézanne. Porter had de Kooning. He revered de Kooning the painter, and was continually preoccupied with a definition of his art which he felt had deep significance, aesthetic, political, and human. He learned profoundly from him in his own painting, and he loved him as one of the great oracular aestheticians. Porter, artist and critic, relates to de Kooning as Valéry relates to Mallarmé. By a personal intellectual alchemy he fused de Kooning's art with that of Bonnard and Vuillard, but especially Vuillard, his other great enthusiasm; drawing on the spirit as much as the formality of these two masters he created his own art, and a critical point of view that was magnetic north in his experiences with other kinds of art.

Artists who are dissatisfied with the criticism of their time have to invent their own, even though they seldom write it down. Such criticism usually has the authenticity of a direct report from inside the studio, but is limited for that reason to a narrow point of view. Its topic is likely to be an as yet undiscussed or undervalued style. Porter had every reason to write like this since his own style lacked a champion. But, compared to the leading critics of his day among whom he was the only artist, Porter can least be said to have pushed one style at the expense of others. This was the result of his approach. He knew what artists are peculiarly equipped to know because they experience it every day in the studio; that is, that no matter how skillfully and knowledgeably they organize what in literary criticism are called the Aristotelian elements of a work—in painting these would be composition, imagery, color, space, drawing, brushwork—a picture will not necessarily catch fire, come alive. This is why artists often read criticism impatiently when it deals only with these elements. Something is missing from such discussions, the most important thing. A sentence in criticism is often clogged with adjectives. This happens when a critic's nouns

*Writers on art that Porter did like included Bernard Berenson, Suzanne Langer, and Adrian Stokes.

and verbs refer to those Aristotelian elements of a work
that can be isolated from the whole, while the adjectives try
to characterize what has not been accounted for: namely,
the energy that animates them. Porter's criticism is notice-
ably sparing in the use of these adjectives because he writes,
in analogies, directly about this energy, which determines
the character of the whole work. He understands the gap
between what artists can consciously control and talk about
(and what they do talk about continually), and what ac-
tually happens in the painting—the gap, in other words,
between the recipe and the dish. This gap often eludes criti-
cism because what bridges it is neither subject to the ar-
tist's will nor explicit in his choice of forms. It is an aspect
of his temperament, and gets in in spite of himself. Once
at the Artists' Club on Eighth Street there was a discussion
as to whether or not it is vain to sign your pictures. Porter
said, "If you are vain it is vain to sign your pictures and vain

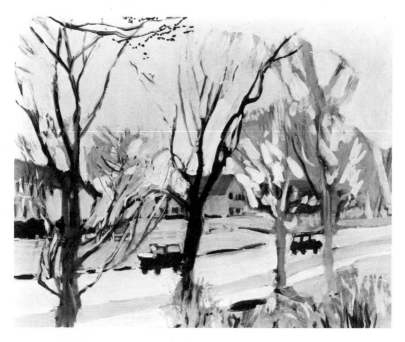

1. FAIRFIELD PORTER: *Trees in Bud*

not to sign them. If you are not vain it is not vain to sign them and not vain not to sign them."

Porter once shocked me by his response in a letter to something I had written about a painting: "I think you do something here that all aestheticians I know about (precious few) do, (except Suzanne Langer) and that I think leads them away from the object of their analysis. (Perhaps only in criticisms of painting and sculpture.) You begin to depart into what the painting ostensibly refers to, that is expressed in the title. I do not think Wallace Stevens does this, though, in his discussion of the Colleoni; he talks about what the statue refers to almost in the artist's subconscious. I believe in doing this, and I believe in Freud's art criticisms—even if they be mistaken, they are on the right track." As psychiatry aims to define the emotional force in an action or a statement, Porter aims to define the force that brings a work of art to life. Porter's interest in Freud is unorthodox in art criticism, but he was no respecter of persons (in this case "all aestheticians I know about"); he does not juggle with existing theories or get waylaid in anybody else's dialectic. His thoughts are his own, and his writing is consequently fresh and full of surprises.

Aristotle divided his discussion of tragedy into the formal elements and the emotional effect, catharsis. Art's resemblance to a reality beyond the work, and catharsis, justified art socially, a justification Plato had questioned. In the Renaissance this division developed into the formula that art instructs by pleasing. Ruskin and Fry split this territory between them. But critics who argue that the value of art inheres in something moral or something formal cut themselves off from too much; their systems are disqualified by the art they exclude. Porter had no set of systematic standards. His taste was unusually broad, his views on art outside this taste illuminating, because the energy he looked for can erupt in infinite forms and attitudes.

This energy Porter called "vitality." Something like it was also noticed by the late Anton Ehrenzweig, who wrote about the importance of unscored musical slurs and subtleties of the artist's brushing. But Ehrenzweig went on to treat them theoretically as a category of style which he called "Secondary Form Elaboration." Porter wrote about the content of this energy to make his relation to actual pictures closer. Art history also tends to concern itself with categories of style which are by now almost more familiar

than the works they were intended to classify. With Porter, classification turns into insight, and the history of art becomes a series of attitudes to reality: "Critics who find non-objectivity anti-traditional, do not see that tradition is a process. It leads to non-objectivity like this: first, acceptance of nature as including the artist, who is, like one of the details of his painting, an equal part of creation; next, a questioning of what things are, of what we see; then a questioning of how we see; from here to a consideration of vision itself; then to the one who sees, the artist as part of a duality of nature and recipient; to the artist in introspection, and a denial of objectivity." In Porter's criticism there is none of the traditional difficulty about whether or how art connects to life; when he writes about Berthe Morisot's paintings, for instance, he seems to be writing about both at once: "She loves, but in proportion, and she is perceptive without malice."

As Porter felt that "it is not possible for an artist to put into his products anything that remains untouched by the artist's nature," he also held that "art, like all social activities, cannot help expressing the common basis of social life." So he sometimes discusses art from the point of view of political attitudes it expresses, or makes a social criticism from the point of view of art. In his later writing Porter distinguishes the nature of art from the nature of science, and so arrives at his definition of art and his statement of its value: in contrast to the thrust of scientific method, which organizes specifics into ideas and in its applied form, technology, becomes destructive, art asserts the innate life of individual things.

What Porter really does here is to explore the most far-reaching implications of his taste. For what he loved above all, and all along, is art that is yieldingly attentive to the life of its materials and to particular sensations of reality. Here, too, by implication, is the subject of his mature painting: to keep as far away as possible from any organizing principle or procedure that could put limits to his feeling for uniqueness. Composition, which he was taught to think meant looking for likenesses and repetitions, he came to believe consisted in making distinctions. He would never return to a site to finish a landscape painting because the light would never be the same. And perhaps no still life painter has ever elevated the art of painting whatever was left on the table after breakfast, just as it is, to the heights

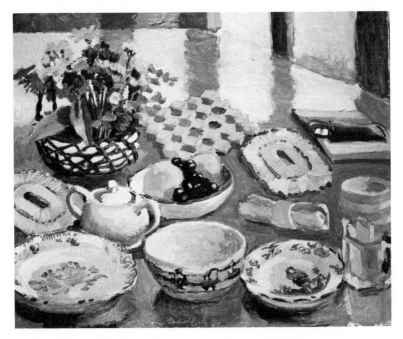

2. FAIRFIELD PORTER: *Field Flowers, Fruit and Dishes*

that Porter did. No matter how philosophical Porter's later writing became, no matter how much he preoccupied himself with what he thought art is not, his thoughts kept bearing on his practice as an artist, and the definition of what he thought art is.

Porter's intellectual world, then, was extraordinarily complete. He was a practicing artist with a developed theory of art, and a practicing critic with a developed theory of criticism. In person, he seemed to form concise, measured ideas about everything, and they added up; his intellectual poise made you want to improve your own. He spoke with an authority which did not stem from will, but was that of someone who had made sure of his point of view and could therefore permit you yours. He was absolutely straightforward; he knew what he had to say, and said it. Some found his manners harsh, even rude. He was tall with a windblown complexion, and stood very straight. He entered

and left a room suddenly without ceremony, and his walk was a stride. His directness in conversation could be uncomfortably challenging; when he was not interested he would be conspicuously silent, or walk away. It was only that what was important for Porter mattered beyond compromise, and time was not to be wasted on the little conventions that make the fabric of easy social life. His friends found his clarity a priceless exchange, and his warmth, expressed in a smile you could call boyish, completely trustworthy.

II

Fairfield Porter was born in Winnetka, Illinois, "sort of the Scarsdale of Chicago," on June 10, 1907, the fourth of five children. His father was an architect of private means who designed the Greek Revival family home himself, and decorated it with photographs of great Italian paintings and architecture, and casts of the Parthenon friezes. On a visit to the Maine coast to look for a suitable seaside home for the summers, from a wharf on the mainland he spotted an island that took his fancy, inquired after the owners, and made them an offer before visiting it. On this island, Great Spruce Head, he built another house; over the years he and the caretaker cut trails, planned so as not to disturb the vegetation, from the house to the shore and back again by different routes. Fairfield Porter later inherited this house which he continued to visit many summers throughout his life; its main living room, its porches, and the views nearby appeared again and again in his paintings.

Porter was educated in the public schools of Winnetka. When he was fourteen the family visited Europe, and at the London National Gallery, Porter discovered for himself Titian, Veronese, and Turner—his father's enthusiasms being for the Italian seventeenth century. At sixteen he was admitted to Harvard, but was considered too young to go directly to college and was sent first to a prep school, Milton Academy, where he spent what he considered a wasted year. At Harvard he studied art history, and was stirred by the teaching of Arthur Pope. He thought history was well taught, aesthetics not so well, lacking as it did any connection to practice. Renaissance art was presented through the eyes of Berenson, and this was one of the few intellectual formulations about art made by someone else that Porter

carried into his own thinking unaltered. Quite as important was to study philosophy with Whitehead. "What I remember of what I got from him was the importance of having very clear terms in your discussion and knowing what they mean. In other words he wants to escape from vagueness. He also told us that the artist doesn't know what he knows in general, he only knows what he knows specifically. What he knows in general or what can be known in general becomes apparent later on by what he has had to put down." In the summer of 1927 Porter made a walking and bicycling tour in France, which ended with his flying from Berlin to Moscow. This brief visit to Russia, during which he heard Trotsky being interviewed, made a marked impression on his political attitudes, especially during the Depression. (A sketchbook survives from this trip with place names carefully written in Russian; it includes a drawing of the interior of the tiny plane, with its curtained windows, which made the fifteen-hundred-mile flight to Moscow at speeds of up to a hundred miles per hour.)

In 1928 Porter received his degree in art history and went directly to New York to the Art Students' League, where he studied with Boardman Robinson and Thomas Hart Benton. The classes were in figure drawing but not painting: "I don't think anybody in America knew how to paint in oils then." Benton, for instance, "had no sensuousness as far as the medium is concerned. After all a painting is made of paint. Benton is one of those who seems to be trying to overcome this. He told us that reality is a series of hollows and bumps." Porter preferred Robinson, because he treated each student differently, whereas Benton had a system. In his Fifteenth Street rooming house Porter had a painting by Harold Weston, and neighbors who recognized it through his open door one day introduced him to John Marin and the critic Paul Rosenfeld of the Stieglitz circle. He was delighted by Rosenfeld's impressionistic way of talking about paintings, and his work was temporarily influenced by Marin whom he continued to admire throughout his life. Stieglitz's idea that paintings should sell for prices high enough so the artist could live off his work was new in America at the time: it left its mark on Porter's thinking.

In 1931 Porter went to Italy; he met Berenson, and told him of his enthusiasms for Tintoretto and Rubens, imbibed from Benton. Berenson replied that Veronese or Velásquez were the best of all. Porter himself, toward the end of his

life, came to like Velásquez best. In the winter of 1931 he copied in the Uffizi and the Pitti. Returning to America, in September 1932 he married the poet Anne Channing whom he had first met while at Harvard when she was sixteen. They settled in New York City.

At this time Porter painted New York street scenes and studied anatomy at the Cornell Medical School; after a day of dissecting he walked out on the street and remarked: "People look so beautiful just because they are alive." At the League, Porter had met Alex Haberstroh who painted a mural in the socialist Queens Labor Center. Through him Porter became involved in the activities of the Socialist Party. Though he called himself "the least of dilettantes" he painted a mural himself, representing imperialist war turning into civil war, and taught evening classes at the socialist Rebel Arts Center. This center published a short-lived magazine *Arise,* which was conceived as a counterpart of and in opposition to *The New Masses.* Porter was on the masthead along with Haberstroh and the poet John Wheelwright who published a series called 'Poems for a Dime' for which Porter made lino cuts. In *Arise* was printed his first piece of criticism, "Murals for Workers," an account of left-wing murals then existing in New York City.

In 1936 Porter moved back to Winnetka where he stayed three years. There he met the German refugees Paul Mattick and Fritz Henssler, writers and political theorists. Their politics, which they called Council Communism, impressed Porter. Their idea was to create a genuinely classless society, one, unlike any existing form of socialism, without a bureaucratic class. Porter wrote a statement of his political beliefs soon after this which appears in Chapter IX. The Council Communists were sharply critical of conventional leftist politics, and Porter's outspokenness made him unpopular with members of the regular parties in the area. He disliked, among leftists, the lack of connection between ideas and actuality. Years later he wrote, "Before the war I was much influenced by some German refugees, radicals, Marxists, but not Trotskyists, or, of course, not Leninists or Stalinists. And one thing that impressed me was their manners in argument. They NEVER interrupted. They also really listened, even when what you said was by no means new to them." The photographer Ellen Auerbach, who, with her husband Walter, also a Council Communist, met him at this time, recalls that he was reading Toynbee un-

abridged; he would come from reading, suddenly entering the room where company was sitting, and, without greeting, start right in: "He says . . ."

In the fall of 1939 Porter moved east again, to Peekskill, New York. Through the Auerbachs he met the dance critic Edwin Denby, and through him, Willem de Kooning, the photographer Rudy Burckhardt, and the painters Elaine Fried (later Elaine de Kooning) and Edith Schloss. Like Denby and Burckhardt he would from time to time buy paintings by the then unknown de Kooning; from him he said he learned what workmanship means for a painter: "it means not knowing what you are going to do ahead of time. The ability to be open to what is happening while you work."

These were crucial years for Porter's art. He had never painted an abstract painting, and never was to. In Chicago in 1938 he saw an exhibition of Vuillard and Bonnard. "I had never seen so many Vuillards before or maybe so many Bonnards before. I looked at the Vuillards and thought 'Maybe it was just a revelation of the obvious, and why does one think of doing anything else when it is so natural to do this?" When Bill de Kooning was first influenced by modern art it was Picasso he was emulating. With me it was Vuillard." Then, after the move to Peekskill, he met Clement Greenberg. As Porter recalled it: "We always argued. We always disagreed. Everything that one of us said, the other would say no to it. He told me I was very conceited. I thought my opinions were as good as his or better. And he once said—I introduced him to de Kooning —he was publicizing Pollack and he said to de Kooning (he was painting the *Women*), 'You can't paint this way nowadays.' And I thought, 'Who the hell is he to say that?' He said, 'You can't paint figuratively today.' " De Kooning's comment on this was, "He wanted to be my boss, without pay." Porter's reaction was, "I thought, 'If that's what he says, I think I will do just exactly what he says I can't do! That's all I will do.' I might have become an abstract painter except for that." When, in 1940, Greenberg first came out with his program for the arts in *Partisan Review,* Porter was prompt to reply in a letter to the editor: "He seems to say in 'Toward a Newer Laocoon' that History justifies the latest fashion. He confuses the arts of painting and history instead of the arts of painting and fiction. I would say that art exists not for history or for fashion, but

for men." This exchange prefigured the politics of style in New York painting for the next thirty years. Porter also recalled that Greenberg, who had just become an editor at *Partisan Review,* asked him to contribute a piece on de Kooning; Greenberg and Dwight MacDonald liked it, but it was turned down by the other editors, and again by the *Kenyon Review,* this time on the grounds that de Kooning was unknown. This was Porter's first article on de Kooning and, evidently, the first written by anyone about this artist.

In 1943 Porter moved to New York City and stayed for seven years. During World War II he worked for an industrial designer who had Navy contracts; "as soon as VJ day came I quit." He took night classes with Jacques Maroger, the former restorer at the Louvre, who taught his students to make and use special painting mediums which were supposed to approximate the recipes used by the Old Masters. Porter, who had previously been painting in tempera, used this medium thereafter—"it stays wet and it stays put," he said—except for a brief period with acrylics in the 1960s; on them he liked to quote Neil Welliver: "they dry too slowly."* It was during the war that, copying one day at the Metropolitan, "a little man with very, very bad breath," who said he had known the Impressionists, told Porter that, unlike the work of other copyists, Porter's had light. This was a refugee painter named Van Hooten, who gave Porter some practical lessons that he felt were extremely important to him. He told him that the Impressionists did not copy, and encouraged him to be more spontaneous. Porter had to work hard for his eventual accomplishments. Rudy Burckhardt recalls seeing in his studio a painting with an awkwardly cropped composition; when he pointed this out, Porter replied that first he had to learn just to paint: composition he would worry about later. But he was certainly not bothered by self-delusions on this issue; he once wrote to a friend, "It is interesting about your reaction to my early paintings. It was not so different from my own: I, too, thought them atrocious." It is a feature of Porter's criticism that he shows little tenderness toward the evidence of struggle in paintings. Rather, he writes almost enviously of

*When Welliver first made this remark, Porter asked him to elucidate. Welliver said, "When I paint in oils I work all the time. With acrylics I have to keep stopping to wait for them to dry."

French facility and French tradition, and of all English painters likes the dashing Sir Thomas Lawrence best. In 1949 Porter settled in Southampton, Long Island, which was not yet popular with artists, going to the family island those summers he could afford it. "We moved here because I wanted to be in connection with New York, as a painter. It seemed a place that, if we couldn't afford to keep going to Maine, would be a place where in summer one could swim in the ocean."

In 1951 Porter was arguing again, this time with Elaine de Kooning over a Gorky exhibition at the Whitney Museum. "She talked to me about how good they were. I talked to her about how bad they were. We had a complete, thorough disagreement about them." Whereupon Elaine de Kooning recommended Porter to Thomas B. Hess as a reviewer for *Art News*. Here Porter would review about a dozen shows a month. At the beginning Alfred Frankfurter, the chief editor, commented, "He is so intense, I give him a year." But he kept this up for eight years, as well as writing feature articles and, of course, painting. His short reviews cover almost every aspect of art; Porter's mind placed things in relation so that, taken together, these reviews make him seem like the empirical Carl Ruggles of art criticism. Bad art and famous art bring out the worst in a critic; they tempt him to suspend his attention. But in Porter's reviews, for all their range of topics, it is hard to find instances of him lapsing into adulation, contrariety, indignation, or contempt. Porter kept a calm head in the face of all the novel trends that were so much the preoccupation of criticism in the fifties and sixties; he kept his eye open for fresh individual talents. There had been the early critique of de Kooning in the forties; Porter was the first to write something consequential about Alex Katz's paintings; and he wrote enthusiastic, perceptive reviews of the first shows of Roy Lichtenstein, Alfred Leslie, Jane Freilicher, Wolf Kahn, and Jasper Johns, among others. In 1958 Porter published a firm article called "The Short Review" in *It Is,* a magazine edited by and very much for artists—the house organ, one might say, of the Eighth Street Artists' Club. It sets out his opinions on reviewing and criticism. It appears in Chapter VI, followed by a brief selection of his own reviews. In 1955 he had published an equally firm letter to the *Partisan Review* criticizing Clement Greenberg's article, " 'American-type' Painting." He undertook the responsibili-

ties of a double talent, writing in one case as the painter-as-critic addressing artists, in the other as the critic-as-painter addressing a critic and his audience.

At about the same time Porter went to *Art News* he started to exhibit his own paintings regularly. John Bernard Myers of the Tibor de Nagy Gallery has written: "My friends are a bit surprised when they learn that it was Bill de Kooning who first suggested I exhibit Porter. I told de Kooning I would show the work *sight unseen* if he thought it was that good. 'But it is!' exclaimed de Kooning. Needless to say, I discovered the paintings to be dramatically different from what I imagined they would be." Recommendations also came from Elaine de Kooning and Thomas B. Hess, as well as from Jane Freilicher and Larry Rivers, artists already in this gallery, which also showed Robert Goodnough, Grace Hartigan, and Alfred Leslie. Wolf Kahn recalls how impressed he and other painters were when they first saw one of Porter's paintings at the de Nagy Gallery; he seemed to be doing so successfully the sort of things they were concerned with in their own work. Myers edited a magazine called *Semi-colon* which published the group of poets who, with the painters mentioned above, made up Porter's circle of friends at this time: Frank O'Hara, Kenneth Koch with whom he once exchanged verse letters in the sestina form, James Schuyler, and John Ashbery. Meeting at the Cedar Tavern, "they would take poems and short plays out of the side pockets of their jackets and pass them around." Porter wrote one of the earliest and still one of the best critiques of this then little known group, and he wrote poems himself, including translations of Mallarmé; in his criticism he takes a special interest in the painters who associated with Mallarmé, Vuillard having been among them. Porter's circle of artist friends soon grew to include Alex Katz, Paul Georges, Jane Wilson, John Button, Neil Welliver, and Robert Dash. He acknowledged the influence of Freilicher, Katz, Button, Rivers, and Joe Fiore, all younger than he, on his own work; no doubt the effect was reciprocated in many cases.

In 1959 Porter became art critic at *The Nation,* where he wrote a column almost every week. He thought this his best criticism. He had freedom of topic and considerable latitude of length, and these columns (they constitute most of the contents of Chapters I through V) sum up, synthesize, and enlarge upon all the years' experience at *Art News.*

Like the Salon reviews of Stendhal or Baudelaire they are full of fine writing and fresh, resonating ideas that survive the occasion; at the same time they convey the flavor of how art was experienced in the artistic capital of the day: in Porter's case, the excitement of New York gallery and museum going. Here, in one-man shows and group shows, haphazard or focused, a wide variety of contemporary and past styles jostled for attention, often championed by polemicists. Porter gave them all a hearing, and, as the surprising juxtapositions, the connections and contrasts he makes between different artists indicate, he experienced them all in the present tense, and on their own merits, something that criticism, in search of greater historical and categorical tidiness than actually existed, does not always manage to do.* In these columns one sees how Porter's thoughts develop from direct experiences, from what he is looking at: his criticism has this quality of contingency. Sometimes in a disparaging way he uses the phrase "literary criticism" by which he means, not the criticism of literature, but the criticism of art conducted in a literary way, where art becomes the background for ideas; this he opposed to criticism which sticks close to the object of its attention, which "tells you what is there."

Robert Hatch, cultural editor at *The Nation,* recalls that Porter worked hard at his columns. When he asked him why he did it, since he was doing well as a painter, Porter said, "I want to be better known." Two years later, talking with Hatch about plans to leave the job, he put in: "I'm better known now, you see." In a letter to the poet Howard Griffin he wrote, "I am not going to review in *The Nation,* or anywhere after June, but concentrate on painting, which I haven't been able to do for some time, because criticism seems to take more and more time, for possibly less and less lines. I guess it is my resentment at writing about paintings and sculpture instead of doing it, that makes it go so slowly." During the years at *The Nation* Porter was elected to the International Association of Art Critics and received a Longview Foundation award for criticism. He had, in 1959, published a short book on Thomas Eakins for a

*In a letter, Porter expressed his views on history by way of a comparison between Marc Bloch and Hannah Arendt: "I think of him as opposed to her as Darwin is opposed to Marx: Darwin is empirical, Marx somewhat 'formalistic.' "

series on American painters published by George Braziller and edited by Thomas B. Hess. The subject he wanted was de Kooning, but "Eakins was what there was." It is unfortunate that the Eakins book, interesting though it is, together with the number of articles he was assigned to write about older American painters for *Art News,* seems to have spawned the notion that Porter was "in the tradition" of American realism. But a reading of this book will show that those were not the painters he admired or felt close to. Porter perceived the development of modern art in a strikingly original way. He saw Impressionism as a revolution in favor of empiricism, which Vuillard developed and Cézanne reversed. American abstract painting in the 1940s, responding to aspects of the American situation and environment, returned to a form that relates to the Impressionist-derived art of Vuillard. "Abstract Expressionism and Landscape," an essay published here for the first time, is Porter's fullest statement of this idea, which threads through his criticism and provides his painting with a more appropriate context, one to which the opposition between abstraction and figuration is irrelevant.

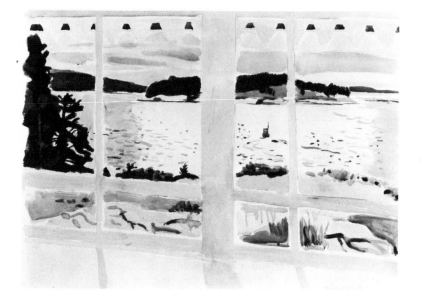

3. FAIRFIELD PORTER: *Morning from the Porch*

In the 1960s Porter's painting grew more confident and more influential. He appeared in the Sao Paolo and Venice Biennales and had a retrospective at the Cleveland Museum. His reputation was that of a uniquely distinguished and respected individualist, but not that of a celebrity; that was neither in the nature of his art nor of his temperament. Neil Welliver once remarked to him that his prices seemed too modest and that perhaps he should raise them. No, he said, he didn't think so; to sell for higher prices would only mean raising his living standards. Nineteen sixty-one had been his last year of reviewing, and it was now that his criticism took its increasingly philosophical turn. He was requested at numerous schools as a guest lecturer, and he took this job extremely seriously: it was the new outlet for his writing. The paper called "Art and Knowledge," which ultimately appeared in *Art News,* grew out of many trial versions read at various colleges—there was no question of condescending to his audience. As a painting teacher, what he did was probably what all artists do when they teach, but it did not satisfy Porter: "I think one reason I dislike teaching (which I also like very much) is that all I can do is communicate exactly what I do or want to do, and I do it in spite of myself, and in spite of even not specifically advocating anything, in spite of silence. This seems to me not good enough." But one of his students, Ted Leigh, said, "He took me more seriously than I did myself." Porter spent the year 1969-70 as visiting artist at Amherst. It was then that he began an ambitious paper he called "Technology and Artistic Perception," which preoccupied him until his death. He read this paper in long versions and short; after the last time he gave it, April 1975, he wrote in a letter, "I have been awfully busy rewriting my usual talk to read at Yale last week. But after hearing myself at Yale, or 'hearing' the effect on the audience, I think I still have to rewrite it. I agree that aesthetics should be, or I think I prefer to say, is, a collection of personal remarks, avoiding systems and extrapolations. That is the trouble with my talk. At the New York School of Visual Arts a conceptualist student, who annoyed me right away, and to whom I was trying to explain my position, asked, 'Why do you talk in general terms?' He had a telling point." But Porter might have answered that if his attack on systems was itself systematic, this is not the paradox it seems; for the nature of a plea is not to be confused with the nature of what is being pleaded

for. Porter kept up a busy correspondence during the years he worked at this paper, in which he told his friends of its development, and explained himself when they misunderstood or disagreed; his letters gloss a dense and radical train of thought. As in the 1930s when he had taken the political line that seemed right to him, though it was unpopular and unconventional, so during these years he was open to all sorts of corners of knowledge and experience that seemed to him too easily dismissed by official opinion: Sufi wisdom, folk medicine, Velikovsky... He read extensively about organic farming and even thought of giving up painting to practice it, which he also thought of doing to join the fight against atomic energy, on which he was extraordinarily well informed. But happily he did not; for surely his painting was the strongest expression of what he called "artistic perception," or the affirmative side to his critique of technology. He was producing some of his most beautiful work, and exploring the theme of his ambitious paper, when he died on September 18, 1975.

I

Contemporary
Artists

Willem de Kooning

[*1959*] The exhibition by Willem de Kooning, which has just
closed at the Janis Gallery, was an event. It has always been
so with de Kooning; his first exhibition in 1948 established
for the public what the painters who went to his studio al-
ready knew: that a painting by de Kooning has a certain
superiority to one by any other painter, which is that it is
first-hand, deep and clear. A painter of my acquaintance
said of de Kooning, "He leaves a vacuum behind him."

The phrase "abstract-expressionist" is now seen to mean
"paintings of the school of de Kooning" who stands out from
them as Giotto stood out from his contemporary realists who
broke with the Byzantine conventions of Sienna. The paint-
ings are very big, approximately square; or if small, in the
same big scale; in very broad strokes of a house painter's
wide brushes, with a dry speed and some spatter; in deep
ultramarine, a brownish pink, a very high-keyed yellow
green, a cool bright yellow, white and a little black. They
represent nothing, though landscape, not figures or still life,
is suggested. The colors are intense—not "bright," not
"primary"—but intensely themselves, as if each color had
been freed to be. The few large strokes, parallel to the
frame and at V angles, also have this freed quality. So does

36

the simple organization, the strange but simple color, the directions and the identification with speed. And in the same way that the colors are intensely themselves, so is the apparent velocity always exactly believable and appropriate. There is that elementary principle of organization in any art that nothing gets in anything else's way, and everything is at its own limit of possibilities. What does this do to the person who looks at the paintings? This: the picture presented of released possibilities, of ordinary qualities existing at their fullest limits and acting harmoniously together—this picture is exalting. That is perhaps the general image. The paintings also remind one of nature, of autumn, say, but autumn essentially, released from the usual sentimental and adventitious load of personal and irrelevant associations. The names of the paintings are misleading (*Lizbeth's Painting, Ruth's Zowie, September Morn*). They are partial, they do not tell all, they do not tell what the painting may have come from (which it may be impossible to verbalize) so much as what the painting partly in each case became. The first incorporates a child's hand prints.

Abstraction in these paintings has a different significance from that in other abstractions. Thus there is an abstract element in classical Florentine painting which says that the deepest reality is tactile: what is real is what you can touch. For the Impressionists, light counted most, for the post-Impressionists, geometry. Or the Bauhaus painters said that mathematics is the most real thing. Nor is there in de Kooning's paintings the idea that abstraction is the historically most valid form today: which might be called the sociological basis for abstraction. All these theories put something ahead of the painting, something that the painting refers to, that it leans on, and if this is removed, the painting may often fall.

Once music was not abstract, but representational, representing a secular tale or ballad, or a religious ritual. When the first abstract music was made there was a release of energy, and people expressed something about sounds in terms of some instrument that was not verbal. After this the human significance of music was also released, and in this way, de Kooning's abstractions, which are in terms of the instrument, release human significances that cannot be expressed verbally. It is as though his painting reached a different level of consciousness than painting that refers to a theory of aesthetics, or that refers to any sort of program:

in short any painting that is extensively verbalized. His meaning is not that the paintings have Meaning, like certain vast canvases notable for the difficulty of containing them in any given space. Nor is their meaning that They Have Not Been Done Before. Nor is it the romanticizing of nature, as with the West Coast abstractionists. The vacuum they leave behind them is a vacuum in accomplishment, in significance and in genuineness. No one else whose paintings can be in any way considered to resemble his reaches his level.

Richard Stankiewicz

[*1959*]

".. . Is it to sit among mattresses of the dead,
bottles, pots, shoes and grass and murmur aptest eve:
Is it to hear the blatter of grackles and say
Invisible priest; *is it to eject, to pull*
The day to pieces and cry stanza my stone?
*Where was it one first heard of the truth? The the."**

The sculpture of Richard Stankiewicz is welded together from junk: scrap iron, pieces of discarded machinery, and broken castings. It is to sculpture what the collages of Schwitters, glued together from transfers, tickets, wrappings, and pieces of advertisements are to painting. As Wallace Stevens in *The Man on the Dump* associates nouns and adjectives one would not naturally associate, so Stankiewicz associates a spring, a weight, and the casting from the top of a gas cooking stove to make a non-machine frozen into immobility by its own rust. "Where was it one first heard of the truth?" Stankiewicz' creativeness is childish and barbaric. He uses things for purposes that were not intended, or only partly so, as the early Christians used pieces of temples for their basilicas, or as a child makes wheels for his cart out of crayons. The original material still shows. Respect for the material is common enough in art; it is part of the organic theory. But his material has already been used once and it retains the quality of some previous construction, which was mechanical and functional.

* Lines from "The Man on the Dump" by Wallace Stevens, reprinted from *The Collected Poems of Wallace Stevens,* by kind permission of Alfred A. Knopf, Inc.

4. WILLEM DE KOONING: *September Morn*

As a stone carver sees the statue in the stone—Michelangelo said carving was easy, because all the sculptor had to do was cut the stone away from the statue—so Stankiewicz sees a beginning with his outer vision, which is sensitive to entirely new relationships between the given parts. Modelers in clay and other welders (who are closer to modelers than to carvers) shape material to a pre-existent image. His is not pure art, because it is related to what it reminds you of. His machines look as though they might run. There is an ambiguous representation—has he made a birdbath, a sun-dial, the emergency steering gear on the afterdeck of a ship, a winch, or what? The ambiguity gives it a

39

mischievous life of its own, a resistance to classification, a stubborn humor, that comes from the form contradicting the function. There is the sort of life that inanimate objects have, especially (or perhaps only) manufactured objects. A child sees this life in objects whose function he does not understand, or whose function he takes so much for granted that function inadequately comprehends its reality. A California Indian who owned a car that he knew how to repair, said to an anthropologist, "You white people think everything is dead." Stankiewicz shows everything to be alive. The child and the Indian feel in things a consciousness (which may be a projection of their own consciousness), an awareness that reflects their own consciousness. Stankiewicz does not have to make things over in man's image, nor in an animal's, though he does this sometimes. In his material he finds how to communicate with things, and he is capable of something better than surrealism. Surrealism

5. RICHARD STANKIEWICZ: *Playground*

can be an easy way out. Surrealism makes compound monsters. Stankiewicz can perceive below the surface as well as make things up. He sees a vitality in things before he gives them artistic life, which is neither a functional purpose nor workability, but the vitality that has rubbed off onto things from the humanity that went into their manufacture; and this vitality is as adventitious and as important as the smell of someone else's clothes. The curved edge of a lamp shade, of a doorknob, of a keyhole, of a spring, is a center of awareness where impressions are received and exchanged.

He releases this life in things before a new artistic life is made. The liveliness is strongest when it is not illustrated. His most abstract sculptures that represent least have the most individual life. This life is one that strengthens through rusting and industrial decay.

His sculpture, using junk, is a creation of life out of death, the new life being of a quite different nature than the old one that was decaying on the junk pile, on the sidewalk, in the used-car lot. In its decay there is already a new beginning before Stankiewicz gets hold of it. At his best he makes one aware of a vitality that is extra-artistic. His respect for the material is not a machinist's respect, but the respect of someone who can take a machine or leave it, who respects even the life of things, which is more than mechanical.

Giacometti

[*1960*] A sampling of the art of Giacometti is on view at the World House Galleries. It expresses artistically the extra-artistic statement that there can be a view of the world and man's place in it. That is what one would expect of religious art. But religious artists today are seldom as serious as Giacometti. Religious art much too frequently illustrates religion archaistically. Rouault, who is a Catholic, uses conventions recalling stained glass windows. Religious sculptors like to go in for Gothic elongation, as if a starved look infallibly stood for spirituality. In such cases the religious artist, through his sentimentality, patronizes religion; he makes religion belong to a romantic view of the past. Or when he tries too hard to give religion contemporary validity by the device of clothing his saints in overalls, the effect is often ludicrous, like a minister telling heavy jokes. It makes

excellent anti-clerical, even atheistic, propaganda. On the other hand, by using modern art forms, the artist patronizes art, as though art were chiefly a matter of fashion.

In addition to religious art, as a way of placing man in the world, there is art as sociology. In order to be as objective as a scientist, the sociologist puts himself outside the world; if he is an artist, he treats art as though it were raw material for a factory that produces a commodity called understanding.

I know nothing about Giacometti's beliefs; I do not know whether he belongs to a church, or if he is agnostic. But his paintings and sculpture show an overriding concern with placement. This is a modern concern, one of the practical aesthetic concerns of artists since Cézanne. However, it is usually relative and ungrounded—the painting can go any side up. Giacometti's concern is to place the relationship of man and landscape with the ground. And he further considers man and everything else as having a dual relationship to the environment as a link between the earth and infinity. His standing figures have enormous feet, and they taper somewhat, thinly upward, to a very small head that seems ever so far away. He expresses sculptural volume in planes vertical to each other: a head mostly in profile is placed at right angles to shoulders expressed mostly in breadth. If the figure is female, the breasts are again in profile parallel to the head and vertical to the shoulders. The stance is an awkward flow, like a much extended African idol. And the texture is rough and complex. The thinness makes the volume of the figure secondary to the volume of infinite space: the figure places infinity as much as it places itself. Infinity, in short, has the single limit of its beginning; it is actual, it exists, and one can experience it, in the way one experiences the sea, by looking at it from the beach. The roughness of the modeling can be thought of as the beating anything takes in an assertion of its existence against the vastness of the universe. It is its dignity, its payment for existence against the weight of indifferent adversity. The complications of the surface are, as it were, the scars of battles of limited assertion. They make shape a very serious thing.

As Giacometti expresses volume by planes, so in paintings and drawings he expresses space by linear co-ordinates. His drawings are full of parallel lines that reinforce position. The

6. ALBERTO GIACOMETTI:
Figure from Venice VI

pencil drawing of a woman stooping over in her chair (perhaps she is sewing) between two tables and in front of a window with its repetitive and partly erased lines makes physical existence and spiritual existence (where a thing is and what it is), its displacement and its position, its relation to the horizontal and to the vertical—it makes all these things inseparable, as mind is inseparable from body. The lines of the window sill partly continue across her shoulders and across the chair-back, and are erased in the gap between her back and the chair, where in nature one could see them. This says that the reality of their behindness (expressed as if she were transparent) is greater than the reality of their appearance to one side. To the side, the erasure of these lines between her back and the chair makes this space, which is in front of the window, more real than the window.

Giacometti's paintings are full of lines that connect. These, however, are not decided in advance, but organically arrived at. The eaves of the house connect with the slope of the mountain across the valley floor. Giacometti expresses the large by the small; he expresses volume by planes, and planes by lines. He expresses the vast in concentrations, and space by direction. Horizontally and vertically are not about the plane of the canvas, but about the horizontality of the ground, against which existence is vertical, or defined in co-ordinates. When he paints or draws a head, he places it below the middle of the paper or canvas, because he never forgets the space around, but chiefly not the space above.

Of all artists living today, Giacometti has perhaps the most profound imagination. As his figures, in their relation to all of space, place the beginning of endlessness, and as his interiors and landscapes take their measure and position from the small things they contain, so for him art itself is placed in the world, and by graphic compression does itself place the world.

The Education of Jasper Johns

[*1964*] The fascination of Jasper Johns' paintings lies in their seeming not to be about what is represented, hardly even the paint from which they are mostly made up. What does he love, what does he hate? He manipulates paint strokes like

cards in a patience game. The same holds for the arrangement and rearrangement of lower-case letters, numbers, primary colors and the humblest and dustiest tools to be found around a studio loft where an artist lives. What he keeps on doing is pointed up by the banality of his subjects. He constantly makes the most careful distinctions between these counters and their separations. The distinctions are limited by careful adherence to the rules of his game.

Johns's painting and sculpture relate to Pop Art, which they precede and differ from. Pop Art is much more about what it seems to be about. It is directly sentimental about bad food, standardized sex appeal and things made for sale instead of use. Otherwise it comments with Gandhian passivity on Industry's use of commodities as satanic instruments of domination. Pop Art either pretends to like junk or to criticize through *reductio ad absurdum*. It may make a *New Yorker*-style annihilating answer to industrial design and the pretensions of the Bauhaus. But Johns is not a social theorist, and he is not thinking in the ordinary way about the subject at hand.

The retrospective exhibition of Johns's work at the Jewish Museum follows the course of an education that has been carried out in public. It shows the reaction to his education of an individual intelligent enough at first to take in all that he is being taught while giving it only part of his attention. First, he has been taught the public matter that everyone is taught from the age of five on, and, secondly, his contemporaries have taught him his profession. A target used in physical education is a symbol of the accurate achievement of a purposeful goal. A flag symbolizes love for the largest community commanding loyalty. Letters are Shakespeare's medium, as numbers are Newton's. A painted wall symbolizes the way things are after they are made; and paint and color are the artist's mediums. Johns's paintings say these obvious things while simultaneously making a private commentary. Compliance takes their ordinary connotation for granted, but if one questions this connotation, it becomes meaningless.

It becomes meaningless like the ultimate statement in the famous story of the dying rabbi. The people gathered around his bed, outside his house and throughout the village, even to the village idiot, were waiting for his last words of wisdom. "What does he say?" asked the village idiot, and the question came back to the rabbi's house and to his bed-

side. "Master, what do you say?" to which the rabbi responded, "Life is like a bagel." The remark spread through the village until it finally reached the idiot, who asked, "Why is life like a bagel?" The idiot's question came back to the rabbi: "Master, we do not understand the profundity of your remark. Why is life like a bagel?" With his last breath the rabbi answered. "So it's not like a bagel."

Here is the American flag along with which goes grandfather's charged memories of service under General Grant. Here is the map of your country. Is the United States a kind of yard, or is it the whole village between home and school? Johns paints what "they" present to him as objects of reverence. He does not dislike these things, but loves them in his own way.

He has room in his mind to resist the hypnotic effect of his first teachers' generalizations. Intelligence is often associated with an ability to generalize. The uneducated mind begins with a great sensitivity to distinctions, which education teaches one to suppress. The more one learns to generalize, the more one may lose the ability to distinguish. A criticism of a generalization calls attention to an overlooked difference, which may lead to a new generalization with a better sense of the whole. But Johns, instead of criticizing, finds another generalization, with a different, rather than better, sense of the whole. He loves these symbols for their domestic familiarity and resistance to assimilation. He does not love them for what they refer to, but for their shapes, which he knows as one knows one's own house.

By his inattention, or perhaps rather by having more attentiveness than the situation in a practical sense calls for, he changes the target's symbol of skill into his own skill at making concentric circles with a care that shows that as each ring is the equal of every other ring in width, this all the more precisely emphasizes their difference in area. He displaces the meaning of the flag from a general idea to a concrete assemblage of puppyish stars, and of stripes of accurately generous equality. It is not narrowness, but width within edges that he can securely rely upon. This is not expressed casually. It is a responsible matter of paying the closest possible attention to distinctions of shape. The new generality is in the way "the paint goes across the canvas," to use a phrase of Alex Katz, a motion that is not held up by the sharpest contours, but rather enhanced by them. Not even the actual relief of wooden balls between taut canvases,

7. JASPER JOHNS: *Two Flags*

nor of projecting drawer knobs, nor attached lumber, dan-
gling spoons and wires, holds up the motion of the paint.
His generality is the painterly insistence on flatness in diver-
sity, even three-dimensional diversity. You can reject this
generality of his at the cost of preferring nothing better than
some Fourth-of-July cliché. Breadth is implicit in all the
details: it shows in his choice of an old-fashioned type face
derived from railroad freight-office stencils; it shows in the
unstrained curves of isolated numbers; in the spread of each
star like young footprints in the snow; it shows in the scale
of the lettering of the names of the states compared to their

topographical contours; in the precise amount of the spilling of the paint; and in the small strength of the wooden balls caught between stretchers. It is this breadth and this banality, a banality extending to the grayness and the monotonous textures, which saves his paintings from preciosity and gives them their wholeness.

In the paintings the vitality comes from the specific generalization. Breadth is their wholeness. In the sculptures of beer cans, light bulbs, flashlights, paint brushes in a can, the private comment almost disappears. They do not seem to transcend the obvious reference, and they are often as deathly as the castings made from the holes in the lava and ash of Herculaneum and Pompeii. A used beer can had a function, but his casting has none. Is it enough to remove an object from its context to see it as a shape? This is the second stage of education, when an individual's attention is directed toward imitation of a world which is not yet his own. His attention to distinctions so much occupies him that he finds no other generalization than the given one. He becomes fascinated by technique, such as the problems of casting and patination.

Generalizing dominates the third stage of an education. One does not reserve part of one's attention, which is undivided. To this stage belong the paintings in red, yellow and blue applied in the spilly and irregular way of the New York School. The objects of his world include a larger proportion of the elements of his profession, colored pigments. If he wanted to find distinctions from which to put together new generalizations, he could make his own distinctions between the given primaries: he might invent his own primaries, and find new generalities in the qualities of texture. Actually he uses what is given by his professional contemporaries. Does this mean that the nature of painting is not taken enough for granted to be expressed almost altogether in clichés as stale as those of patriotism, culture and industry?

Pop Art is an abortive attempt to show that painting today, especially that of the maturing avant-garde, is entirely in the hands of stuffed shirts. Pop Art may itself be a victim of the cliché of the *dernier cri*. Johns does not try to transcend the avant-garde. I believe the reason for this is that Johns's expression is no more that of an artist who is first of all a painter than of an artist who is satisfied to use painting. Perhaps his quality would come out as well in another

medium. In this he is like Pop artists, who are more interested in what they say than in their tools and mediums.

Joseph Cornell

[*1966*] The boxes of Joseph Cornell were first exhibited in the Julian Levy Gallery, in the early 'thirties. The exhibition was called "Toys for Adults." The title suggests that Julian Levy, whose gallery specialized in surrealism, was not certain that the boxes could be included within the category of art, or were to be taken as seriously as surrealism, or had the literary quality that surrealism had restored to the visual arts.

Nineteenth century civilization, more than that of any previous century, was dominated by the written word. And so were its visual arts. Literature comes into painting from criticism, usually written by writers. And though, probably first influenced by the independent assertion of the Impressionists, criticism has for some time disparaged a literary content in the visual arts, this disparagement is a verbal thing, and civilization is still dominated by the written word. As much as any articulation of ideas in words, it is literary criticism that led to the development of schools in modern art. It is the economic pressure on scholarship exerted by the universities that leads to the naming of movements in the arts, and once a movement is named, it is justified by words, and the literature around it gives it critical validity. Even the separation of form from content and the description of form in words makes form into a kind of verbal content owing its life to the way this formality is expressed. Visual form, once expressed in words, is form translated; and having made this translation, criticism refers to it, and it becomes no longer necessary for the critic to see what he is talking about. He starts talking about the words that replace his experience. Indeed the most avant-garde critics like Marshall McLuhan and Harold Rosenberg have substituted for seeing a manipulation of the symbols brought into being by this verbal translation. They resemble the science fiction fantasy of a super brain kept alive in some fluid for consultation and direction: the pure intelligence, the super-boss.

Surrealism imitated the literature of the subconscious written in the early part of this century: this literature gives

it its validity in criticism, and surrealism could be said to illustrate this literature as Gérôme illustrated the historical novel. Sometimes the quality of this content can be measured by Freud's supposed remark to Salvador Dali that he found himself more interested in Dali's conscious than his unconscious mind. Though Joseph Cornell's boxes do not seem to be visual art pure and separate from literature, it is not easy to say what their content is. They escape the classification of criticism. They also escape formal classification: are they sculpture, collage, painting? Because they are three-dimensional, they communicate their quality as badly by photograph as sculpture does. Rather than directly to volume and space, they allude to emotions and memories associated with them like a poetic material, and instead of illustrating poetry, they compete with it. Some of the remarks by Albert Béguin in his preface to a collection of the poems of Gérard de Nerval come closer to expressing the quality of Cornell than art criticism could. These remarks about Nerval's sonnets are applicable: "Their mystery is of such a unique quality that their emotional power possesses the [spectator] without his wishing to translate their secret into less secret language.... A language allied thus to facts which the [artist] alone is aware of should be least communicable of all, but here on the contrary, because his choice obeys no other than an affective reference, because he tends to seize a secret universe, drawn from true awareness...the [spectator] is touched to the heart." "Like all true poets, he invites us to see things in a light in which we do not know them, but which turns out to be almost that one in which we have always hoped one day to see them bathed."

As in sculpture and painting the elements of Cornell's boxes are partly volume and space, but Cornell uses them for their associated allusions. Moholy-Nagy said that the illiterate man of the future would be the one who did not use a camera: this remark has journalistic impact and the Bauhaus romanticism about machinery. Cornell uses his elements as though they were words, but what they allude to have no verbal equivalents. In this sense they are not literary and you can no more substitute a verbal program for one of his boxes than you could do so for one of Cézanne's paintings—as on the contrary you could express a nineteenth century salon machine or a twentieth century painting by de Chirico in a written description.

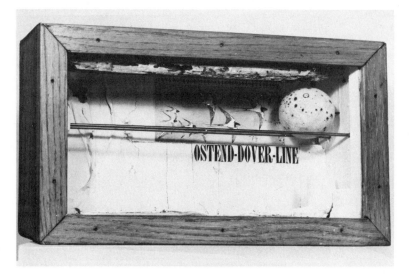

8. Joseph Cornell: *Ostend-Dover*

The boxes are 12 by 15 inches more or less, or the size of
call boxes, such as in old fashioned elevators or in a butler's
pantry indicate by number the floor or room from which a
call comes. A sheet of glass in front is held in a carefully
and imperfectly made frame, whose mitered corners do not
fit tightly. The finish looks worn and handled, and a foreign
newspaper may be varnished over the surface. The inside
is usually white, clean, cracked and peeling. The contents
vary greatly. There may be a round column on one side
establishing the space of the room, and a horizontal bar from
which hangs a piston ring. There are actual objects like
wooden parrots on a perch, coarse screening, springs, cork
balls like fishing rod floats, wine glasses whole or broken,
clay pipes, a bearing plate of a pocket watch, a dried star-
fish, gears, bits of driftwood whose shape indicates that they
were once part of something used, nails, coins; sand colored
navy blue, pink, yellow or white. There is collage material:
letters in foreign languages, signs (Hôtel de l'Etoile, Grand
Hôtel Bon Port, Apollinaris), a Florentine milliner's notice
in slightly inaccurate English, astrological and astronomical
charts and diagrams as if cut out of a dictionary, stamps,
photographs of portraits by Bronzino, mirrors and peeling

51

colored patterns. There is a sort of box that is meant to be picked up, with loose sand in layers separated according to color by an inner sheet of glass, in which the bottom layer shakes over a background of incised rays in a white or navy blue surface, and with a loose piston ring or broken spring moving in it. His favorite colors suggest provincial European hotels: white, Parcheesi yellow, pink and French blue-gray.

A list of the contents is misleading, because it does not tell about Cornell's sense of how little is enough, like an actor's sense of timing or the Japanese sensitivity to the value of emptiness and the isolated object. As composer he is director and stage designer both, with the director's feeling for the emotional value of each actor's part, and the most efficient use of the space allotted to him.

Any artist, and in Cornell's case the parallel is closest to a poet, has a style which determines and is the particularity of his communication. Those boxes that resemble most a room, a subjective container of the soul, are, even when the printed reference is to a hotel, like the stateroom of a ship; the round column recalling the structure of the hull that obtrudes in all except the most elegant first class staterooms of ocean liners built to make the passengers forget they are at sea. The color is white, thick, caked and scrubbed; it is ship-shape even where it is worn, like the many coats of thick paint that never quite succeed in protecting the iron from the corrosive effects of salt and spray. The reminiscence of a ship cabin brings the suggestion that the room is on a journey. The view out the window is the stars, the constellations, which as abstractions of the stars are constructions of the human spirit. The sand in the sand boxes is conceptual nature, the abstraction of number, which is also a construction of the human spirit. The starfish is dry and mathematical, a particular realization of the eternal concept five. The bits of driftwood, usually fragments of something artificial, imply nature indirectly, as does the caked and scrubbed paint of his interiors. The view may be a photograph of a work of art, or a mirror. He implies nature through its effects, the effect of time, another human abstraction, or of number, with a suggestion of vast distance and quantity. So far is the distance (astronomical), so great is the number of grains of sand (impractical to count), so many the combinations of these numbers as the box is shaken, so many the combinations of patterns as they catch

on the rayed incisions of the background and the spring and piston rings slide around in them, that it is as though he were telling us that this small space contains infinity and eternity. Infinity, in short, is not a matter of physical size. This is mathematically accurate. It is for example demonstrable that a line of infinite length and definite pattern can be contained in any space, say a postage stamp. The present recalls the childhood of the Medici, and this present place, this ship-shape cabin of the soul, is one end of a line reaching light years away in space-time, to the most distant constellations, which themselves, like the astronomical or astrological charts, are smaller or larger, depending on how you regard them; they are varying imagined forms that contain these distances, as they are in their turn contained in the subjective box of the whole. The cabin of the mind reaches back in time and across the ocean to Bronzino. The mental box of sand, by analogy and like a book, can hold within its small and determinate volume Cantor's theorems of transfinite numbers.

Nature in Cornell is not nature directly experienced by the senses. The sensuous world is only implied. It is presented after having been experienced and translated by the abstractions of art, mechanics, mathematics and science. Nature appears most directly in its limitations as the enclosed box whose corners do not fit perfectly, and whose insides, for all their whiteness and order, are worn by the defence against time.

His content has something that has not been seen in works of visual art since the Renaissance, and that gradually disappeared from them during the seventeenth century, which is an inclusion within itself of references to the highest reaches of the human spirit, without pedantry, artistically and imaginatively. Unlike Cornell though, the Renaissance was triumphant and extrovertive, while he is introvertive and melancholy and includes the spectator in his awareness. Cornell's nature is an abstract matrix through which journeys the cabin of the mind. What floor, what room does the call come from? It comes from sixteenth century Florence, it comes from Antares; and to answer it requires a journey in a carefully made, worn and imperfect ship. He could say with Nerval, "I have carried my love like prey off into solitude." (J'ai emporté mon amour comme une proie dans la solitude.)

II

Contemporary Styles

American Non-Objective Painting

[*1959*] International interest in American art is a new thing. It is comparable to the nineteenth-century interest in Japanese popular art, or the twentieth-century interest in Impressionism and Cubism. American painting has a new quality that attracts interest even behind the iron curtain: Polish artists admire it, and Russian art circles take time to express disapproval. From international exhibitions it looks as though this painting style, which is more accurately called non-objective than abstract, is not a spontaneous growth contemporary in all countries, but that it has its greatest authority in New York. The new American painting comes from a variety of sources, mostly French and Japanese. It does not matter who influenced who, or who came first; quality is what counts. Arthur Dove and Kandinsky may have made the first abstract paintings in 1908 or whenever, but Picasso's and Braque's Cubism has more authority. De Kooning derived from Picasso, Picasso from Toulouse-Lautrec, Bonnard from Gauguin, Cézanne from Pissarro, van Gogh from Hiroshige and El Greco from Jacopo Bassano. But the distinction that finally counts is not how unlike one artist is from another, but how much this quality stands by itself and honors what it came from.

The new quality in Japanese art that was attractive to the nineteenth century was an expression of the temporary nature of experience. Impressionism expressed the empirical theory that what you know you can know only in your sensations. The new American painting expresses the habit of thinking that what one does is what one is; that a past origin is no more real than its present derivative, and that the significance of future ends is contained in present means. From this it follows that art does not stand for something outside itself. This notion contains the difference between typically American non-objective painting and the European abstraction that preceded it, and also between American non-objective painting and the contemporary European painting that resembles it. Non-objective European painting still either stands for something outside itself or, if not, then the painter, being used to making symbolic art, does not pay close enough attention to the painting before him.

As painting reveals, like handwriting, the state of the artist's soul, so a national school shows the strength and weakness of the class that produces it. The finest French painting is in a great national tradition. French non-objective painting is as much outside this tradition as American Cubism. The French non-objective painters express the chauvinism and avarice of the French petite bourgeoisie. It is as if they thought it were enough to be French, and also cynically believed that they were getting away with something. Soulages is a French painter whose work somewhat resembles Kline's: but Soulages does not "follow the paint" as Kline does: his painting is less attentive to the paint than to a pretended mystery of representation—say, the sky seen through tarred fence boards. Manessier, more cubistic than de Kooning, is very far down what Clive Bell would call the slope that starts with Picasso.

Non-objective Italian painting looks very much like American painting, but it is tidied up. Tidiness is inadequate formality. Except for Burri, the Italians have a common sense of humor that prevents them from taking their art seriously enough. They are like wise clowns inhibited by a knowledge of the vanity of all human effort. The Germans are still under the influence of the Bauhaus idea, and they believe in the supreme importance of the communication of ideas, as if art existed for education's sake, as a guide to the good life. As ideas in German have a concreteness that

they lack in any other language, so in abstract German painting the details embody general ideas, and the painting as a whole is something that can be taught rather than experienced.

The British are the most sympathetic in their understanding of American painting. Alan Davie (who derives from early Pollock) and Peter Lanyon have shown two qualities that exist in no other national school: a sense of the division of the canvas reminiscent of the division of the wall in eighteenth-century architecture, and a love for the countryside. Americans have no continuing sense of what architecture is: we are sentimental about the past and about functional engineering; and, since the American countryside is still in the process of destruction, our colors are drug store colors.

However, the new American painting stands by itself, and one remembers it on its own terms. That happens when the artist pays profound attention to the painting itself while he is making it. Art is measured by an interior intensity. The intensity may have taken place previous to the specific painting, or even in some other artist's work. (This latter is the carried-over intensity of a highly skilled performance.) But somewhere along the line the greatest possible attention has been paid to something whose importance to the artist is a measure of its reality to him. The painting compels the imagination of the spectator as it compelled the painter's. The Impressionists taught us to look at nature very carefully; the Americans teach us to look very carefully at the painting. Paint is as real as nature and the means of a painting can contain its ends. Shaw said of playwriting that once the characters are started, the writer must follow them, not will them; he must pay attention to the life that has been given an independent existence. This idea of creation is nonintellectual. Also, because what continues to interest in such a work of art is the work itself and not outside references, this idea necessarily stresses formal values. In the criticism of painting it has led to an emphasis on decoration as a standard, which has in its turn the weakness of a standard external to the painting (what is decorative ornaments the environment), and so what is only decorative has no life of its own.

The non-intellectuality of self-sufficient art is quite different from the anti-intellectuality of the Nazis or the Com-

munists, who want to be the only client of art, which they can then use to advance their power, as Madison Avenue wants to use art to advance the power of its various clients.

Any number of accustomed things may be real to the painter of non-objective paintings, but one thing is new to the paintings under discussion, namely that the labor of the process is a subject of contemplation. To be attentive to a process is a way people have of making tedious tasks palatable. If one loses oneself in washing the dishes or in cutting the grass, one makes a game of it. The task is transformed by attentiveness to the process: work becomes play, and it is said that one is being artistic about it. The non-objective artist separates the process from the work result.

Symptomatic of this attitude is the use of accident. Accident would seem to be an element unworthy of the ends of a completed painting that has been willed in advance (as the Bauhaus painters planned their art). But when an artist pays the closest possible attention to the work as it goes along, it does not escape his attention that the accident may have a place. (When Japanese painters copy this characteristic look in American painting, the effect is that of putting artificial worm holes in new furniture.) The organic use of accident, that is, the attentive use of it from following the painting as Shaw said a playwright must follow the characters, makes painting as art relate in a new way to painting as labor, and to its function as a protection against the weather. American non-objective painting is playful about work. The practical end of work is disregarded. In this particular way work has not been turned into play before. It makes art out of the contemplation of work, as Stendhal made art out of the contemplation of love and politics, or as Dostoevsky made art out of a contemplation of the conflict of Christian belief with atheism. I think of a carpenter who built a barn for my father. He was very skillful, and to entertain the children who watched him, he would either hammer in a nail very rapidly, never missing the head, or else, in parody of a clumsy novice, make what he called "hammer blossoms"— scars around the nail where he had just as accurately missed. He turned labor into comedy.

The quality of American painting comes partly from a playful exploitation of the medium and partly from the fresh eye of an outsider. It is as though American painters had, as John Strachey said of T. S. Eliot, "ransacked" the history

of art in search of how the classics were made, and taken these means out of the context of their original purposes. The fresh attitude toward the process is like the fresh attitude of a small child toward the words that he has known for only a year and a half, but it does not mean that the painter is interested only in the process any more than the child is interested only in the words for themselves, and not in what they can do. American non-objective painting has an articulateness coming from a sudden mastery of a tool, making the tool seem full of bright and unrealized possibilities. European non-objective painters are inhibited by a realization of the greatness of their past.

Here it may be appropriate to say something about Russian painting, which is so different from what has so far been discussed. Judging from the selection at the Coliseum last summer, Russian paintings lean on extraneous ends even when there is no obvious propaganda purpose. One immense painting of flowers tells you that what moved the artist in nature can be reduced by conscientiousness and hard work to an unpleasant task, stoically carried out. And of the propaganda paintings one thinks, what a laborious way to point a moral! It is like American advertising art with the difference that what an American commercial artist paints in less than a week, is shown by the dates on the Russian painting to have taken years to complete. Taking the Russian paintings as space covered with paint, they protest their spots of meaning with a literalness that has less to do with life than with a will that is everywhere in opposition to natural processes. These moments of meaning—that Stalin was there, that the sun sets behind new constructions as well as old ones, etc.—are like a musical composition stopped on a single note, that blows and blows. They are connected with conscientious passages of gray and brown paint. Structure is arithmetical, nature is transformed into jargon. Art is turned into work. Russian painting is closest of all to the painting of the early development of capitalism. The conscientiousness resembles the bad conscience that Eakins struggled with in presuming, by his decision to be an artist, to live off the money his father had earned through hard work. But the conscientiousness induced by the Russian state has none of the intensity of Eakins' burden.

You look at a Russian painting and appreciate the hard work that must have gone into it, but also you wonder why anyone bothered to make the effort. It is a way of making

a living, like another. You think of a good American paint-
ing, how easily done, what a pleasure; I, too, would like to
makes it possible for the spectator to participate.
do that! Russian painting is a skill for those willing to pay
the price exacted by a government-induced conscience:
American painting presents the pleasure of art in a way that

New Images of Man

[*1959*] The new show at the Museum of Modern Art is held to-
gether by a tenuous theme. It is called "New Images of
Man," and like most themes, it is forced, and therefore in-
teresting. The common superficial look of the exhibition is
that it collects monsters of mutilation, death and decay. It
is less an exhibition for people interested in painting and
sculpture than an entertainment for moralists. It has a
painterly-plastic side and a literary side. The painters are
Appel, Bacon, Diebenkorn, Golub, Balcomb Greene, de
Kooning, Lebrun, McGarrell, Müller, Oliveira and Pollock:
the sculptors, Armitage, Baskin, Butler, Campoli, César,
Paolozzi, Richier, Roszak, Westermann and Wotruba. Du-
buffet and Giacometti appear in both categories. In his
introduction to the catalogue, Peter Selz, director of the
exhibition, says, "Like the more abstract artists of the
period these imagists take the human situation...rather
than formal structure, as their starting point." And in the
preface, Paul Tillich, the theologian, writes: "The image of
man became transformed, distorted, disrupted and it finally
disappeared in recent art. But as in the reality of our lives,
so in its mirror of the visual arts, the human protest arose
against the fate to become a thing."

The most monstrous creations are contributed by the
sculptors, and the most horrible paintings by the British
Francis Bacon. His gratuitous horrors illustrate the con-
clusions of untold stories: why is the Cardinal screaming (or
maybe yawning) in his brass cage; and Van Gogh's shad-
owed face, is it mutilated by a leprosy? After a while
Bacon's images become absurd. With a very few notable ex-
ceptions the English have been literary artists, at least since
Blake. Their strongest impact or most haunting memory
comes from a suggested story. For instance, Paolozzi's
muddy concretions of broken clockwork are richer for the

suggestion of the aftermath of a bombardment. Paolozzi is British. But Dubuffet's *Knight of Darkness* or César's incomplete torsos are essentially plastic and say their say in terms of volumes. They are French. So is Germaine Richier. She makes human figures of insect vitality from the slash left by the lumberman. She sees figures in the forest. Hers is not so much a new view of man as an anthropomorphic view of nature. Baskin is American. His smaller than life-sized, unemployed fat men come out of a Turkish bath. They have none of the eloquence of his statement: "Our human frame, our gutted mansion, our enveloping sack of beef is yet a glory. . . . Between eye and eye stretches an interminable landscape."

There are straight monsters, and there are formal ambiguities. There is the ambiguity in a Balcomb Greene painting about what is light and what is form. There is the ambiguity of making something real by looking to one side. In this way a figure by Giacometti is real because its thinness and height bound the space around it: its surface is infinity's single limit, as zero is the single limit of the series of all the numbers. Instead of feminine grace, de Kooning's women have the grace of the stroke of the brush at the end of his arm. Diebenkorn's ambiguity is that one is doubtful, not of what anything is, but only of where it is: the definiteness of structure comes from the indefiniteness of spatial relations.

To react against formalism is to begin a new formality. It would be difficult to say for sure whether the first motivation of these artists is formal structure or the content of the human predicament. For instance, Golub's archaic classical giants covered with an artificial patina, or Oliveira's re-rendering of a Renaissance painting, show neither "total commitment" nor a concern with the human predicament. Neither do they show any clear preference for formal structure.

Or if one takes as his subject matter the pit of Buchenwald, as Lebrun does, one takes for subject matter something safely remote from the smallness of daily-life experience. Are these artists protesting against the terrors of the modern world, or against a fear of not being accepted? Are they protesting the dehumanization of modern man, or are they afraid of the responsibility attached to an assertion of individuality? Do they show man-become-a-thing because they are afraid of it, or because they wish to be so them-

selves; because they wish to be ordinary? The violence of their subject matter may very well hide a fear of appearing ridiculous. The violent image of man has the purpose of making a creation acceptable to critics, it gives an easy subject matter to critical writing, for these paintings and sculptures seem to mean something profound in proportion to the amount of distortion and the violence of their appearance, and in this way the artist clears himself from a conscience made uneasy by his choice to be only an artist in a society where moral threats emanate from sociologists and practical threats from politicians. The artists want to be as needed as scientists or generals or bureaucrats or entertainers. The new image of man may be a disguise, an excuse, an apology for the artistic profession.

On hearing Stavrogin's confession of his ugly crime, Dostoevsky's priest commented that fear of ridicule would prevent him from making his confession public. And in the same way the artist's indifference to moral censure covers up his fear of ridicule. He may seem to be courageously facing the human predicament, but this courage saves him from the harder necessity of accepting the difficulties of art and public contempt. It has probably been like this only since the artist was told that he is a prophet, and that art is a substitute for religion. His job would be easier to face fruitfully if he did not think that he was supplying a lack that it is not his business to supply. The fate to become a thing may not be so terrible as the pressure to become a seer.

Happenings

[*1959*] The Reuben Gallery is a new gallery at 61 Fourth Avenue, New York. It plans to show avant-garde art that you can see nowhere else. The first exhibition is not of paintings but is an "event" consisting of eighteen "happenings," by Allan Kaprow. Kaprow has had thirteen one-man exhibitions, and he teaches art history at Rutgers University. He wishes to stretch the limits of art; he wants to make something outside the old classifications, to which one responds with several senses. Like a composer of opera, he wants to combine all the arts in one form. He is ambitious; and as a teacher conscious of history he is impatient with the brush: he re-

sembles the critics who say, "you can't do such and such any more, it has already been done."

To see the "Eighteen Happenings" it was necessary to reserve seats in advance. During the performance different things go on in each of three different rooms, which are separated by semi-transparent plastic partitions. After two sets of events, you move, during an intermission, to another room, according to instructions given you at the door. After two more events you move to the remaining room, and so each member of the audience sees one-third of all that goes on; but you can hear and partly see what is happening in the other rooms. Actors come in, read or speak or play a musical instrument, or paint, or just move; and accompanying this are tape-recorded sounds and the activity and noise of wound-up mechanical toys. Sometimes the words spoken are drowned out by other sounds. In one room is a collage of artificial fruits, partly painted over. There are vari-colored lights.

The movements are military, disciplined and solemn: the words spoken have a similar solemnity, the fragments of ideas are romanticized, there is something about time from T. S. Eliot, phrases like "art: dear to you all" and "the mocker mocked." A game is stiffly played according to plan by two players with cubical blocks.

The details, like the details of collage, are ready-made: reminiscences of sets by Rauschenberg for dances by Cunningham, of Cage's music (this in the quality of timing), of modern poetry, of Dada and German Expressionism. The action is monolithic, the materials of the setting flimsy, and the voices have an unrelieved seriousness. Kaprow's method is almost the opposite of most artists, literary or visual, who make something out of clichés or ordinary things or rubbish: he uses art, and he makes clichés. Kaprow debases what he quotes and what he refers to. If he wants to prove that certain things can't be done again because they have already been done, he couldn't be more convincing. The "Eighteen Happenings" devalue all art by a meaningless and deliberate surgery. And the final totality is without character, it never takes off from the sidewalk.

Avant-garde art has the merit of surprise. Kaprow's avant-garde "event" constantly disappoints one's expectation of surprise. Like so many science fiction movies about the future, his subject matter is the undigested immediate past.

Abstraction in Sculpture

[*1959*] Sculpture is a displaced art. Since the Renaissance, at least, there have been many fewer sculptors than painters, and the quality of sculpture has not equaled that of painting. And, except for Rodin, the best sculpture since the eighteenth century has been made by painters: Degas, Renoir, Matisse, Picasso and Giacometti. Nowadays the problem of exhibiting sculpture is a very difficult one. It is hard to get space enough: outdoors is usually better than indoors. But even the Museum of Modern Art's sculpture garden looks like a cramped storage room; only Rodin finally holds his own there.

Is sculpture an adjunct of architecture? It certainly has been; but how can it be an adjunct of modern architecture, which is mostly anti-art and anti-ornament? Before the Industrial Revolution architecture was monumental; *things* were made. Art made thingishness coherent, logical and objective, in a single building or façade, or in a larger way, in the baroque street or square, or the Paris of Napoleon III. Paris has the beauty of a visible humane coherence. Buckminster Fuller once suggested that the architecture of the future would be invisible. In the twentieth-century urban environment of America the presence of the present is ghostly and the connections with the past are weak. The coherence of New York is invisible, though it can be experienced.

The most visible urban coherence of this century is the Los Angeles system of freeways. Los Angeles or New York is a complex of functions. Experience of our twentieth-century-created environment is linear and textural: lines of force of traffic, water, gas and electricity, and texture that builds nothing. "Man" is not an object to be looked at in the round; instead he is what one is inside of. Man is interior and subjective, and it is unprecedented for artists to try to express this with three-dimensional objects.

And so modern sculptors, I suppose influenced by their environment, often do not present any image of man at all. They present an image of the environment. The current fashion for steel as a material comes from the use of steel in modern construction. (It also comes from the absence of craftsmen trained in bronze casting.) Beside the challenge

of the materials, the social challenge that issues from the functional instead of monumental character of the environment makes man, too, a part of a function, or at least diminishes his scale. Consequently much sculpture, like much painting today, resembles Chinese painting, in which man is subordinate to the environment; and many sculptors, like Smith, carry the resemblance further, by sometimes making landscape their subject matter. What goes well with modern architecture or, rather, what do modern architects admit as an adjunct, if not plants? The terrace of the Lever Building contains, as far as one can tell from the street below, a wilderness of trees, a most informal garden. Sculpture to go with such architecture would by no means have to be a heroic version of man, not even a sociologist's or moralist's version; but instead some sort of undisciplined life to set off the engineering, like autumn weeds blooming in the cinders of a railroad embankment.

Two exhibitions of sculpture in October had a lot to do with meeting these challenges: the show at the Castelli Gallery, called "Art in three dimensions," and the sculpture group at the Stable. Both exhibitions, though arranged with all the skill at the command of the galleries, were crowded and confused. They showed the various responses of sculptors today to their environment. Some try to represent man, as developed from the Cubists' view of man, which, by the way, being geometrical, can harmonize with architecture. Such sculptures are Kohn's *Ecole Maternelle,* a wooden "figure" with a head stuck full of projecting dowels, or Geist's figure with non-matching legs.

Louise Nevelson responds to these challenges by building her own architecture. She makes a façade. This is close to that Renaissance non-objective architecture that consisted of useless façades. Her sculpture-architecture is fantastic rather than representational.

Weinrib's tangle of wire and bent metal on two supports, though looked at from the outside like any sculpture, created a thicket that the spectator is imaginatively drawn into, as one imaginatively enters and walks around in a Chinese landscape painting. Its formality is to be judged from every direction, but as if from inside. It is therefore somewhat subjective; or perhaps one should say it is an object that communicates physical subjectivity. Chamberlain showed jammed-up conglomerations of brightly painted

mudguards. The color, which is easy and natural, contradicts the look of ruin: the forms are those of a junk yard, and the color suggests acceptance: they are like rowboats planted with flowers. Ortman's neat constructions have the brightly painted geometry of games of chance. His moral could be that you find your reward by following the rules, without regard to the outcome, as one enjoys Parcheesi.

Seley's figure was subjective in another way. A lacquered, smoothly curved irregular piece of metal stands erect on two angle irons; at the top is a burnt vertical slit-mouth. It represents the subjective experience of the nude. Jean Follett's cindery trays with an arrangement of insulators have poetic nostalgia.

Sugarman created volume in a sequence of heavy curves chiseled from a long lamination of planks. Of all the exhibitors he perhaps depends least on sentimental overtones.

The influence of Brancusi dominates the diversity of Kohn, Malicoat and Noguchi. Malicoat's rock has the Japanese appreciation of nature-for-itself. Noguchi's *Square Bird* is one of the few sculptures to express any sensuality, which is in the smoothness and precision of the surface. The overwhelming presence of science and technique has tended to eliminate sensuality even more effectively than it was eliminated by Victorian morality. Instead of the Puritanism of religion there is the new sociological puritanism, like that of the Communists, creating the pressure to be contemporary; even creating the belief that one can know what one's time is. It seems that many sculptors, under the spell of the invisible reality of functions that dominate our world, want to get out from under the thingishness of their art by elevating subjectivity and evanescence. Where the painters rebel against the nature of their métier by opposing illusion and favoring materiality, so the sculptors on the contrary search for reality in the invisible. Both painters and sculptors rebel against their métier in order to accept better their environment. Abstraction is the result of the attempt to be more truly representational.

Constructivism

[*1960*] Throughout May the Chalette Gallery is exhibiting a collection of Constructivist painting. This show covers the

history of Constructivism from the pioneers—Malevich, Kandinsky, Van Doesburg, Vantongerloo, Mondrian, Lissitsky, etc.—to the present; the youngest are Agam and Ris, both of whom were born in 1928. But why not Reinhardt, Bolotowsky and Xceron?

The catalogue of the exhibition begins with a quotation from Apollinaire: "But it may be said that geometry is to the plastic arts what grammar is to the art of the writer." This is followed by a preface written by Michel Seuphor, one of the fifty-one exhibitors, notable for an angry denunciation of the "vogue of informal, lyrical, eruptive painting. . . Thus the surrealist menace of the twenties reappears in another form. . . . For ten years we have witnessed this release of torrents of mud and of intestinal matter in which remains of viscera, a whole viscous mass in the process of decomposition, can sometimes be made out." Against this visceral matter, produced by a "failure of adaptation to the environment created by the century," Seuphor opposes "a return to simple rules, to the limitation of means, to a certain deliberate poverty" where "cold reason, the most arid calculation, will suit art's purpose perfectly. . . . I see a return to rigor. . .the artist's personality expressing itself in spite of it, and almost in spite of himself." "I believe that it is. . .much more difficult to make an abstract painting than a successful figurative painting."

Almost all the paintings are geometrical; that is, the shapes are bounded by straight edges and arcs of circles. And the exceptions, like Arp's irregular curves or the coarse, neat textures of Kandinsky, which are not precisely geometrical, still have such sharp or contrasty definitions of shape that they count as artificial instead of natural, as isolated instead of part of an ambience, and therefore they belong to an ideal world of mathematics, and not to an empirical world. Albers and Vasarely believe that modern techniques make it possible and desirable that a work of art be no longer unique, but can and should be ultimately machine-made and indefinitely reproducible. And so these abstractionists take science as the precedent for their art—or at least engineering. They do not make the distinction between science and art that has been expressed very clearly by Suzanne Langer in her essay "Abstraction in Art and Abstraction in Science": that artistic abstraction is unique and scientific abstraction is general.

In some paintings of this school, notably Albers', and Agam's "kinetic" paintings, with their fluted bases covered with triangular vertical ridges that make the underlying pattern of ellipses shift as you pass—in these paintings there is the pleasure of optical illusion, as if expressing a rebellion against the self-imposed discipline. By teasing the spectator, the painter gets his revenge against his own negativism. The colors remain in the memory as red, white and blue, with some black, and less yellow and green. The exhibition resembles a congress of flags. All the color is even, washable, neat. And still, in spite of the austerity of each painting, the total effect of this display of the flags of personality is more rich and various than an average "abstract-expressionist" exhibition, where, though a single painting has more variety, a whole show presents a monotony as of the sea. Here sharpness clarifies personal difference.

Even without the ferocity of the manifesto, these paintings express a ferocity only secondarily directed against the spectator. It is first of all directed by the artist against himself. But the spectator, whose tendency is empathically to identify with any work of art, will feel this tightness in himself.

It is the pretension of the Constructivist that he sees more profoundly than another artist: he sees below appearance. He believes he is closer to reality. Reality is geometry. Constructivism implies the comment about realistic art that it is not real enough; about Impressionism that it is too feminine, too concerned with subtleties; and about Cubism, that it is not pure enough Insofar as the Constructivist sees the reality below the surface in a Platonic way he adheres to the traditional view that spirit and intellect are higher than materiality, and that the aim of civilization is the development of a disembodied intellect. This requires sublimation, which in turn requires repression. The repression is the origin of the rigidity of line and immaculateness of surface. The firm lines, the colors that are not colors seen, but colors intellectually understood, the general quality that any Constructivist painting can be reproduced, and even completely explained verbally, devalues the bodily life of the sensations. The painting substitutes a new life of sensation based on the world of sublimated art. And finally, repression exists as a method whereby one adapts oneself to worldly and external reality. What Seuphor denounces is

the disorderly world of the body. What he believes in is "adaptation to the environment created by the century": he believes that what exists most truly now, the reality underlying present appearance, contains the moral imperative to adjust. "Poverty, coldness, aridity" are all his words; the poverty, coldness and aridity of the state of soul of a person who suppresses his instincts. And the rigor is justified by his belief that it is "more difficult to make an abstract painting than a successful figurative painting," because in the former case you fight your instincts instead of using them. Value is measured by the artist's suffering.

All this sounds very negative. What do these paintings have? For they do have something, or one would not bother to look at them. For one thing, the artist's personality expresses itself in spite of the rigor, "through the meshes of a discipline that he imposes on himself." For instance, there is a great deal of difference between the personality of a painting by Mondrian, in which a rectangle of yellow is carefully and exactly banished to the edge of the canvas by a central square of blankness, and a painting by Nicholson, with its weak friendliness, also expressed in rectangles. Or between Vantongerloo's few horizontal bars, so ingeniously and spaciously extending the width of the canvas, and Malevich's flashy scatter of quadrilaterals. Or consider the delicacy and precise lyricism of Sophie Taeuber-Arp's rhythmical arrangement.

There is truth in the observation that this painting is "Communist." The combination of radicalism with a disciplining of the individual, the desire for absolute order, the polemics associated with the movement, the simplification of problems to black and white, or to colors as invariable counters abstracted from actual sensation, in the way that Marx abstracted capitalism from the machinations of individuals in the market—all this is like Communist abstraction of the idea from the particular. And the three countries where Constructivism counted most were the three countries where Marxist ideas had the most intense life in the decade following the First World War: the Netherlands of Pannekoek, the Germany of Rosa Luxemburg and the Russia of Trotsky. Seuphor's preface even has a Trotskyist literary style.

The limitation of this painting is, in addition, the limitation of painting that is not primarily a painter's painting (the

painter in Mondrian was repressed almost out of existence) but rather an engineer's or architect's or industrial designer's painting. Man is pushed away—insofar as he will not adapt to the machine—as he is pushed away from a hallway by Gropius, where one expects to see ball bearings roll, but where people have only a statistical life, and clothes are like mechanical constrictions. And though this painting comes out of radicalism and revolt, it is in the anomalous position of so much modern architecture and Marxism-in-practice. Architects, Constructivist painters and Marxists all base their activity on an awareness of a condition in building, art and social relationships, where the dead hand of the past is an obstacle to the fullest expression of human possibilities. But in practice, they do not think of changing the environment to suit men, but want to fit man to their vision of the essential nature of the environment. They believe their more profound understanding entitles them to a position of leadership. But they assume only positive values for the technical revolution; they admire the mechanical world and the sublimated life of cities, of which they fancy themselves in more efficient control, and the dead hand of the past symbolizes, finally, only personal rivalries. It does not symbolize a basic maladjustment of things to people, but of people to things, which they believe they could adjust better than the academics or the capitalists have done. These three are alike: the practical Marxist who is less indignant at the inequities of capitalism than at the successes of capitalists; the modern architect whose contribution to the problems of planning is a new whimsicality and whose skyscraper thickens the traffic congestion; and the Constructivist painter who elevates his secular suffering above the spectator's pleasure in sensuality.

Recent American Figure Painting

[*1962*] The exhibition opening at the Museum of Modern Art in May has the purpose of "exploring recent directions in one aspect of American painting: the renewed interest in the human figure." Since painters have never stopped painting the figure, and since the exhibition shows no change on the part of particular painters from a non-objective to a figurative style, it could be said to represent a renewed interest

in the figure on the part of critics and the audience rather than among painters. To this extent the critics are following the painters. But there are a number of ways in which many of these artists follow criticism.

Art is in a race with its interpretation. Since the impressionists got ahead of the audience, followed always more rapidly by one movement after another, criticism, in its attempt to keep up, has sometimes got ahead of the artists. The painter who looks for a subject, or doubts his role, has fallen behind in the race. In the Depression, when criticism acquired prestige among writers, painters looked for guidance to those literary critics who in their turn looked to politics and the social sciences. After Picasso went from cubism to archaeology, later abstract painters began to be influenced by anthropology. Literary critics talked about "the myth," and writers and painters looked for "symbols." Early Pollocks and Rothkos are full of symbolism at second-hand from "The Golden Bough." Painting moved from Benton's outward look at the American scene to Pollock's inward look.

Before he became an art critic, which led to his position as Minister of Culture in France, André Malraux was a Marxist novelist. The Japanese painter in "Man's Fate" characterizes Western painting as follows: "The more your artists paint lines that do not represent objects, the more they show the state of their own souls. For me, it is things that count." As an editor of *Partisan Review,* Clement Greenberg took on art criticism as his speciality. In 1942 he promulgated the idea that it was impossible to paint the figure any more. Presumably it had already been so thoroughly done that nothing new could be added—an important consideration to a critic allied to the principle of social progress. He thought the critic's role to be that of an especially competent interpreter of the Will of History. He addressed his remark to de Kooning, and he saw Pollock as the apex of the arrow of progress in art.

To say that you cannot paint the figure today, is like an architectural critic saying that you must not use ornament, or as if a literary critic proscribed reminiscence. In each case the critical remark is less descriptive of what is going on than it is a call for a following—a slogan demanding allegiance. In this case criticism is so much influenced by politics that it imitates the technique of a totalitarian party on the way to power. This is most marked in the case

of French criticism, as in the surrealist manifesto, or the polemics of the various geometrical schools. However, I believe that the prestige of the American form of abstraction comes from its being the present style in which most attention is paid to painting as painting, and that its particular content and relation to history are secondary. And partly because it is ahead of criticism, I believe that it is in a profound way traditional.

Non-objective painting shows the state of the artist's soul, and it stands at the apex of progress; but it is more relevant that it may represent an attention to the nature of painting itself, and that its content can be entirely contained by the physical nature of the medium. This is its non-literary side, which historical and sociological criticism might miss. And it is likely that painters who are mostly influenced by literary criticism or by psychoanalysis will miss it also. To take the nature of paint as the artist's object of contemplation, to turn work into art, was de Kooning's contribution to what is called the New York School. In the race between art and its interpretation, de Kooning's painting is more interesting than its interpretations.

The painter is ahead of the critic insofar as his painting expresses experience directly. Nowadays most direct expression of experience in painting takes the form of non-objectivity—these artists directly express the paint before them, their creativity and their environment, together. Some of the most direct landscape painting is non-objective. This can be said differently: some of the painting in which the experience of the environment is least translated from the total impact of nature, into paint, is non-objective. On the other hand, figurative painting takes a roundabout route through all the history of art, as does, for example, Picasso. The question is whether the artist's most significant experience comes directly, or through his education. And, is he interested in the world, or is he interested in what it means? Is his art empirically based, or does it begin in concepts?

Figure painting is the classic form for Western painting. Before succumbing to landscape, it went through the stages, roughly, of portraiture, history and genre. In America the artist has always had a peculiar relationship to the figure. This is partly because our civilization began as a more or less independent entity at the time when landscape took over. But this does not completely describe the situation.

For instance, most great portraitists show the mystery inherent in human beings. But, what is the mystery in Copley's sitters? Stuart and Morse, who were more European, gave their clients a largeness of stature; they experienced man through the spectacles of art. Eakins' audience believed in the virtue of work, and he had the originality of using his painting to demonstrate to his audience that art is work. American painting contains no praise of the human figure: the closest it got to this was the sentimentality of Cassatt and Thayer, or, rather peripherally in Whistler's estheticism. Homer painted children, or men at play in the wilderness. To Remington, man's dignity consists of a capacity to endure discomfort. In imitation of society, the American artist turned directly to his environment, of which he was not in control. "American-type" abstract painting begins after the frontier was closed, and there began to be time to take stock, so that formality became possible. The form is functional, in which a whole is made up of relationships, movement and change. The environment that an artist in America today sees is made less of objects than of ways of dealing with functions that have been set going.

All this has an effect on figure painting. A result is to see the figure as significant in such a function as its movement. Another is the journalistic attitude, which Bellows exemplified. An event is important in proportion to its violence; or it may be interesting because of an angularity of vision of strangeness of emphasis. This is often a character of Larry Rivers' figures. The functionalism of the environment has caused a good deal of specious expressionism and humanitarianism. The humanists have their bookish pity. There is the paradoxical attempt, called realism, to recapture the large scale and grandeur of the Renaissance by pedantic attention to the details of Renaissance execution.

A special case of art following criticism is found in the California artists, who bear the same relationship to modern art that Blake bore to Italy. As Blake knew Michelangelo from engravings, so the Californians know the impressionists and cubists from the color plates in Skira books. They follow the implicit criticism of Skira's printers.

I believe that in American art, there can be no "return" to the figure. A movement toward painting the figure will be new, not renewed. It will be the first time American painters have tackled the problem directly. And there are in America today a number of artists who paint the figure

without affectation, sentimentality or evasiveness, and who do not follow criticism, but precede it. Two in the exhibition whom I would particularly like to mention are Richard Lindner and Elaine de Kooning. Lindner, like a Balthus corsetted by cubism, has the strength of his European training. (Perhaps it means something about American painting that two such outstanding artists as Lindner and Willem de Kooning were born and educated in Europe.) Elaine de Kooning faces her experience directly, and her figurative work is more interesting than her New York School non-objective painting.

The exhibition does not pretend to survey all the figurative work that is being done. I regret the absence of Alex Katz and Paul Georges. Katz takes off from the comic strip and advertising: he humanizes banality and finds art in the commonplace. Georges uses the discoveries of the non-objective New York School for realistic ends.

III

Art, Nature, and Reality

Perfection and Nature

[*1960*] When a critic suggests that something is not worth doing because it has been done before, he is in effect urging an artist toward one of the more exciting aspects of art, the attempt to achieve the impossible. The creation of life by imitating its appearance was the impossibility attempted by the first representative artists. "Life" now has subjective validity, and deadliness is concomitant with what is not achieved, or in Cézanne's phrase, not realized.

The Janis Gallery got together excellent examples of the painting of Mondrian and the sculptures and reliefs of Arp, in what they call their classical phases. The show was beautifully arranged. What these artists have in common is that each in his way made a heroic effort to achieve the impossible. Each one goes to a certain limit, and insofar as they achieve this limit, which is a sort of perfection, what they have done is paradoxical. They fix something—life— which cannot be fixed. However, the paradox is a logical one, for a work of visual art is stationary, it doesn't grow or move, or if it does, it inevitably changes into something unintended. Mondrian's paintings, characteristically straight black bars dividing the white rectangle of the canvas into right angles, with smaller rectangles of red or blue, have a severe, puritanical look; as de Kooning has said, like prison bars. But though the indiscipline of feeling seems to be rigidly excluded, at the same time they are not "thought

up," not systematized, nor in the narrowest meaning, willed; but reached by contemplation.

It took Mondrian a long time of much adjustment to find the exact arrangement, which in every case has the absoluteness of justice. Mondrian seems to deny sensibility, but really what he lacked was quickness of intuition, a quality close to trust. It took him a long time to arrive at his decisions. He needed protection from the world, like an ascetic. He withdrew, to be free from interruption. His unbending exactness of line, his limiting himself to the right angle and to parallels, and to red, yellow and blue, gave an outer support against inner distrust. Certainly the right angle is reliable. But his fierce will was countered by a strong attachment to rhythmical music. His later paintings, like *Broadway Boogie Woogie,* are dominated, not by black bars, but by the intervals between squares sectioned from bars; and *New York City, 1* (1942) is dominated by yellow bars. They emphasize absolutely controlled rhythm and color. Rhythm is the most temporal aspect of a temporal art, and time is what these paintings control into fixity. The tension is almost too much. Mondrian's effort was always in a way the denial of time, as well as the denial of depth. All of his paintings resemble a section across depth. But depth takes its revenge, and the white background becomes a hole.

Mondrian paintings that relate to music make, as it were, an instantaneous cross-section through the music. Ingres "left it to time to finish his paintings," but Mondrian would not have thought of that. Mondrian's paintings would be perfect raw material for a picture restorer, who wants to make the paintings that come into his workshop look as they looked when they first issued from the hand of their creator. Already the paintings from 1921 are beginning to look a little dingy; the perfect white surface (or in 1921, sometimes gray surface) is covered with fine cracks where the paint strokes have shrunk away from each other. Mondrian denies time, which in its turn has demonstrated its supremacy.

Arp's tour de force, in his smooth marble abstract sculptures and in the reliefs of flat jig-saw cut-outs on a plane surface, is to reconcile infinite variety with absolute definition. As Mondrian used only right angles, so Arp never uses

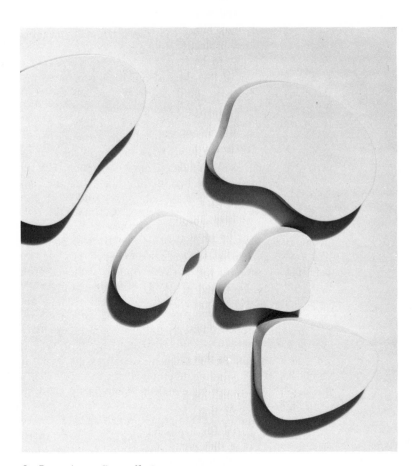

9. JEAN ARP: *Constellation*

right angles, seldom straight lines (then only straight line-segments that are part of a continuity, which in topology comes under the definition of a curve), never circles, ellipses, or plane surfaces, but always irregular or ovoid curves and surfaces, and incommensurable angles. This is the infinity with which Arp is concerned. He encloses it. He cannot accept infinity, so he goes right to the heart of the matter, and uses it. He not only uses it, he polishes it: he tries to make it completely perceptible. Few artists in any field think about the question at all (maybe Arp does

not either, but if not, he has intuitive knowledge of it); they accept variety, they take it for granted, it is the way things are. Arp, too, knows that it is the way things are, but he wants somehow to control it. Like Mondrian, his originality consists in not taking the obvious for granted. But what he does is not (maybe) so impossible as what Mondrian does; for instance, some infinities can be enclosed in a limited space: it is mathematically possible to make a line of infinite length on a postage stamp. His magnificent craziness consists in wishing to have this under his thumb, in not being willing to let anything escape him. And so something does escape him, as it will escape any artist who wishes to deny the mystery of his actual existence. If all there is to life is its infinite variety, Arp gets it; just as, if life can be willed, Mondrian gets it. One can say that life is more than these things, for if infinity can be enclosed on a postage stamp, or if time can be sectioned, what you have is limited to the postage stamp or contained in an instant without duration, and all outside of this is judged invalid. The question is how satisfying are either of these points of view. I think that insofar as they approach logical perfection, they are very satisfying. But sometimes one wants something else.

There is something else at French and Company: a huge exhibition of the sculpture of David Smith. Smith is the first American sculptor to make extensive use of welded steel. In a way, one could call his abstraction an answer to Arp and Mondrian. He does not represent, but his variety is the variety of the direct experience of nature. Nature means landscape (his sculpture looks best out of doors), and it means also experience that comes from more senses than just the visual one; for example, the welding, *Running Daughter;* and nature includes further, one's experience of tools and machinery. Smith's sculpture is sculpture for a new country, an empty country, where a high degree of technical achievement goes with the development of new and relatively uninhabited lands. It is the Coca-Cola bottle glinting in the wilderness, the abandoned gasoline pump at the edge of the virgin spruce forest, the railroad signal tower among the sunflowers of the prairie. It is these things, taken out of context, mischievously or artistically considered. Smith has tremendous energy, and he keeps producing things that have no systematic background or philosophical

77

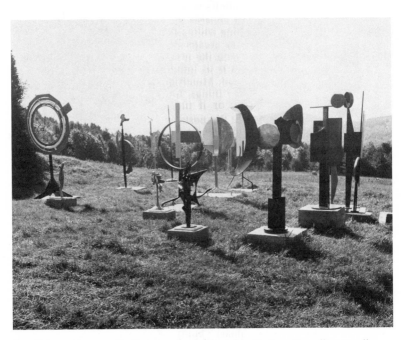

10. DAVID SMITH: Sculptures in field at his Bolton Landing studio.

program; he convinces by the weight of his endlessly various invention, like Victor Hugo, pouring out poetry. But Smith's sculpture seems to me not to be a sculpture for cities, where it is overwhelmed, and where it doesn't add. His *Tank Totems* which were suggested by watertanks on skyscrapers. would not compel your attention on the tops of buildings. In the city his *Sentinels* and *Landcoasters* look like unemployed baggage dollies: inadequate or superseded. Smith's various *Agricolas,* suggesting farm implements, make art out of the machinery that rusts with disuse and obsolescence around farm buildings, since they are too large to be got rid of. In this case the organic structural relation to their use with growing things complements both an artificial and natural environment, while the disk-and-bar constructions called *Albany* hold their own best if helped by a bare or uncompetitive background.

The Immediacy of Experience

[*1960*] Hölderlin's poem, *Nature and Art,* characterizes the Golden Age as a time when the ruler of heaven and earth "uttered no command, and still not / One of the mortals by name had named him." (Vernon Watkins' translation.) In the Saturnian age the world appeared new: things had no names, there was no past or future, all concepts were unconscious, and all order. The radiance of such an age has been expressed by poets; but has it ever been expressed in painting or sculpture? Perhaps in fifth-century Greek sculpture, and perhaps sometimes by Monet, and oftener by Sisley. But these Impressionist painters expressed it in a generalized way, and only by color. The color of nature is disappearing from painting, even though non-objective painting represents a turn away from conceptualism and toward direct experience. Non-objective painting is more graphic and emotional than open to sensation; and realist painting is less interested in nature than in ideas, as: what is natural, or what should painting be about? An expression of the immediacy of experience—for what else is the namelessness of everything—is proper to poetry and natural to photography. I know no photographs that express this so well as the color prints of my brother, Eliot Porter who, like Audubon, is known for his record of the birds of America.

He has made a series of color photographs illustrating Thoreau on the seasons, which were shown last month at the Baltimore Museum, and are now on exhibition at the Eastman museum in Rochester. They are not like other color photographs. There are no eccentric angles familiar to the movies, snapshots or advertising, and the color is like a revelation. The color of photographs usually looks added: it floats in a film above the surface; it is a dressing-up. And it is usually rather inattentive. It is inattentive in the way that printers in this country are inattentive to the accurate shade, and the way color reproductions are almost invariably insensitive. It seems that the fact of color itself is considered enough: one knows the sky is blue, and the grass green, and you can let it go at that. But Porter's colors, with all the clear transparency of dies, have substance as well. They are not on top.

79

His range of colors contributes to their namelessness. For photography has limitations comparable to those of paint—there are primary and secondary colors. Memory contracts and symbolizes and one thinks of his winter photographs as pale yellow and white; spring as blue-green; summer as red and green; autumn as orange and yellow: however if you look again, you discover that you cannot generalize, you cannot conceptualize, the colors do not correspond to words you know, they are themselves, a language that is not spoken. The color indications are all primary, as a poet might use words as though they were new, without precedent or possible future, but tied to the event. The color is tied to the shape and the context; no habitual meaning is suggested. In the corner of this grayish wall of trees, that blue, is it sky? No, it is ferns. It is as much of a discovery as the broken color of Impressionism. The shadows of leaves are yellow or black, the light on them white or blue. The weed stems in the snow are yellow, better set in and stronger in their contrast than Wyeth's black virtuosity. But you cannot describe one language with another. Drawing and painting have a language, but literature and photography *are* language. This is what Moholy-Nagy must have meant by his suggestion that the illiterate man of the future would be he who could not use a camera. These photographs make wonder the natural condition of the human mind. Have you ever seen before the redness of grass, the blueness of leaves, the orange cliffs of autumn, the two circles of sunflower blossoms, or a kersosene lamp against the sun in a window? Or that where a tree has fallen, it seems to have fallen with intention? There is no subject and background, every corner is equally alive.

Photography is nature, and so critics have thought it was not art. But if these photographs did not show you what they did, you would never have been able to discover it. The golden age of the child's omnipotence is succeeded by the Jovian world of adults and of art. Adults classify, generalize and ignore. But the ability to distinguish comes first. Can we as adults be sure that we see more deeply, through art, than the photographer who pretends to do nothing but pay the closest possible attention to everything? He distinguishes endlessly and he dares not ignore. What does love come from if not just this scrupulous respect and close attention? The trouble with art is that, in choosing, the artist ignores. The trouble with the realistic artist is

that he is indirect, and between himself and his experience he puts concepts: a steely equality of detail, conceptualistic anatomy, or the métier of the old masters. The non-objective artist is closer to the photographer in his reliance on direct experience. But, because he is not interested in objective nature he tends to lose his contact with concrete variety. The trouble with this is that it leads to a loss of a feeling for pluralism, as though all experience were becoming one experience, the experience of everything.

Intellect and Comedy

[*1961*] An exhibition of Giorgio Morandi closed at World House January 14. More than any contemporary Italian painter's, his work has a quiet commanding authority. It is as though Cézanne had mellowed into a simplified serenity. There are two themes: in one, soft grayish bottles and leathery boxes cluster in the center of the tiny canvas; in the other, boxy Italian houses stand in olive groves, by the sea, under cliffs. No human face appears. Cézanne looked for the "motif" as a vehicle to express his "little sensation." Morandi's motif is not elaborated, but presented in abstract nakedness. It expresses idea rather than sensation. The color is subdued and clear.

The New York school paintings that are without any natural image, with no "motif" of landscape or still life, nevertheless have the variety of the sensible world. It is almost "photographic." Morandi's variety is intellectual. What he has seen in the fields or on the kitchen table illustrates the theory that what is most truly known, is not known by the senses, but by the mind. The various boxes in a Morandi still life were constructed before they were experienced. They differ from one another like the cases in the declension of a Latin noun. The cover of one box is partly open, another has a label (without printing), a third is plain and closed; and also in the cluster, as if to show a range of container shapes, there is a carafe and a custard cup. If one of the containers has a handle, Morandi maintains the unity of the cluster against its surroundings by painting the hole darker than the background. Roses in a vase fit together like porcelain. Landscapes are verbal conjugations, and the most interesting, like irregular verbs,

have some unique, odd and unrepeated element. His containers and boxes are soft, his olive trees have no prickly branches, there is no crispness of tactility, or hardly any difference between textures; the order is the order of the mind.

Part of the quietness of his paintings seems to come from his having thought about the question of the least number of things in a class necessary for a sample of diversity. If you count the members of a class, I would guess that there are always less than six of a kind; and unique things have unique shapes.

A medieval view of the world seems to underlie these austerely lyrical paintings—a view that assumes that the intellectual is more certain than the sensible, that the form and logic of an inflected language corresponds to objective reality, and that an effect is part of a whole that caused it to exist. Morandi's particular paintings seem to give precedence to the ultimate reality of which they are particular effects. They are remote from the facts of journalism and personality, and have a limited logic, the logic of the few, a contentment with a little quite contrary to contemporary restlessness.

Also contrary to contemporary restlessness are the paintings of Nicholas Vasilief, at the Heller Gallery. But Vasilief asserts the biological values of the country instead of

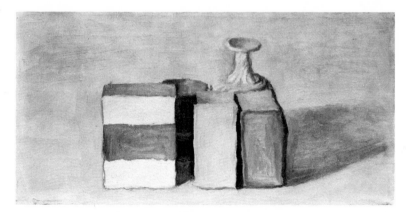

11. GIORGIO MORANDI: *Still Life*

the spiritual values of solitude, and his method is comedy.

Vasilief's father was the proprietor of an unheated third-class restaurant in Moscow, patronized by priests, nuns, jugglers and coachmen. His art teacher was Leonid Pasternak, the father of the poet. After serving in the First World War, Vasilief became professor of art in the Moscow Academy, where he had been a pupil. In 1921 he emigrated to America. His paintings, like the work of an icon artist who studied in the atelier of Matisse, have a juicy richness of color attained by no other contemporary. He has a range of glowing off-blacks, a variety of exact pinks, a rich orange tan, and a green as green should be, but never quite is, in nature—a green of dark, moist growth, like the most delicate, fresh-from-the-garden spinach.

His pink-cheeked, pig-eyed women, wearing fancy hats, are countrywomen dressed in their store clothes. His thick-walled, junky interiors are stuffed with cheerful Victorian luxury. The furniture and vases are like peasants dressed up for the city; and all the finery fails to conceal bursting,

12. NICHOLAS VASILIEFF: *Red Pitcher*

healthy contours. The crockery has more personality than the human beings: a princely pitcher, a black teapot dominating the table with maternal efficiency, coarse country lace and gilt curlicues, a tile pattern of the floor that depends on the table edge rather than supporting it. The table is seen from above in isometric plan, or even in reverse perspective, the vases in profile, to bring out their character. The fruits, flowers and vegetables, though they have no precise botanical classification, do have strong specific individuality: vitality counts above race or species. And though the flowers, fruits and vegetables all look exotic, you know that where they come from, they are as common as turnips. But his white is unconvincing. He fusses with its texture, he draws with it. Perhaps it is because white is not vegetable enough: it is too citified, and it is the color of the spirit.

The humor of the paintings consists in showing that fine manners and sophistication cannot hide an essential health, a cheerful stupidity. The country is bigger than the city. The juice of the vegetable animates the fragility of the flower. But though his paintings objectively show that art cannot conceal nature, and that biology supports artificiality, still, subjectively, they reveal just the opposite. The apparent primitive crudity of his drawing is only superficial: it cannot hide the sophistication of the form, and that the jewelry of his sequences is strung on a thread of invention.

Reality and the Museum

[*1961*] Advocates of "realism," "the human image" and "tradition," those who dislike paintings in which you recognize no natural details, would like art today to resemble what they have found and got used to in museums. They use the past as precedent for what they propose in the present. The issue is the museum. And the more artists interest themselves in this version of artistic tradition, the more they separate art and life, to the detriment of both. The separation of art and life comes from the belief that form belongs to art and content to nature. In order to have art enough, they search for order. The search for order, and the prejudice that order is not natural, limit the artist's awareness. Take for example the difference between the coast line in a

map surveyed from the ground and the same coast line in an aerial photograph. The first is irregular and chaotic: the surveyor was looking for order according to his conventions and scientific prejudices. The second has unforeseen linear beauty, which can appear only in complete surrender before nature. The deepest order is not within the ability of the artist to create, instead it is something that he is able to find, either within or outside himself, and only if he is open enough, unprejudiced enough and attentive enough. Advocates of "humanism" (when it is opposed to non-objective art) may believe that reason is the highest human quality; however reason is only one quality, and who is to say which is highest? These questions are concretely posed in three exhibitions. One, at the National Arts Club, is called "A Realist View," and opposite to this are the exhibitions of Joan Mitchell at the Stable, and of Mark di Suvero and Ronald Bladen at the Green Gallery.

Joan Mitchell's paintings contain in concrete detail only bright swishes and gobs of paint, but the total effect is landscape: clouds, sunset, vegetation, water. Her form is the positive of Turner's vortex, and the feeling is a very strong experience of the presence of nature. Although there is no specific place, nature is more "really" present than in most representational paintings. It is because of the "reality" (not representation) of the detail. The details, shaped like brush strokes, have committed shapes, and the colors have committed texture, hue and substance. They are not muddy, which has nothing to do with the presence or absence of browns or grays, but with their being clearly what they are. Miss Mitchell has been attentive to outside nature and her inner experience, and she gives you something real.

Mark di Suvero's sculpture is a huge, triangularly bolted-together mass of beams worn by use and weather. Ronald Bladen's paintings are in two colors only: a vast thick lava-like mat surface from which project a few much thicker troweled lumps of another color. Both the sculpture and the paintings insist on their objectivity. They give an experience of the splintered surfaces worn by traffic, sun and sea, of heavy dockside construction. Like Miss Mitchell, these artists are attentive to experience and sensitive to reality.

The painters at the National Arts Club are: Harvey Dinnerstein, Sheldon Fink, St. Julian Fishburne, Stuart Kauf-

man, David Levine, Seymour Remenick, Daniel Schwartz, Aaron Shikler, Burt Silverman and Herbert Steinberg. Robert White is the sculptor. Though the painters have always considered themselves realists, some of them are moving away from attentiveness to reality in favor of attention to craft as an end in itself.

Reality cannot be faked; unless it is total, it fails to convince. It fails when an idea of reality—a doctor holding a new-born baby, a house painter with brush poised—is superimposed on no matter how skillful a technical exercise. It fails when it exists in the detail but not in the whole surface. It fails to convince when it amounts to a repetition of equal wrinkles of clothes, as in Silverman's *Family Circle,* representing a group in a theatre box. The light on individual faces is good, but the whole breaks apart into separate passages, some beautifully painted, some conscientiously. Form coordinates diversity, it does not pile up facts. That is why form comes from the artist looking for chaos, in which case he finds that order that is directly discoverable by unconscious awareness, which is wiser than awareness directed by the reason following systematic rules. Critics who demand to know what something means, demand to have reality translated into conventionality, maybe the conventionality of language: they wish to limit communication.

Another example of unconvincing reality is Levine's *Brighton Beach.* The artist has used his experience of people behind the boardwalk as raw material for a translation into something resembling in its craft a painting by Rembrandt, like a school exercise to show how well he has done his homework. You recognize each detail, and you are left with the inescapable conviction that Brighton Beach is a boring figment of Levine's imagination. But Levine's portrait of Sheldon Fink has reality because it has art, and art because it has reality. Because you see the bloodshot face for the first time, you can have no hesitation in believing it, and the details of the suit, its flatness, the shadow under the lapel in one brush line, the narrow torso above wide trousers, all have that formality that is discovered and so has got to be true. And Fink's large group of a mother reading to her three children is real because like the best inventions it comes from attention to something beyond the artist's ability to control.

Dinnerstein's *Motorcyclists* is reality manipulated, the way old-fashioned photographers used to do in their studios. Because he doesn't accept this photographer's studio aspect of art, he doesn't get as far as the photographer did in making an imitation of art instead of an imitation of nature. However, imitation of art can be valid. Remenick sees nature as real insofar as it imitates art, but since his imitation is total, so is his reality total, and he combines diversity into a singleness of surface. His still lifes look like paint: this is their integrity. They are real in the thoroughness of their artistry, even though the reality he portrays is a studio reality. After all, a studio is just as real a place as a hospital or a race track.

In Shikler's paintings, also, there is this split between attention to something either inside or outside the artist, like his paintings of the antique dealer, or *After the Bath,* and those paintings that try to make art imitate art, like the *Bridal Preparations.* In the latter painting the surface is broken into a monotonous flutter of leaf-like strokes, that are neither interesting in themselves, nor a contribution to the subject.

Robert White is different from the painters. He hardly ever goes in for genre, and the reality of sculpture is at a different level from that of painting. *The Ploughman* has a form that comes from its details, it is internal: he sees the anatomy as if from the point of view of the man inside the body, as though he were the animate principle of his own landscape, and therefore beyond his own comprehension. As a whole one might think, why was the figure cut off above the knees, what is the composition? It is because the experience was inner, and the figure stopped where the experience ceased. This is as far as it goes, this is it, which makes what there is more intense. *Salome* seems to start with the whole conception, Salome dancing. But this too is known from the inside, and it is organic instead of conceptual. However, the virtuosity of the modeled detail of the *Bar Room* is lost in an artificial conception.

What Is Real?

[*1960*] The Midtown Gallery exhibits drawings and paintings by Isabel Bishop. The tiny drawings have an easy careful ac-

curacy. Isabel Bishop's name has been associated with a group of artists who favor realism and the human image. Her paintings show girls on the street, in the subway, at lunch counters, and men at drinking fountains. The color

13. ISABEL BISHOP: *Subway Scene*

is transparent tan, opaque gray, and in almost every painting, there is an abstract triangle or oblong of acid red-orange that at a distance, where subject matter is lost, counts as the part that holds the painting down. The figures hurry over subway platforms; the legs, and especially the shoes at the instantaneous still point of the motion, clearer than the faces and bodies above. They walk in tiers, in Piranesi's prisons. Underlying the grayly opalescent transparent bodies and crisp transparent architecture, are small impastoed horizontal strokes, over gray horizontal striping. This texture and the acid triangle of solid red gives each painting its tactility.

What is real? The canvas surface, recalled by this tactility, dominates the illusion and, since representation is shown to be illusion, Miss Bishop supports, except in choice and taste, the non-objective painters who want no part of illusion, for she emphasizes more even than the painter friends of Mallarmé, the illusory nature of objectivity. The horizontal impasto, parallel to the floor of the room where the painting hangs, places one indoors: she will not allow herself to forget that the painting is a dream, which convinces by virtue of its dreaminess. What is real, the room where we spend most of our time, or the human imagination? One painting shows a girl's face reflected in the mirror of a subway gum dispenser; to the right is the girl's head looking toward the mirror. The acid orange of the gum machine is the only opaque color besides the ubiquitous gray, and therefore the only color with materiality. The girl's head in profile is almost lost; the image in the mirror, the most sensitive passage of the painting, is in many colors. The materiality of the box that frames the mirror is bright, strong and ugly, the girl herself is passing, but her image, her sublimation, of the thinnest substance of all, holds you by its subtlety. You are held by an image of an image. The human image, and its architectural setting, which are important to Miss Bishop, are only half of her subject; the sublimated and immaterial half. The other half is not image, but the wall behind it. Her paradox consists in saying that the part of art which represents the outer world, and which criticism associates with reality, is a sublimation; and that the abstract part that represents nothing, and that criticism associates with non-objectivity, is the part that stands for reality, for the object, for being awake.

A Realist

[*1960*] Alex Katz is a "realist," meaning that you recognize every detail in his paintings, and the whole too, though the whole takes precedence and the detail may be only an area of color, in short, abstract. *Ten O'clock* is an interior toward the morning sun streaming through the tall window beside which sits a tiny figure on a couch. The other furniture of the room is displaced a little in the sunbeam. But the light

14. ALEX KATZ: *Ten O'Clock*

is not light for light's sake, but for color's sake, and even more for the painting's sake. The parallelogram of sun on the floor, for all its brightness, hardly darkens the shadowy quadrilateral of wall, sofa and abstract whatever. Though the woman is recognizable by her features, the details of her features are part of the construction, and contribute, like all the details, to the whole, and all this without distortion or any other affectation. The colors and shapes which are necessary expressions of each other, make, without losing any part of their individuality, even in the flattest simplification, an integral space, the manifestation of an integral spiritual whole. And so the artist in no way requires any of the usual explanations that reality is to be found here or there. He does not need to say that the deepest reality is in visual experience, or in the paint medium as the medium for nature, or in communication, or emotion, or the image, or in art as aesthetics—the ivory tower. Katz uses all these things, and he uses nothing too much—appearance, colors of pigments, geometry, anything you can name. He leaves out nothing that pertains to the nature of painting in favor of emphasis on one part. He includes a better understanding of what color and color-plus-tone do than any of his contemporaries, and just as good a knowledge of how paint goes across the canvas, and just as sensitive a feeling for nature as the most ambitious Californian non-objectivist. He is not overwhelmed by nature but stands outside it; it is outside him and includes his subjectivity. His vocabulary of colors is one in which between one color and another there is just enough space, or interval, because they are accurately chosen. This is like the space in an accurate sentence between nouns and verbs, between words and their modifiers. His opaque colors point like prepositions, definitely; or if there is ambiguity, it is the ambiguity of alternatives, a fixed and usable paradox.

Non-Objectivity and Realism

[1960] The difference between non-objectivity and realism is not so simple as it seems. This shows in the current exhibitions of Elmer Bischoff at the Staempfli Gallery and of Robert Goodnough at the Tibor de Nagy Gallery.

Bischoff's exhibition of painting is his first in New

York. His art is entirely in its performance. He is the most magnificent performer of all the Californians seen in this city who have given up abstraction in favor of realism. Painting as performance is something that he shares with Kline (who gave up realism for non-objectivity), and it relates to Sargent. The paintings are large, many more than six feet square, very broad, as if he used no brush less than two inches wide, and he has a color sense that makes no mistakes. Each area from bright to gray is a thick, wet mixture without a single muddy spot. His subjects are landscapes and interiors with women. In the earlier paintings especially, form is paint determined by courageous control of its powerful flow. *Houses and Hills,* which keeps rocking, is like the successful carrying out of a wager that he will navigate the painting into port through the roughest seas.

My wife remarked that the paintings have an Edwardian dash, as of a glove thrown down upon a table. The challenge that he throws down is this, that he knows exactly where everything is, especially where one thing ends and another begins; in short that he knows where the connections are. However, in the later work the paint does not always lie on the form, and there are sharp dry places of conflict between paint and subject, as though a failure of energy made him slip into unconscious illustration. The conscious feeling may be a wish not to spoil what is already achieved.

The strange thing about his realism is that the "things" in his latest pictures tend to lose their reality—just because they have lost a firmness of form—with the exception of his beautiful skies of liquid light. The figures are less real in so far as they are more actual, and so is the ground. Something trivial has taken over, as in the gestures in *Figures in Vermilion Light,* which are so incidental that the women themselves do not matter any more. *Figure by the Sea,* quite opposite to an Impressionistic painting, looks more like a sketch at a distance than it does close by, and this renders its size meaningless.

In my opinion, Goodnough's new show is his best. He is completely "non-objective" (representing no recognizable object), but instead of a continuum where forms flow into each other until their separateness is lost, his paintings are full of concreteness. Spherical triangles swirl in a paper storm, or long, curved vertical strokes detached from each

other are set against gray, as in *Odysseus*. Though his paintings are the same size as Bischoff's large ones, they do not look especially large, nor do they look smaller from a distance. Their apparent size and weight do not vary, because their objective (in the sense of external) reality is too fixed. When they are called after classical names the composition is derived from an analysis of a classical sculpture; or else the flow of red, white, blue and gray paper scraps in curve and counter-curve describes the principle of Venetian composition, in a way comparable to the way music describes visual sensations. The paintings called *Summer* have the motion of leaves growing and falling, plus all the stir of weather (as in a movie about plant growth) to make a ballet out of what summer means. Goodnough's colors

15. ELMER BISCHOFF: *Two Figures with Vermilion Light*

16. ROBERT GOODNOUGH: *Summer III*

are conventional, like the colors of a parade. He makes a generality out of what the painting may refer to.

Bischoff takes a specific moment, a finger on the nose, a temporary hesitation and generalizes it; and his generalizations have the weakness, even the unpleasantness, of those plaster casts of human and animal bodies made from the holes in the lava of Herculaneum. The gestures of Bischoff's figures are the gestures of people overtaken. His emphasis on the incidental emphasizes its meaninglessness. Goodnough particularizes the idea. Which painter better makes you feel the reality of the particular? Goodnough, unlike most non-objective painters today, derives from Cubism rather than from Impressionistic performance. He is old-fashioned. Out of concepts he makes equivalents of concreteness. Bischoff's background in non-objective painting could be a background of disbelief in academic humanism. Goodnough describes his belief in the culture

of the past with spherical triangles, or Cézanne's or Mondrian's thin strokes, while Bischoff determines the limits of the expressiveness of pigments suspended in linseed oil.

Goodnough is not so sure as Bischoff as to where connections are, and so he makes more sure. Because he is not a virtuoso, he must be clear. If his decisions are ambiguous, it is between definite choices, like, this is before, *or* it is behind. It is the ambiguity of eighteenth-century verse. Bischoff's ambiguities are those of vagueness: it does not matter to him whether something is before or behind so long as two adjacent colors connect. Bischoff is a romantic in the sense that what is real is himself even more than any canvas. He is a personality, celebrating his own good health. Goodnough is full of respect for tradition which he uses freely for new formal ends.

Kinds of Beauty

[*1960*] Ever since the academicians associated beauty with that which is respectable and unchallenging, artists have hesitated to use the word. But abstract artists, consistent with their Platonic ideals, associate beauty, an abstract word, with simplicity and coherence. Robert Engman, head of the sculpture department at Yale, exhibits at the Stable Gallery abstract metal constructions, cut, bent and polished from squares of brass, that are baffling in direct proportion to their simplicity and logic. Leather shaped into a shoe is not baffling, for one can imagine its flat origin, and perceive what it has become. But it is hard to follow in Engman's constructions the transition from original flatness to a volume suggesting a surface again. There is a twisted thing that partly rolls and partly rocks on its corners; having a constant diameter, it could do the work of a ball bearing. There is a smooth bent square with two obvious clear holes in it; and these holes are bounded by only one circumference. Constructivist sculpture began a long time ago, but I am aware of none so radically inventive as Engman's. He is neither mathematician, scientist, nor philosopher; what he does is make things up. His experiences are created out of whole cloth without any roughness to catch the burrs of sentiment. In leaving nothing to conjecture, he stimulates

your imagination. He is at once completely matter-of-fact and utterly mystifying.

Engman speaks of beauty as an abstract quality, but for Jasper Johns, who exhibits at the Castelli Gallery, beauty is how you do it. He used to try to force your awareness of process by applying it to subjects of such ordinary or exhausted symbolism as the flag or lower-case letters, with the contrary result that he forced you to look at the subject. His ability to animate the vapid was more distinguished than the paint texture. It was as though he printed doggerel in order to make you look at the type face, but succeeded only in giving new life to stale verse. Now he is beginning to give up the subject, and though he fastens window shades and thermometers to the canvas, what one appreciates is the irregularly starry surface of red, yellow and blue strokes. He has been absorbing a great deal from New York style non-objective painting.

Whereas Johns opposes subject and performance, finally isolating the performance as a thing in itself, the subject of

17. ROBERT ENGMAN: *Untitled sculpture*

18. PAUL GEORGES: *Self-Portrait*

Jane Freilicher's paintings (at the Tibor de Nagy Gallery) is partly implicit in the performance. Her paintings describe nature, what Blake called the vegetable world of Wordsworth. Their non-objective form sometimes inhibits her sensibility. The subject is the outdoors, the country and the weather. There is a characteristic vertical-diagonal shear across the canvases like a visible cold front. Except for one landscape, dominated by the horizon between dark ground

and pinkish sky, presenting the essential structure of land-scape, nature is not structure to her, but rather a sensuous experience. As a whole, nature is irregular and it is partly in its specific irregularity that it reveals its presence. Being tied to no place, except near the sea, the irregularity looks abstract. So beauty does not mean for her clarity and logic, but the total fact that nature is naturally specific and never the same.

For Paul Georges, who exhibits fifteen self-portraits at the Great Jones Gallery, beauty is to be found in reality, of which art is the mirror. And for Georges logic is subordinate to reality. Reality is stronger than thought, feeling, the means of its achievement, the artist's ego or his subjectivity. He uses tonal contrasts and close values and a freely decided choice of colors, of which red, green and brown stand out. His paint is thick and juicy. In the large painting facing the door, divided into the painter on one side and the wide brown back of the canvas on the other, there is a rapid linear indication of the feet. All these means, any means at all, and the variety of individualities in one single model, impress on you the reality of the person looking out at you. Realist painters often complain that the human figure should be the chief concern of art, and that it is missing from current styles. But most of these artists seem to see only some arbitrary, even abstract concept of the way man should look. They see a lay figure or a caricature: they do not see without prejudice. Because Georges gets an unprecedented and always different individuality, he can be called one of the few true realists painting in New York.

Realism Transcends System

[1960] The following four exhibitions have something in common: the Rembrandt drawings from American collections at the Morgan Library; the oils, pastels, drawings and prints of Degas at Wildenstein; the welded iron sculpture of Richard Stankiewicz at the Stable; and the painting constructions of Robert Rauschenberg at Castelli. For each of these artists realism transcended and transcends any systematic artistic formality.

Rembrandt created a total world of greater human depth

and breadth than any other visual artist. The language of his drawings is, like Chinese, or the English of newspaper headlines, a language without grammar: the part of speech depends on the context. In a Rembrandt drawing a detail is almost meaningless by itself, and there is no form separate from the form of the whole. A line, or lines, or the wash, tells where, before it tells what: where in space, where in action and where in dramatic significance. A figure is analyzed in terms of its presence, which precedes its articulation; and the articulation may be expressed with physical vividness by the expression of a face. The turn of a neck is indicated by the eyes. A line does not mark an edge or change of plane any more often than it marks the center of weight. A line either separates what is on each side of it, or it gives integrity to where it is. Artists have had and still have certain common ways of translating external reality through appearance or tactility into flatness, but for Rembrandt essence comes first. Figures are either emphasized or made unimportant by thicker lines, as one may shout or whisper to attract attention. Wash is color, or shadow, or projection, or recession, depending on the context of the drawing as a whole. Nothing can be abstracted; the parts are meaningless, rubbishy, tattered: the ground which as a whole has its total feel all the way to the horizon, is in detail only muddy litter; the clothes of his figures as a whole may be grand or poor, but they always suggest the temperature, and in detail they are just rags. The unreality of the detail gives connectedness to the whole, which is held together by the artist's compassion. It is interesting to observe his copies of Mantegna and of Indian miniatures, which give the human effect of these works without any attention to the artistic style.

For Degas, the tension of his paintings and pastels is in the conflict between the decorum of art and the unprecedented nature of nineteenth-century society, whose form was more and more determined by the mechanization of industry. Visual form is contrapuntal to dramatic form: what people do is one thing, and art is another. A jockey lies wounded on the ground, while the beautiful motion of the horses continues. Chance dominates decision. The humanity of his dancers has nothing to do with their skill. Degas seems to dislike life for not being art; though he had sympathy for it. The whole is greater than the part,

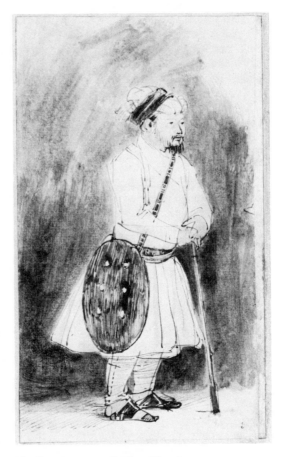

19. REMBRANDT: *Indian Warrior
with a Shield Leaning on a Stick*

but since Degas lacked the energy of Rembrandt's compassion, even a whole painting by Degas has something fragmentary about it. Degas could not include an attitude of the whole in one canvas. The grandeur that he could perceive lay more in art than in man; and art for Degas meant Ingres, Delacroix, Holbein and possibly the Florentine fifteenth century, even more than it meant the talent of his fellow artists, or his own. Except for the motion of horses and women, the present inspired sarcastic distaste. And Degas chose to express the disorderly present with the

orderly grammar of the art of the idealists, whose remoteness from him made them idealists.

The idealists of New York painting are the non-objective painters, who isolate art from details of actuality. They wish to see profoundly and they are against illusion. Or perhaps they simply wish to seem to see profoundly. Rauschenberg's art is disorderly in its incorporation of real elements. His red, white and black, or blue, white and black are slapped on with the skill of hand of the New York school. This is his allusion to art; he alludes to his contemporaries, as Degas' classical line and subtle values alluded to the masters of the past. Rauschenberg combines in his paintings a catalogue of real parts: radios that can be turned on simultaneously to different stations, stuffed birds, homemade ladders stained with drips of paint, chair backs, squares from cotton pants, a compass, can opener, light socket with chain, flattened and crumpled metal, photographs and pieces of newspaper, umbrellas opened flat, rough-sawn lumber and assorted hardware. His extremest construction called *Gift for Apollo,* consists of a cupboard door mounted on doll-carriage wheels, with a doorknob and glued-on necktie smeared with green; from this hangs a chain ending in a bar embedded in the hardened cement in the bottom of a battered pail.

There is a resemblance to the scavenged metal work of Stankiewicz, with the difference that Stankiewicz's material has, as it were, spoken to him before he has used it, as the piece of wood in the beginning of *Pinocchio* spoke to Master Cherry even before Master Cherry touched it with his axe. Stankiewicz responds to a preceding life of things, and Rauschenberg does not; for Rauschenberg the life of the parts depends on the final context. When a part of a Rauschenberg construction has its own life, the effect is disturbing, calling attention to a general grubbiness; I never find his stuffed birds sufficiently assimilated. In a Stankiewicz sculpture the life of a part gives character to the life of the completed sculpture. Rauschenberg's work completely counters so many preconceptions that in order to see what it is one must be open to new form beyond old formalities. He expresses a morality of poverty, inducing a monastic respect for things that no one values. He protests the waste in this society, where we take for granted that automobiles are disposable, and that our trash cans

are filled with paper work. He calls attention to the success of industrialism opposite to the way the Bauhaus did, which saw industrialism as it wished to be seen. Moholy-Nagy was like an academician finding beauty in the copying of something already beautiful, with the difference that what he found already beautiful was not the Parthenon, but the skills released by modern machinery. Rauschenberg's work has more personality than anything like it. Its weakness is that it tends to approach the chic.

Rauschenberg is able to assimilate his real elements better than he usually cares to. It is as though in calling attention to the unassimilable, he disparaged art in favor of reality. Stankiewicz's fantasy about plumbing makes him sometimes illustrative, as in the two boiler-bathers playing at the beach. His more formal, abstract and untitled sculptures have greater reality; it is in these that one feels more strongly the human life that has rubbed off into his broken pieces of machinery, or the inevitably inherent life of hardware, like the resistance of things to man's purposes.

Against Idealism

[*1964*] Berenson said that it was an English and American vice to try to limit the means of your expression.

Artistic manifestos indicate where the artist directs his attention. His attention is directed to the place that interests him as most important to him, and this place is either his conception of where reality resides or of what he is sure he knows. Artistic "realism" is usually conceived as an interest in things as they appear to be. This is neither the scientific idea of reality, nor the idea of most philosophies. However realism depends on using the help of science to reproduce appearance.

The opposition between "realism" and "abstraction" is a misleading one. Both realists and abstractionists think they embody an ideal of art of which each work is the shadow: the realist making a reflection of the natural world and the abstractionist making a reflection of the world of ideas in the largest sense, which of course includes non-verbal ideas. Both think that what is real about art exists in the realm of Whitehead's "eternal objects" and no matter how much either one pretends to prefer either reality or unreality (like

Clive Bell), this reality or unreality is an eternal object which an artist of whatever persuasion constantly refers to whenever he makes something. So is the opposition between "Humanism" and whatever a humanist thinks is non-humanist, unclear. It can mean, for an artist who wants to represent appearances, a preference for representing the human figure. It can also mean putting concern for man's welfare ahead of indifference to it. Such art chooses a content of social consciousness, and such a content in turn usually implies a criticism of the social order. This art wavers between a satire that is most effectively put into words, and sentimentality. Yet it is not possible for an artist to put into his products anything that remains untouched by the artist's nature.

It was fashionable a few years ago to disparage, in the cause of abstraction or non-objectivity, what the abstractionists called "illusion," as if their own products were without illusion. A few years ago at the Museum of Modern Art in New York there was simultaneously exhibited in adjoining galleries the works of Jackson Pollock and of Balthus. And on the stairs leading up to these two exhibitions hung the museum's purchase, de Kooning's *Woman*. I suppose most people would agree to include Balthus among realists, and Pollock among non-objectivists. In this example of his work de Kooning falls into neither category, though it would certainly be included with the anti-illusionists. Balthus has always used the illusion of appearance. What was the effect of these paintings? Balthus' paintings, based on the use of illusion as it was understood at the time, gave the strongest sense of the actual presence of something —what? I suppose the presence of the personality of the painter. Certainly the sense of a directed and still unresolved emotion. The Pollocks communicated rather a sense of consistency. The de Kooning had least sense of the continuity and flatness of the paint surface: most of all three artists' works his was like something floating in the atmosphere, it was phantom-like, and like all ghosts, illusory. Pollock's paintings and de Kooning's one painting belonged to the category (invented not by artists but by critics) of "abstract expressionism." Expressionism is meant to mean art in which the content is an expression of strong emotions: but the effect of Pollock's painting is one of all emotion spent: these are the aftermarks, from which whatever emotional pressure may have gone into their making has evapo-

103

rated completely leaving behind, as it were, stains. Balthus, who would be called the most "realist" and full of illusion presented in these paintings strong emotional pressure, which was far from having evaporated. De Kooning, who might be classified as anti-illusionist and expressionist, showed in his painting not an evaporation of emotion so much as the ghost of emotion, consistent with the ghostliness of his form. His painting was both formally and emotionally ghostly. In this painting, de Kooning, eschewing illusory representation, gave up also any illusion of material presence, resulting in a weak emotional presence. Homer's phrase, "the silly dead" refers to this emotional feebleness of ghosts.

Today when a painting is criticized by another painter as "too realistic" or praised as not realistic, the painter-critic refers to the belief that reality is not known through sight alone, but conceptually. The purely visual painting is never considered as realistic as the conceptual one. A concept is an ideal that can be referred to. It is an "eternal object." In other words, what is "too realistic" refers not to appearance, but to knowledge, and what is known is assumed in this criticism to be beyond appearance. A painter who presents something that is limited to the reality known to sight alone, is not criticized or praised for realism. This idea of realism in painting goes back at least as far as Giotto. In Florentine and North Italian art the sense that gives you the closest apprehension of reality beyond appearance, is the sense of touch. The painters of these schools tried to stimulate the observer's tactile sense in all kinds of ways, for you are convinced of the existence of something if it is suggested or if you believe that it is tangible. Not until the Impressionists was it thought sufficient to appeal to the sense of sight alone. They made the most complete break that has ever been made from the real as equivalent with the tangible to the real as equivalent with the visible. This idea still meets much resistance, though if you ask someone which one of his five senses he would most mind losing, he is almost certain to agree that sight is the most precious. And attached to this predominance of vision is also an unspoken feeling that what you can only see may not really exist: it needs to be verified. Empiricism casts doubts on the validity of knowledge gained through the senses alone, to propose that through the senses alone you can know nothing beyond them. Yet science, based

on sense experience, has good reason (the success of the scientific method) to think that you can know the real from a beginning in sense impressions. The scientific method also supports the belief that reality is attained through a process of reduction, as von Liebig thought that he knew what was essential to the life of plants from an analysis of their ashes after he had burned them up. Pasteur's discovery of the importance of micro-organisms has never quite erased the commonest scientific habit of thinking that reduction leads to the ultimately real, and that since life reduces to death, death is the eternal object of which life is the shadow.

Impressionism can be claimed to have reduced sensations to the primary one of sight: no painting before Impressionism relied exclusively on sight alone. Rather than reduction however, this may be an acceptance of human limitation and a refusal to believe that what you know immediately is only a shadow of something beyond that is more real. Impressionism has never been completely accepted, partly because of the pre-Impressionist emphasis on the tangible and partly because of the prestige that scientific method gives to the belief that truth follows from a reductive process. Seurat first tried to validate Impressionism by reducing it to a scientific theory of light. Cézanne was unhappy with Impressionism, and his wanting to make of Impressionism something solid and enduring like the art of the museums, plus his preoccupation with the contour, shows that he thought that tactility should be restored to primary dignity. Then his suggestion that nature could be reduced to the forms of solid geometry was taken up by Cubism, representing a further retreat from Impressionism. Cubism is based on a theory of knowledge that distrusts sight, and attempts to go beneath sight to "essentials." The Cubists have in common with the pre-Impressionist realists a belief in reality as that to which shadowy actuality refers. Still, Cubism is saved by the playfulness of its most distinguished practitioners. It led to a cutting loose of geometry from nature, in the geometrical abstractionists, then to further generalization in Constructivism, which leans on topology, which is generalized geometry, or on mathematics as a whole, which is still more general. The teachers at the Bauhaus, with absolute logic and humorless consistency got furthest away from the actual, and they attempted to turn art into a science subservient to industry, as the totalitarians try to make art serve the state. Art as idea is most purely

achieved by the neo-plastic artists. Their primary colors and ruled lines come out of the mind and even their pigment is like a distillation of itself, leaving no place for the senses except as guided by conscious reason.

In all of these schools art is placed under the control of some limiting idea. The originality of New York school painting is that like Impressionism, which expresses the obvious fact that if it were not for seeing, there would be no painting, it returns to seeing. If the real is what can be seen, it follows that seeing is real. Since these painters work in studios empty of properties, what they see is their paintings, and as the subject is the way the painting looks, then what the paint does, including what it does accidentally, becomes valid. These painters have the harmonious relationship to paint as it is that a Japanese gardener has to nature as it is. Ad Reinhardt carrying non-objectivity to the logical extreme of disembodied estheticism, plays in New York school painting the role that Seurat played in Impressionism. He tries to validate it by reducing it to an ideal.

A manifesto proclaims a division between the artist as director and the work he directs. This split is unnecessary if the artist accepts himself and takes his work for granted. This acceptance requires getting past science, philosophy and sociology to an assertion of what art itself does that other disciplines do not do. To follow them limits art. There is an artistic theory of knowledge different from a scientific or philosophical one. The artist can direct his attention to what he is sure of This is not an idea, not an eternal object, it is actual, and it has immediacy. The artist can profitably forgo the scientific or philosophical attempt at grandeur and keep to what he knows, which is what everyone knows and does not dare accept, because he fears that knowledge is not reliable until it is explained, or rationalized, or proved; until, that is, it can be controlled by repetition like a scientific experiment. Art permits you to accept illogical immediacy, and in doing so releases you from chasing after the distant and the ideal. When this occurs, the effect is exalting.

IV

Tradition and Other Topics

Abstract Expressionism and Landscape

[*undated, c. 1962*] At first the term "Impressionism" did not mean very much. If Degas and Monet are both Impressionists, can you say that they are more like each other than Degas is like Ingres, or than Monet is like Courbet? Today "Abstract Expressionism" is just as vague a term. If it means a way of painting that can be identified, it means one that makes no particular reference to any object, not even an abstract object, outside the painting itself. It is a name given to non-objectivity.

Many of de Kooning's first abstractions were like Léger: when they began no longer to look like Léger, in about 1941, he remarked that European abstractions derive from still life, while his referred to landscape. He remarked further on the difference between European and American painting in general, that even European landscape has an objective center, as if the landscape were a still life, of, say, a mountain, while American painting does not have this sort of center, this division into "subject" and "background." Cézanne told his sitters to be as still as apples. Alex Katz, the American, once said that in nature he preferred a field. (A field is not an object.) Chinese landscape shows a continuum of relationships among the specific

characters of the hills, rocks, trees, water and people. I remember an American "primitive" landscape of a farm near Mount Monadnock, in which the compositional principle is sequence; nothing repeats, you move in imagination from house to barn to paddock, and the mountain is a blue pole of one direction of motion away from the farm. Cézanne's *Mont Sainte Victoire* is a center of gravity between the balance of earth and sky, each of which has as its minor characteristic something that is a major characteristic of the other. Someone once said that if Venice, Paris or Dresden were bombed, irreplaceable objects would be destroyed, while if Milwaukee, San Francisco or Chungking were bombed, a function would be interrupted. European art is objective; American and Chinese, functional.

Non-objectivity as a quality of landscape comes out of the way landscape painting developed in the West. Before landscape existed by itself, it was a background, the stage setting for Giotto's illustrated Biblical action, for Veronese's classical myth or Watteau's *fête galante*. Botticelli was supposed to have said that you can paint a quite good enough landscape by throwing a sponge full of colors at the canvas. Turner indicated that this setting was as large as the globe: he replaced Claude's flats projecting from the wings with a vortex, and his horizon was sometimes curved. To remove the object for which the landscape is the setting, or to indicate that nothing smaller than the whole world is significant, is to make a stride into non-objectivity. But in American painting in the nineteenth century non-objectivity included more than landscape; as a quality of American painting it was also its greatest weakness. Morse, with quite as much ability as any of his European contemporaries, could find nothing to paint. His *House of Representatives* shows no central event, he communicates no belief in the significance of any object, there is no convicing subject beyond his masterly control of the medium. This is also true of Eakins' work, though he had a stronger will than Morse. Does the *Gross Clinic* celebrate a great surgeon, or does it celebrate the artist's will to control his researches? In all of Eakins' work the subject is never quite released. His problem was to find the application for all of his science. Or did he believe in the paradox of applied science for its own sake? What was Bierstadt's object in his landscapes? The grandeur of the Rockies, or a demonstration that he could finish an ambitious project of work?

While the provincial Americans never transcended the innate non-objectivity of Western landscape painting, and while instead all of their painting became infected with this quality, in the nineteenth century in Europe this inherent non-objectivity was transcended in two ways, first by Turner, and next by the Impressionists. For the Impressionists it happened in the way Toynbee calls etherialization. The object is not materially present, for it is either light, or the painter's sensibility. And there is an affinity with the affirmation that started Greek sculpture, which, it seems, was first carved for its own sake, for no outside use or purpose. And like Greek sculpture, the early paintings of Monet and Sisley have a morning awareness that is perhaps otherwise non-existent after the fifteenth century. In the whole history of the arts, a contemplative, afternoon sensibility (emotion recollected in tranquillity) is much more common. And Degas? His non-objectivity uses space and drawing to represent motion, rather than light; and in this he partly foreshadows Expressionism.

The European art de Kooning referred to in his comparison with American art was Post-Impressionism based on Cézanne, whose ambition was to make painting objective again, like the art of the museums. Cézanne made landscape objective. Post-Impressionism had its first impact on American art in the Armory Show of 1913. It made the most sensitive artists decide that Impressionism was superseded. Such painters as Sargent had been discovering that the artist's sensibility to the medium could be substituted for the object and they were beginning to discover that artistic ends can be implicit in the means. The Armory Show upset all this. It made Sloan and Bellows attempt, without understanding it, Post-Impressionist objectivity. American painters became serious and graceless; they shackled themselves with superficial and inorganic formal ideas like dynamic symmetry and the color theories Bellows adopted; their modernism was a language of clichés, instead of, as in Cézanne's case, a finding in the unconscious depths of his nature of the connection between what he did and what he was.

In a country where tradition remains alive, like France, there are enough examples around of how and what to paint to keep the artist going. But in America, where tradition came from abroad, there weren't enough examples around, and no connection between the museums and cur-

rent practice. The artist tried to get this from reading and listening. What he could read and listen to was mostly literary criticism, and even his ideas of painting were verbal and indirect. And so during the Depression and up to the war the artist was most susceptible to graphic or logical painting like Expressionism or German and Dutch geometry. Writers understand graphic art, which has an easily identifiable object, and mathematical logic appeals to anyone for whom intelligence starts with the recognition of signs. The German refugees brought with them a taste for Expressionism and a scientific way of presenting art, even non-verbal art. They seemed to promise an understanding of what art essentially is. This was very beneficial to American painters without traditions to lean on. The relationship of American to European artistic achievement at that time resembles the present relationship of the former Asiatic and African colonies to Western industrial development. The former colonies want to skip the first stages of the industrial revolution and start right off with steel mills. They do not look to the older capitalist countries for help, but to the Russian technicians, who purvey a capitalism no older than Lenin's. Similarly American artists learned less directly from France with its long tradition, than from France at second hand via German experts. Nasser's and Sukarno's economic anti-American chauvinism today is reminiscent of Thomas Benton's artistic anti-French chauvinism of the thirties. The scientific methods of the Bauhaus organized art much as Russian economists organize capitalism into five-year plans. Do not timetables prove the existence of trains?

The New York School of "Abstract Expressionist" painting began after the conquest of France in 1942. Then, even if, like Benton, they wanted to be independent, the painters could no longer rely on Europe, but had to do everything for themselves. And there began a hard-boiled, unsentimental ransacking of the tradition of painting to find out how it was done. They listened to Gorky and looked at the paintings of Gorky and de Kooning. Like the first Greek sculptors fired by an ambition to emulate the Egyptian example without any care for the meaning in Egyptian tradition, they thought it would be a great thing to make paintings as the Europeans had done, without caring for the objective reason or tradition in European painting. Painting was painting, the manipulation of the medium. De Kooning, separated from his craft background in Hol-

land, established a connection between painting as a profession and craft, and the environment in America of a painter who is first of all a worker. He set the example of art as a point of view toward work. Gorky, with his Russian belief in masochistic submission to a teacher, attracted followers partly with portentous hokum, like his remark to de Kooning, "So, you have your own ideas." He set the example that by working hard it is possible to demonstrate an appreciation for art, in particular, Picasso. The painting that developed from these examples was abstract in the sense of having no outside references, neither the "real" world, nor the geometry or neatness of the group that called itself the American Abstract Artists. This painting had a more direct reality than that of the realists, who, having to go through a process of translation, present finally the method of translation. Nor did this painting, deriving from the examples of the work of de Kooning and Gorky, present, like that of the official abstract artists, an idea of reality, but rather the acceptance of the reality of the painting itself. What it could communicate was the most immediate reality which the painter doesn't know he is communicating, his kinetic and visual sense of the world. And as communication is unavoidable, he communicates a real sense of his environment (like the taste of onions in a cow's milk), the presence of the city or the presence of nature. There was a return from the objectivity of Post-Impressionism to a non-objectivity like that of Vuillard, which derived from the immaterial objectivity of Impressionism. Cézanne wanted to give Impressionism a form, an object, an end, using Impressionist means. (Monet to him was only an eye.) But it was Vuillard who found the form within the means of Impressionism, the end that the means imply. And the Abstract Impressionists found the object that the paint implied. For both Vuillard and the Abstract Expressionists there is no object in the sense of there being no separation of means from ends.

Impressionism and Painting To-Day

[*1960*] What was revolutionary about Impressionism was that color, which distinguishes painting from the other visual arts, was

for the first time considered primary in the painter's concern with the subjectivity of vision. Subjectivity, being personal, is not conceptual, and neither is it abstract. The Impressionist was not interested in what was out there, but in how, whatever it was, it looked to the one who was looking. The Impressionists used color instead of the contour to express materiality, and since they were realists in the sense of not being romantic, color had to have substance. And color, which may give the spectator a great deal of pleasure, comes from the artist's intellect; drawing, which is accessible to the spectator's intellect, comes from the artist's emotions.

The Armory show of 1913 was a Post-Impressionist exhibition, and it had a disastrous effect on American painting: for example, the damage it did to the style of Bellows, Sloan and Eilshemius. In 1913, the difficulty for American painters was that society was anti-art; it gave the artist the choice of making silly and acceptable fantasies, or of expressing society's anti-artistic beliefs. Since Post-Impressionism emphasizes concept, it can suggest that art is valid because it "means" something. The Armory show pointed out to American painters an anti-artistic direction, like that of German Expressionism. A vulgar idea of art teachers that comes out of the Armory show is that "modern" is equivalent to distortion; that art is valid if it teaches, satirizes, or propagandizes. But the Impressionist revolution, which implied that the value of art is intrinsic, was much more of a revolution than any that succeeded it.

American painting of the present fashion has been called "abstract-expressionist." This means that the texture of Expressionist painting, whose form came from social comment, was divorced from that use in being made non-objective. However, since non-objectivity suggests anarchy, it makes a social comment after all. American non-objective painting followed American socially conscious painting; by the time it was accepted, a social tie-in was no longer required by the audience, and American painters were well on the way to painting for a public that accepted art as intrinsically valuable. If art is valuable for itself, then again one can appreciate the radical originality of Monet, whose work is being shown in a large exhibition at the Museum of Modern Art. This exhibition coincides with several good shows of New York painters who connect more

closely with Monet than with Picasso. It is not so much a connection with the Impressionist theory of the primacy of light as with the Impressionist practice of making a distinction between color and graphic description. Not contour, but color gives substance. In this connection, Thomas Hess once wrote an article on painters as writers and writers as artists. Writers draw well, but that is usually all; on the other hand, painters do not have a feeling for words as entities with their own life, but go in for ideas. Take for example the artists' magazine *It Is,* weighted with an overlapping sequence of one leaden sentence on top of another; or Mallarmé's remark when Degas showed him some sonnets he had written, "But, Degas, a sonnet is made of words."

The paintings of Herman Rose at the A.C.A. Gallery connect not only with Monet's primacy of color, but with Impressionist light as well. There is a cityscape of the upper East Side, that is full of such light as Monet or any other Impressionist would have been proud to have achieved. A non-objective painter who starts from color is Esteban Vicente at the Emmerich Gallery. That he constructs out of color does not mean that the color is in "good taste," nor that it is bright. At times it is certainly both of these things, but much more important is the fact that whatever the color, color relationships give the canvases their life. Neither line nor edge creates the form of the color, but what it is inside itself. The Howard Wise Gallery (a new gallery subtly designed by Wilder Green) exhibits 10 by 16 foot canvases by Milton Resnick that have the superficial look of Monet's water lily murals. Resnick's color is linear, defining no clear areas smaller than the whole. At the Peridot Gallery still lifes and landscapes by Leon Hartl are made of shimmering pinks and grays with the generalized light of a fourteenth-century Florentine. At the Janis Gallery, Franz Kline's paintings are for the first time made of color. His forte has always been light, but previously any of his colors could have been exchanged for any other. These paintings, parallel to de Kooning, have a speed and largeness that is inimitable. What holds them in place is not so much the up-and-downness of gravity as that they look like part of the wall. At the Stable Gallery, Alex Katz's flat, representational paintings combine a tightness of adjustment of areas with an accuracy of color, less found in nature than created for nature. Though Hartl and he are

realists, they are both abstractionists in color. Rose's color is his personal convention, a habit of the palette; Resnick's color is the color that the Impressionists used for nature; Vicente and Katz use colors like weights in a scale.

The Oriental in American Art

[*1960*] The exhibitions of Ad Reinhardt at Parsons and Section 11, of Joseph Fiore at Staempfli, and of Cy Twombly at Castelli indicate an assimilation of the Oriental influence in American art. This influence began with the opening of Japan a hundred years ago, and showed first in the work of Whistler and the water colors of Winslow Homer. It appears in a distinctive attitude toward nature and art, something like this: man's relationship to nature is not one of domination, but adaptation; nature is not an object of material conquest, and aesthetics instead of science is the mode of understanding it. From adaptation follows passivity, which leads to subtlety.

Reinhardt takes the idea of non-objectivity quite literally. His tall new paintings appear at first sight almost evenly black—then you see that they are divided with absolute symmetry into rectangles in a cruciform pattern. The difference between one color and another is very slight and there is no play of textural variation, except as much as one sees on velvet, brushed in opposite directions. Reinhardt is not non-objective in order to express the nature of nature or his medium more sharply: like Whistler he could say that the last step in the completion of a painting is to cover all traces of how it was done. Whistler is the painter Reinhardt resembles most closely. Like Whistler he takes from the art of the Far East its decorativeness. In some of his early paintings the vertical rectangle is made up of a zigzag of horizontal strokes recalling characters incised horizontally on Chinese bowls. The red is Chinese, and the favorite enclosing shape is that of a hanging scroll, or of a screen. Chinese art was Byzantine in its adherence to tradition. Reinhardt would like to see the establishment of a new and strict Academy. He believes that the proper subject for art is aesthetics, and to the humanists or the socially conscious who say in their various ways that man's chief con-

114

cern is man, he might answer that man in his smallness should behave with decorum.

That subtlety is not exclusively an Oriental virtue, however, can be seen by looking at the Giacomettis across the hall in the Janis Gallery. The figures sitting in rooms, emerging and melting into the gray surroundings, have as narrow a color range as Reinhardt's abstractions. They are defined by a web of white and dark lines of a delicacy equaled by the closeness of two colors, warm and cool; the subtlety is obvious and rich. In Reinhardt's paintings, once you have penetrated his darkness like a mask worn at a fancy dress ball, and found the subtlety of color relationships which do not oppose warm to cool, everything is there on the surface, there is no more; quite the contrary to Giacometti, who keeps on revealing himself.

Fiore's more or less abstract landscapes seem to express the Oriental view that man's value inheres in an equality to the other small parts of an immense whole. The paintings, done from memory, are unspecific as to place. He is specific about such things as the quality of a storm from the sea in Maine, the Maine light, the way the land is divided from the water (which is different on different coasts), the blackness of a north wind, the color of deep water over rocky bottoms, the green of short and intense summers; and that nature is continuous beyond any aspect of it. Some painters conquer nature through aesthetics in arrangements of objects. Fiore does not usually paint separate things—isn't a valley, a storm, weather, light, a relationship? His paintings as a whole are less objects than Reinhardt's, since the relationships imply that each painting is in a sense a fragment. His color, remembered from observed relationships, points to no object or place, but only to itself; and its beauty, that leaves out all dullness, lies in its aesthetic accuracy. Where Reinhardt expounds the decorum of the aesthetic point of view, Fiore gives an example of it.

Twombly also exemplifies the importance of the little. His little things are not parts of a nature that dwarfs man, but the little things that people do compared to a much larger world of all human activity. He is a humorist, too accepting, too adaptive for satire. For satire, after all, is an angry assertion of man's failure to be heroic. Twombly's huge white paintings are like walls on which incomprehen-

115

20. JOSEPH FIORE: *Medomak II*

sible dirty jokes have been scribbled—jokes which turned
into art even while they were being put down; a few
numbers; a few touches of pink and blue—the doodles in a
telephone booth. Like Fiore, he exemplifies the importance
of the little in the equality of the small details. In Fiore's
paintings these are color atoms; in Twombly's graphic and

textural paintings, the atoms are tactile. He expresses him-
self in the quality of his touch, which is humorous, respect-
ful and very appealing.

Taste and Energy

[*1961*] In the twenties visiting French painters (Maurice Denis and
Matisse) remarked on the good taste of American painting.
That is not necessarily a compliment because it suggests
shallowness. Good taste is not essential, and it is often
a brake on energy. In a movie which shows Jackson Pollock
painting, I remember his remarking that here he has lost
contact with his painting. That is to say that he had lost
contact with his deepest self, because of a failure of energy.
Energy is a bridge to whatever is essential.

The Graham Gallery is exhibiting work of Edwin Dick-
inson painted between 1914 and 1959. From 1911 to 1914
he studied with William Chase, Frank DuMond and Charles
Hawthorne. But his earliest pictures show contemporary
French influence, as of a painter who wished to apply
Cubism to the problem of truthful representation. "Noth-
ing too much," neither Cubism nor representation. *The
Rival Beauties* of 1915 simplifies the faces and dresses, the
arch through which one sees a Latin street in perspective,
the flags, the gesture of the cellist finding the note on the
piano, and the singer, into flat, modernistic, kidney shapes.
Dickinson's art is a draftsman's art. He perfected a tactile
point of view in which everything goes from soft to crisp.
But his tactility is as indirect as a stonecutter's. It is a
discipline that he has transcended and that he constantly
returns to. He returns to it in his large "machines" with
downward perspective, in which he has assembled objects—
drapery, figures overcome with exhaustion, roses, porcelain
and musical instruments, for the symbolical suggestions of
their association. In these paintings he seems overwhelmed
by an ideal of consistency of texture and accuracy of
rendering—like an architectural draftsman's exercise in per-
spective and cast shadows. In these paintings he does not
seem to be in contact with his deepest self. But the show
includes a larger number of smaller paintings, portraits, self-
portraits, portraits of houses, and landscapes, as well as his
extraordinary pencil drawings, where his energy transcends

and makes use of an almost too rigorous and narrow discipline.

Such paintings are *Black Fish Creek,* of a curving Cape Cod beach, with a few heartbreakingly accurate patches of dark seaweed, and sky above, with hardly a difference in the exact distinction between sky and sand, where color seems a way of defining edges, and edges, color. Or the *Boyer House,* with its Japanese-print orange-tans, in which, though there are no sharp edges, the softness of touch and the divisions of the canvas have an exactness that he usually expresses by a crisp line. The subject is one of the most mundane in American painting—the suburbs, seen with an eye that is both innocent as a child's and professionally careful. Or for contrast and immediacy, the pink *Villa La Mouette* against a perfect blue sky, belonging to the Metropolitan Museum. Dickinson makes the most out of the least, especially in *Winter Woods, Wellfleet,* or *View of*

21. EDWIN DICKINSON: *Boyar House, Sheldrake*

22. MARK ROTHKO: *No. 18*

Great Island. Least is, green, flat ground and blue-green sky; or an impression of trees that gives, with trained simplicity, a single essential for landscape, namely, the presence of nature. In these little paintings, or quick ones, he is in touch with an elusive and fleeting essentiality. In his large exhibition pieces, he is in touch with not entirely coordinated ideas of art. In the large paintings, he expresses, like an inadequate classicist, the limitations of a formality that originates outside himself; in the small paintings he has been able to surrender to his deepest self which has a profounder form than the form one can know and understand. It is a form that does not impose itself on his subjects, nor is it outside them. Chekhov said he wrote about the inkwell, and in the same way, in Dickinson's small paintings,

there is none of the manipulation of the artist who has lost contact with himself.

At the Museum of Modern Art is another retrospective exhibition: the oils and water colors of Mark Rothko. A characteristic Rothko painting is eight feet high by six wide, with an awkwardly placed horizon dividing two fuzzy rectangles of red and orange. His colors range from maroon to the brightest neon scarlet, from brownish to lemon yellow, pale greens, and a somewhat muted French blue. His canvases are divided into smaller rectangles, but not like Mondrian, whose space is cut up as if into servings: Rothko divides without separating, perhaps because of the deliberately awkward sizes, perhaps because of the blurred edges. Whatever the reason, if you add the parts together, the sum amounts to less than the whole. A whole Mondrian equals the sum of its parts, but a whole Rothko is greater than the sum of its parts. Rothko uses color in such a way that, if there are two colors for two rectangles, one inside the other, the effect is of one color; if there are three colors for three rectangles, one above the other and the two inside the third, the effect is of two colors; when the canvas contains many rectangles of many colors, the effect is again an effect of unity. Two is a weak number, and most Rothko paintings seem to express this number. His paintings have no structural skeleton. What holds them together? Perhaps it is simply the artist's energy which acts like a magnetic field around plasma. The paintings express breadth and height: they spread. Their simplicity calls for more wall space than they have been given. They look like non-objective murals for no particular place. Like architecture, they provide a spatial background. They are abstract in the manner of modern American commercial architecture, with its inattention to specific space, place, or function. One might call them prefabricated murals. The energy they communicate is proportional to their size and their simplicity; if they were more complex they might fail. Rothko makes no demands on himself beyond his ability. He asserts space as two-dimensional and finite. His color is luminous and without substance, as if it were light instead of pigment. It is reminiscent of the changing colored light that diffused the interiors of movie palaces in the twenties.

Robert Richenburg's paintings at the Tibor de Nagy Gallery seem to be specifically *about* energy. Bright colors, at maximum intensity, in swirls like sunset clouds, fires, explosions or electricity, are seen through holes in an overlying black, like very thick bars of a window. One sees that the black overlaps, and this forces the black, usually a receding color, to the surface; it brings it forward; and the colors which by their brightness naturally come forward, seem to be forcibly pushed back. The result is an almost unbearable tension. Each canvas exists at the highest possible energy level. Like the Rothko exhibition, this one is much too crowded. Here the conflicting energies cancel one another out like brilliant sunlight reflected from snow.

Tradition and Originality

[*1961*] Tradition is not ideal, nor an idea, but incarnate. It is the form of art and culture; a traditionalist is on the side of civilization. Artistic traditionalists are, for instance, Poussin, who transmitted Italian form to France; Arshile Gorky, who transmitted French form to America; and Picasso, who transmits forms from all the civilizations revealed by archaeology. He is the white counterpart of the cannibal in the silk hat, displacing forms into new contexts. He has skill of hand, transmitting through his nerves and fingers. Form is the stroke, and the forms of civilizations are manners. A stroke of Picasso echoes the stroke of an African sculptor or a Roman painter, or Ingres, Cézanne or Matisse.

The American artist most like this, except that he does not displace forms into new contexts, is Robert Motherwell, now showing at the Janis Gallery. He transmits the art of his contemporaries, through his fingers, not his mind. But his is not action painting like that of Pollock, who was a beginner, nor like Clyfford Still, who searches for something new. Motherwell's art is traditional the way Japanese art has been, transmitting productions of a Chinese-derived civilization. It has conservative grace, and Motherwell is the conservator of modernism. His least touch has a formality distilled from the habits of modern painters.

23. ROBERT MOTHERWELL: *Black on White*

Motherwell believes in the formality of his own time, which is called informality. He completely accepts his era. Even his belief in novelty (which he has stated) is conservative. His is the conservatism of the soft shirt, the open collar, the modern chair—a decorous liberalism. He has no awkwardness at all: everything is in the right place.

But this is only the outside of his painting. His acceptance of his era is so uncritical as to be liberating. The collages with only a few torn pieces of paper, torn in only a few places, only one wrapper (gressins LABOUCHEDE in the collage entitled *The French Line*), the few stripes, the mat colors, the splatter that is free and elegant, the civilized humor, a sense of proportion that avoids the heavy and is never thin, the black, white, maroon-brown, buff, plus stripes of a pink, baby blue or orange which are at once opaque and radiant—all these formalities contain something animate. There are, of course, the *Monster (For Charles Ives)*, the many figures in black or colored silhouettes with polite sexual connotations such as one might expect to result from a successful psychoanalysis. But the animate content is not just where Motherwell points to it in his titles: it is equally in *Painting*, in *Black on White* (which is like Kline, with none of Kline's trouble over color), and in *Striped Above* (two horizontals above a splatter). This last one makes mess into an organism. It is as if a lively pet animal, with an accepted place in the family, neither over- nor under-trained, sought to prove that

122

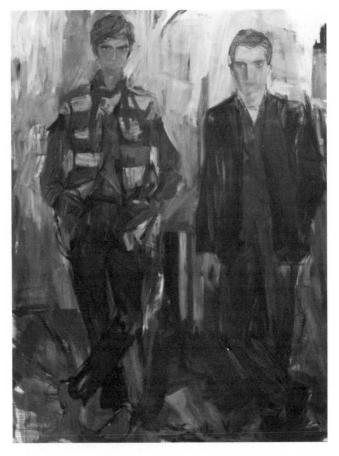

24. ELAINE DE KOONING: *The Loft Dwellers*

it is truly housebroken because it is freely incontinent. His paintings are organisms in which nature and civilization are in harmony. The animation is an inner light. I can imagine a Quaker producing art like Motherwell's. Motherwell is of his time and very much in it.

Another painter of this time, but not in it, is Elaine de Kooning, whose non-objective paintings seem motivated by intelligence and will. Her abstractions, for all their dashing contemporaneity, do not seem to liberate her talent, which

123

is a very great one. They simulate a life not her own. It is as though she were making conversation. She admires what the forms of non-objective painting stand for, but that fails to put her in the movement, any more than admiration for the vitality of the Church makes one a Christian. Intelligence and will are not enough.

Miss de Kooning is of this time, but not in it. She is not traditional, she is an original. She is also exhibiting, at the Roland de Anelle Gallery, the kind of thing that liberates her talent, what she uniquely can do. The show is a series of most extraordinary drawings, especially those of people, for example several of Harold Rosenberg, which are among the more penetrating portraits made today. There is also one huge painting of two young men, about one and a half times as large as life. This painting alone is worth a trip to any gallery.

One is immediately sure that these young men look exactly the way she has abstracted them, so strong is the impact. It is the first time that I have seen her handle, in a portrait, her abstract color so that it integrates with the drawing and the likeness. They stand casually in ordinary and apparently very characteristic clothes, one in a striped green windbreaker and red scarf, the other in a charcoal gray suit; and the wrinkles of the clothes, or lack of them, grow out from inside. The contour, appearing and disappearing, has an inspired looseness. The shape of the heads and bodies have inspired specificity. The features are barely indicated, except for two pairs of intensely shining eyes, one pair gray under dark smooth hair, the other brown under a blonde flourish, looking out from under the brows. The stripes of the clothes continue and counter the pink, violet, apple green, white and heavy yellow of the background and the orange of the faces and hair.

Attitudes to the Past

[*1960*] The Davis Gallery fosters a conscious and openly declared belief in realism and tradition in art. The most expert painter in its stable of artists, Seymour Remenick, is now exhibiting cabinet-sized landscapes, still lifes and interiors, in hand-carved frames of the best workmanship, in a setting of antiques on the ground floor of the Davis house; all of which serves to emphasize this gallery's belief in art as an

appurtenance of civilized life. Remenick's landscapes of Philadelphia illustrate those aspects—domes, spires, masonry bridges and museums—that connect the city to, say, Rome; the copper kettles, fruits and roses, the curtains screening golden or cool light, recall a nineteenth-century bohemian grace; and the interiors have a realism of the total visual effect combined with indistinguishable or unidentifiable details whose specific actuality is that of the artist's gesture more than of the natural object, recalling the drawings of Rembrandt.

The paintings do two things: first, it is as though in Remenick the nineteenth century achieved a belated success, as sailing achieved a belated success in the clipper ships, just when steam was first applied to transport; secondly, his paintings, with their apparent old-fashioned qualities, compete successfully with the most avant-garde painting in the terms of the avant-garde. Though he may not mean to do this, Remenick expresses as well as it is expressed today, the idea that the ends of painting are to be found in its means. His realism is partly a realism of reference to the objective world, but it is just as often the realism of what he has made, without reference to what it is supposed to represent. At least one of his interiors could be exhibited among non-objective paintings, where it would stand out as one of the best of them all. In this show it is only the large paintings (24 x 30 inches) that lack intensity. Though the details are usually completely identifiable as things in nature, they have less "reality" than the details in his smaller paintings; these latter may not be identifiable, but they have much more presence, and much more "color" in both the metaphorical and ordinary meaning of the word. In the large works, it is a matter of inaccurate relative variation, an unconvincing proportion of intensity to size, a difficulty, in short, about scale.

As the "line" of the Davis Gallery is that art is something that must be conserved, the "line" that dominates the Ruben Gallery downtown is, roughly, anti-art. Anti-art has often produced art—the art of the succeeding generation. And one of the artists who shows here, and has a painting in the current show, Red Grooms, has a great deal of vitality, and what he produces is alive. However, the present exhibition is strangely conservative, perhaps a little disheartened. The anti-artistic radicalism is reminiscent of German Expressionism, and it dates to the twenties. The

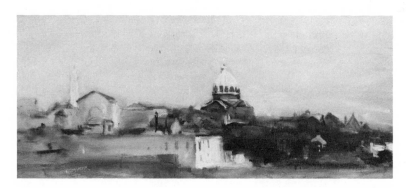

25. SEYMOUR REMENICK: *St. Peter's and St. Paul's, Philadelphia*

Ruben Gallery is in a loft; on the stairs up to it is a winking red and blue light, and the exhibition is dominated by shabbiness, instead of, as Red Grooms has done, dominating it. But in spite of the present show, the Ruben Gallery is worth visiting, partly for Red Grooms, and partly because anti-art is a serious idea.

Around the corner on 10th Street is the Tanager Gallery, whose "line" is different from either of these. For one thing this line has not been put into verbal form. It is apparent, though, in every Tanager show. This gallery deeply respects art. The Tanager was the first cooperative gallery, and the artists who founded it believe in themselves and in what they do, without any feeling that it is necessary to rationalize.

In the current exhibition, John Button's two paintings are of a factory building in front of a huge pinkish cumulous cloud, and another of a bather with the sun behind him, coming up the beach from the sea. Button is neither conservative out of the certainty of his sophistication, like Remenick, nor is he anti-art out of competitive ambition, like many of the artists of the Ruben Gallery. Such problems do not seem to exist for him, and since he entirely ignores them, they disappear. He does not make you feel, as does Remenick, that art should follow precedent, and that he can do anything that has been done before; nor does his assertiveness take the form of a proud rejection. He is a realist, and you do not feel that comparisons with past

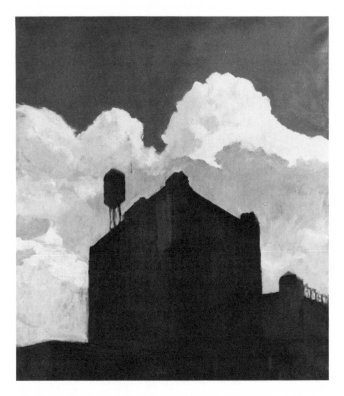

26. JOHN BUTTON: *Warehouse*

or present traditions are relevant. Though his ability to make light shine out of the darkest shadows is hardly innocent, still, since originality is not proclaimed, the only way to regard his painting is as though here painting begins again. This attitude is, by the way, much more fruitfully anti-art than one of constantly looking over your shoulder in order to see what not to do.

Tradition and Revolt

[*1961*] The paintings by Paul Georges at the Great Jones Gallery illustrate in a very interesting way a relationship between tradition and individual talent. The exhibition features life-size—or maybe a little larger—portrayals of a pregnant

nude. There are also landscapes, and they too seem to symbolize pregnancy: one shows a much-pruned apple tree whose huge trunk is quite disproportionate to the thin young branches; another shows the wide, dark end of a barn in the blue-green sunlight; and a third, a black pool with bathers under ballooning foliage. The acidity of Georges' color comes as a shock: violent greens, thin yellows and an almost Prussian blue-black. The flesh color is "traditional," but the acid pinkish bark of the tree-bole is not. Also in the gallery, though it was not hung at the opening, is a portrait of a man sitting on a studio couch below the artist's eye level, with the room behind him. This painting has none of the acidity of the rest of the show: its color is an almost conventional array of grays, browns and reds, and the handling has the virtuosity one associates (without sufficient justification) with the style of Sargent.

The scope of these paintings is a matter of width of areas and a graphic, firm impatience and hurry over details of fingers and feet; but still more, whether the paintings are vertical or horizontal rectangles, it is a literal matter of an underlying emphasis on the second dimension of breadth. His figures sit erect and the trees grow up, but his world is a wide one, a horizontal one. The artist seems instinctively to feel space in the sweeping gesture of spreading his arms. The paintings are impressive in their skill of handling and solidity, combined with a jarring color that holds its place. And they probably could not have been painted before the advent of "American-type" abstraction. They illuminate the relation between tradition and revolt.

An artistic capital is a place where tradition has been assimilated. This cannot be deliberately brought about, and the reason for its occurrence is essentially mysterious. What "assimilation of tradition" means is an understanding on the part of artists of the essential nature of the form of the art of the past, or of another artistic capital, or the previous one. Artistic provinciality means that the artist does not understand the essential nature of the form of art in the capital, though he may be strongly attracted to it. Or he may consider himself a traditionalist, that is, attracted to the art of the past; and if his understanding of this art is superficial, he will be provincial to it. An academy is often a center of provinciality, even when located in a capital. The academic view assumes that art can be expressed in a series of rules, which in sum

miss the essentials. A provincial artist's work depends on the art of a capital, removed in time or space. His work has formality without form. His work does not stand alone, but depends on art somewhere else. Or it may depend on ideas which, though they may make a consistent whole, are better embodied in their verbal exposition than in art. An independent art will elude any exposition of it.

Sometimes there exists a completely original artist, independent of tradition and independent of the capital. His denial of tradition and of the capital are equivalent to a denial of his profession, to a declaration of an amateur status. His work may consequently suffer from shallowness. Such an artist was Arthur Dove, whose revolt against tradition was based on the conventions of American magazine

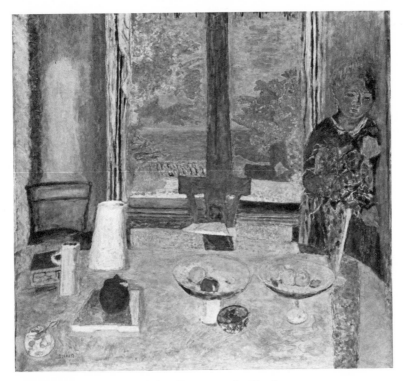

27. PIERRE BONNARD: *Dining Room on the Garden*

illustration. Another was Kandinsky, who based his revolt on the inadequate traditions of a provincial academy. In the paintings of both these artists, there are gaps between graphic and color formalities. Insuperable formal weaknesses usually occur in the work of revolutionary artists unattached to an artistic capital. This can be seen in the Guggenheim Museum. The formality of the Constructivists seldom transcends the detail, as if form should be guaranteed by choosing a formal subject, in this case, the shapes of geometry. Contrasting with these paintings is the Bonnard in the same museum. Any verbal exposition related to this painting would be less than the painting. And still it is the best abstraction there. Bonnard was attached to an artistic capital.

For all of its peculiarity, "American-type" painting contains within itself, just as Impressionism did, a sort of assimilation of tradition. This assimilation of tradition comes about through a reaction with the deepest, most inexpressible force of tradition, and it creates a new artistic capital. In such an artistic capital a significant conservative "return to tradition" can occur. Georges' paintings represent such a return. But tradition is available to him, here in New York, because it was first assimilated by the New York School, and the form in which it is available is characteristic of this abstract school.

California and New York

[*1959*] For December the Zabriskie Gallery has assembled a show of California and New York painters whose work, though representational, comes out of an experience with abstraction. New York art is compared to American art provincial to New York. In the West the audience for painting is smaller than here. Because it is hard to get anyone to listen, the artist shouts. As could be seen at the new images of man show in the Museum of Modern Art, it is the subject matter that shouts, whether "abstract" or "representational." The Californians are Paul Wonner, William Brown and John Paul Jones. The first two paint thick and large, Jones's paintings look like negatives; perhaps he got the idea from the etcher's plate. In all the paintings there is a cavalier use of the human subject—certainly these painters do have a "new

image of man." The image is not flattering to the artist's perceptiveness: it is the non-image of man that one gets from news photographs—a temporary grimace, a meaningless action. Wonner handles the medium skillfully. His paintings are a luminous iceberg-lettuce green. But still life or person larger than life, and broader, for all of the skill, why is it done? Is there more love than displayed by the news camera? As in the bigness of West-coast fruit, size dilutes flavor. It is the landscape that moves: essential landscape: namely, distant horizons. The New York painters are Robert De Niro, Lester Johnson and Leland Bell. The difference is that they are absorbed more in painting than in the audience. De Niro's colors in major key are lassoed all in one throw by the quick rope of his black line. Bell analyzes the figure in a cooler and broader Giacometti-fashion. He sees the skull beneath the flesh. Johnson's paintings, thick, almost black, have a first-hand immediacy, not journalistic like the Californians'.

The contrast between New York and California continues in the exhibition of small Vermont landscapes by Lucien Day at the Morris Gallery. If Wonner's landscapes have the bland sweetness of the Delicious apple, Day's have the intenser flavor of wild strawberries. If the people who appear in Wonner's paintings have the impersonality of retired consumers, Day's landscapes, which contain no people at all, are populated with individuals. The squint on the face of one of Wonner's figures is less specific (less personal) than the paint stroke into which Day may have turned a branch, a tree, a rock or a hill. The artist respects his individuals as separate from himself and separate from one another, each of a different nature. This is part of the same thing that Bonnard does in his landscapes. The artist does not swallow the external world in his creativeness, but watches the separate lives of hill, cloud and leaf. The landscape becomes a democracy of creatures assembled on the canvas, like citizens at a town meeting.

Nicholas Krushenik's paintings at the Brata Gallery show what happens in New York when an artist tries to assert himself against the competition and with the stimulus of this environment. His paintings are divided into from two to four vertical sections, like duplications with variations. What is going on? In most cases energy is contained between thick flat straight bars, like explosions in successive cylinders of an internal-combustion engine; or like the essential

energies of related human souls, separated by the walls that make communication necessary and difficult. One painting resembles the destruction caused (or about to be caused) by the electrical flow between cells of a battery. But Krushenik does not say that man is like a machine, and his theme is not death. He says that there are enormous energies and that they are contained: his theme is force.

Sculpture and the Material

[*1960*] One might reasonably expect sculpture, the most "thingish" of the arts, to be the dominant art of a materialistic age or society. It does not seem to be the dominant art here today. Is this country and this time against materialism? Is it materialistic to appreciate first of all the physical nature of art? Official sculpture is usually nonphysical. An example is the statue of Jefferson in the Jefferson Memorial in Washington. The sculptor's technique was directed toward overcoming the medium, which is marble. He was so successful that it might as well have been rubber. As he did not appreciate the physical character of marble, neither did he appreciate the physical presence of the statue or the physical reality of the human subject. The statue is gigantic in size and petty in treatment. Jefferson stands indecisively, trapped under the architecture. "Drapery" reveals a sculptor's feeling about material. He may be bored by the clothes as standing in the way of the only subject he thinks appropriate for sculpture—the nude. The chances are that if he is bored by "drapery," he will also be bored by the nude, because he will see ideas instead of things. If he sees clothes as social idea instead of as material fact he will be likely to see the idea of the nude instead of its specific structure. Prejudice colors perception: from the overcoming of the nature of the medium follows the overcoming of the specific nature of the subject. The hugeness of the Jefferson statue magnifies its littleness. It magnifies what marble has in common with other materials, and what Jefferson has in common with other men. It is as American as a public-opinion poll.

The revolution in art that affirms its means in order to say that art is physical and material—I am not sure that these words are synonymous—has been accompanied by the popularity of steel as a sculptural medium. Whether he wants or

132

not, the artist has to concede the inescapable toughness and resistance of steel. Working directly with steel has replaced the indirectness of working with plaster as a step toward bronze. Being a preliminary step, plaster was not respected for itself, any more than the copper plate as a preliminary to the printed etching is respected for itself. The plaster casts in schools, substitutes for real art across the Atlantic, look dead. But plaster has a natural lightness and crispness: it hardens quickly, and after it is dry, it can be carved. Exploited for itself, it contributes to the liveliness of modern sculpture.

Reuben Nakian, exhibiting at the Egan Gallery until January, is a sculptor who makes plaster come alive. His favorite subject is *The Rape of Europa,* which he has hitherto executed in terra cotta. He uses terra cotta with baroque speed, as though the form were painted with brushes dipped in clay, appropriate to the charge of the bull, and reminiscent of Titian's *Europa* at Fenway Court in Boston. His latest Europas are in plaster. They look like porous, chalky tufa dug up out of the ground. His first Europas expressed an excitement all in the present; these new ones, in which the subject is fragmentary and hard to make out, are like recollections, changed by burial. They have the partly natural, partly artificial appearance of archaeological remains. What was the speed of the present in the earlier terra cottas, has become an image from the past, static and worn by time. Having lost an immediacy of subject, they have gained another materiality. They have turned into stone.

His two large steel pieces, *Venus and Mars* and *The Duchess of Alba* (presumably referring to Goya's painting) are completely artificial and willed. Nakian adapts the inadaptability of the material, making steel do for modern sculptors what basalt did for ancient ones. The tensile strength and springiness of steel in these sculptures do not make you think of its virtues for engineering, but of its resistance to manipulation. He uses it artistically, not functionally. The sheet steel, barely bent for the bed and figures, is like shadow, or the washes in his ink drawings; and the welded pipe framework is the three-dimensional projection of the pen lines in the grid of the drawing. Neither the edges cut by the blow torch nor the curves of the surfaces are sensual or stimulating to the touch. Their resemblance to a pile of jack straws recalls the delicate, easily upset balance

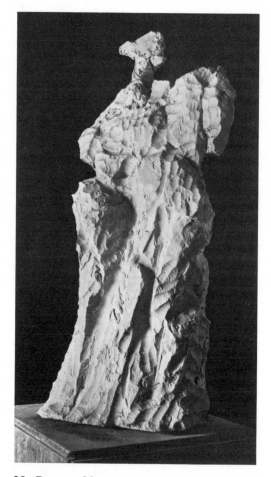

28. Reuben Nakian: *Venus*

of this child's game. They are not tactile, they are for the eye; they aspire to heroic scale, and should be seen high and distant on a pediment.

Sometimes it is a disappointment to see in bronze a piece of contemporary sculpture that one saw first in plaster. The crispness is replaced by the idea of the form. When this happens, it is because instead of the plaster having been thought of for its usefulness as a middle step, it is the bronze

that has been thought of as a useful way of saving a conception from loss. Plaster is perishable. Nakian's sculpture, *The Emperor's Bedroom,* had beauties in the plaster, a crisp whiteness and variation from smooth to rough, a sensuality that the bronze has lost. However, it is better to save a piece of sculpture diminished by casting, than to lose it altogether, as happened to another sculpture that was on view for a long time at the former Egan Gallery on 57th Street. This plaster carving, which looked like an abstract *Victory of Samothrace,* was the greatest piece of sculpture ever made in America. Nakian kept working on it, and finally it was destroyed because it was in his way, and he had no place to keep it.

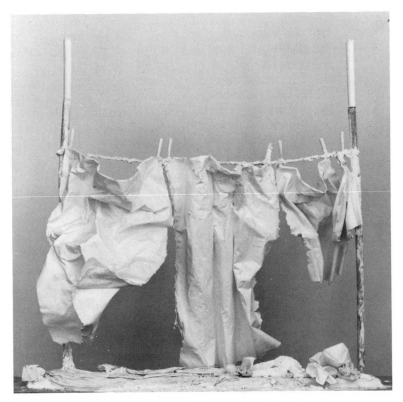

29. PETER AGOSTINI: *Clothesline*

An exhibition of the sculpture of Peter Agostini closed December 10 at the Stephen Radich Gallery. Agostini is another sculptor with an appreciation for plaster, as well as bronze. He seems to be able to carry his plasters through to a completion that satisfies him, so that he can let it be cast. He supervises the casting, and he uses silver nitrate for a cool gray patina that relates to the texture of the original plaster. Contrary to the academic sculptor, troubled by drapery whose structure he cannot appreciate, Agostini shows many rococo-like sculptures that are only "drapery." *Hurricane, Clothes on a Line,* and the various *Wastepapers* and *Blacksmith's Aprons* are very lively. He molds his plaster with egg boxes, corrugated cardboard, crushed cigarette packages, contraceptives and the plastic containers that dry plaster or other such sculptor's material comes in. The forms and textures pressed from these, and from crumpled sheet metal and wastepaper, have a physical presence of an irresistible and joyous tactility that make your fingers tingle. He also shows bronze nudes that are at once figurative and like metal in the lode. Agostini is more of a naturalist than Nakian. His sculpture has the mixed look of something wind- or water-worn, crystallized by heat and pressure, in addition to the artist's manipulation. Where Nakian's sculpture sometimes resembles archaeological fragments, Agostini's resembles the minerals in a geologist's collection. The wind in Nakian's sculpture is, more directly than Agostini's wind, the wind of sex; and his crystallizations are more psychological. They are precipitated out of their solution in time.

Humor in Sculpture

[*1960*] It requires much more imagination to be a sculptor than to be a painter. And because a sculptor's activity is consequently more serious, a sense of humor is more necessary to him than to a painter—the kind of humor that keeps one from making mistakes about relative values. Is this equivalent to saying that humor is art? It may have been this humor that Renoir found in Degas and missed in Rodin; though a lack of inhibition, or simply great energy—which, if not humor, is parallel to humor and possibly even sometimes superior to it—allowed Rodin to carry off his inflated values.

William King's sculpture, at the Alan Gallery, has a deceptive wittiness, so that it looks like something not to be taken seriously. He has a talent for caricature, a quickness of mind followed by a quickness of execution that make him pass from one accurate observation to another. His self-caricature in terra cotta shows an almost characterless, thin face and pendulous chin looking horizontally out from behind thick spectacles like a professor of histology glued to his microscope. *At the Party* is a galvanized iron man like a stovepipe. His thin legs support a jacket in whose right pocket is hooked his right hand; his left arm hangs straight and limp from eagerly stooped intellectual shoulders. It is out of *The New Yorker. Carpenter* is a pine-plank abstraction. At the top is a round blank clock face, tapering narrowly down to the floor; it is a metronome in reverse, pedantically precise about space instead of about time. *Articulated Figure* comments on the habit of anthropomorphizing tools or simple machinery. But King does not use found objects; he completely makes them up. A number of small bronzes show that he can do what is very rare in sculpture: create a three-dimensional whole out of more than one figure in the round. That requires an imagination as much greater than the ordinary sculptor's imagination about volume, as a talent for three-dimensional chess is greater than a talent for ordinary chess.

And if you recall how few equestrian statues are any good, you will be impressed by his wooden *Lady Godiva,* rather abstract, rather flat, but which has a continuously composed silhouette as you walk around it. From any side or angle it looks like a half geometrical bas-relief with all the projections at 30 and 60 degrees. King's sculpture resembles Picasso's most recent sculpture, except that he doesn't get away with so much, and doesn't fall into either of the opposite vices of laziness or pedantry.

Art and Rubbish

[*1960*] So closely do art and rubbish approach each other in the new exhibition at the Martha Jackson Gallery, and so convincing is the appropriately crowded presentation, like an inventory of the possessions of the Collier brothers, that one wonders where the difference lies. This show is a tribute to the genius of Marcel Duchamp. Cornell is an-

other ancestor of this movement in which art resembles homemade toys, and in which formal distinctions between painting, sculpture, illustration, satire and the amusement park tend to disappear. The artists use the ordinary materials of this steel, plastic, paper, plaster civilization. Also newspapers, typography, found objects: the jetsam of the city. And paint, in all its forms, from fresh, through peeling, to removed; and dirt, the smear of life. Behind the glass of Cornell's box are loose white cubes in square white holes. No one has improved on his ability to suggest more than is there, as though each of his boxes were a one-act abstract chamber drama.

30. WILLIAM KING: *Lady Godiva*

Brecht's *Play Incident* allows you to drop a Ping-Pong ball into a choice of holes at the top, whence it falls, playing a tune, to come out at any one of five holes at the bottom or sides. Tapies' *Painting on Unfolded Carton* has this artist's gray elegance. Takis uses the entertainment possibilities inherent in magnetism. Kaprow creates part of an environment out of materials of a Japanese flimsiness; and his and Whitman's object, made, as I remember, of a worn-out rope door mat and rag of terry cloth hanging over a pile of crumpled, soiled newspaper, do to space something analogous to what Castro's four-hour speeches do to time. Some artists use their materials pictorially, as Vanderbeck, who bends a bentwood chair into the likeness of a *Seated Figure;* and Jean Follett, whose little figure assembled from switches, springs and castors on a cinder bed is poetically entitled *My Creature Washed Up All Over the World.* There is the satire of Falkenstein's *Party Line,* with its charred wood and melted insulators; the dadaistic ferocity of Latham's relief of partly burned books opened like flowering pastries from a creamy plaster; and the nightmare of Levinson's lighted sinus operation.

The artists seem to make a visual appeal to ideas too serious for words, even though the meaning derives less from the materials in a sensuous way than through their names. They seem more influenced by the poetry of journalism and of the movies than by what, in this context, I can only claim as the "so-called" plastic arts. The participation of the spectator that Brecht wants makes me think of a host nervous if some parlor game has not been planned for after dinner. He channels the spectator's energy, so that he won't break the furniture. These artists break it first. By their rubbishy, nihilistic look of being against meaning, they concentrate attention all the more narrowly on just this question of what it means.

However, there are several artists in this show who do have plastic concerns; one of them, Indiana, presents a thick, erect plank with stenciled circles and letters, like a signal post considered aesthetically. Another is Paul Harris, shown here, and, much more interestingly, in realistic and abstract examples at the Poindexter Gallery. His realistic sculpture is talented and entertaining like most of the objects at the Jackson Gallery, but his abstract sculptures are very original. Though he has given them titles like *Chandelier of Love, Winter Gladiolas* and *Wishing Well,*

which give a dadaistic reference, what counts more is the use he has made of modern plastics as containers for plaster castings. Like many contemporary American sculptors, he is able to make plaster come alive. The sculpture, like broken upholstery, has partly the sensuosity that gives promise of rather uncertain pneumatic bliss, and partly a sick person's sensitivity about the sheets. As in a description of the beauty and intricacy of detail revealed under mescaline, every wrinkle counts. His sculpture doesn't mean anything, but is directly tactile and utterly useless. Through the detail of wrinkle and round object, he goes back to a beginning of sculpture, much as Kline goes back, through the stroke, to a beginning of painting. It seems to me that in his abstractions he has made an insanely inspired jump into significance.

Is Photography an Art?

[*1960*] Photography in the Fine Arts, the second in a continuing series of exhibitions at the Metropolitan Museum of Art, New York, is based on a fallacy. It is fallacious to think that the question, is photography an art?, can be decided by much the same process that elects Representatives-at-Large to Congress. A number of photographic organizations, both professional and amateur, and organizations of publishers and advertisers, nominated 800 photographs by nearly as many photographers, and from these a final selection was made by a jury of twelve: curators, museum directors, art critics and photographers, who voted quite secretly and without regard to any consideration but their own preferences. The jury elected 127 black-and-white photographs and 49 color photographs, which can be seen at the museum until September 4th. One objection to this procedure is that the works were first of all screened by organizations—an organization has no taste—and another objection is that democratic choice is irrelevant to artistic standards.

Photography is an art if the photographer loves it enough, and if the juror who selects the show responds. James Rorimer, director of the museum, says, "In our era, when art enthusiasts are welcoming paintings of white on black and black on white, even white on white, the photographer should have his day in court." But photographers

are not suing anyone, and they need no defense. When was black-and-whiteness the essential nature only of the photographic medium? And where does color fit in?

Photography is a medium—you can recognize a photograph—but attempts to define it, to limit what it is, will always come up against important exceptions. Is photography a kind of ultimate realism, as is implied by the pejorative adjective "photographic"? What, then, about abstract photographs? Very often a diagram, or diagrammatic drawing, can be more informative than a photograph, as in an atlas of anatomy. One wonders whether a photograph is art, not so much because of anything inherent in the medium, as because the difference between art and craft, and art or craft and mechanism, is very subtle in photography. This subtlety has mostly eluded the screening organizations and the jurors; so if this rather disappointing exhibition proves anything about the artistic nature of photography, it is that among the thousands of photographs taken every year, very few are art. Which is not to be wondered at, for it is also true of painting, sculpture, literature, music and all the arts. The exhibition proves that art is not what people look for first of all in photography, which has so many uses, like recording and advertising. And it is hard to tell immediately when a photograph stands out as art.

The color photograph that stood out for me was Horst's *Two Moslem Women.* Nothing escapes from the picture, every cool color is where it should be (as good color also should be in painting). Photography enjoys the advantage of having hardly any problem about muddiness, since its color is an aspect of light. Pleasing color photographs are Kauffman's *Punting on the Cherwell* and Haas's *Norwegian Fjord,* which depends perhaps too much on being a record of a landscape extraordinarily beautiful in nature.

In black and white a standard for me is whether the photographer, either in the dark room, or at the shutter (like Cartier-Bresson, who leaves developing and printing to anyone else), can maintain a life for values and textures all over the picture. Matisse told the pupils in his painting class to make every corner alive; and this seems to have been supremely the practice of the photographer Atget. Among the black and whites that I liked are Cornell Capa's photograph of Pasternak sitting on a park bench among a litter of leaves against a background of young birches,

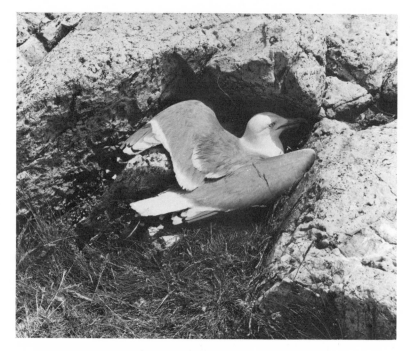

31. ELIOT PORTER: *Sick Herring Gull*

which has that multiplicity of nature found in Pasternak's verbal descriptions; Breitenbach's *War Orphan, Korea,* with all its grays alive; Carolyn Mason Jones's *Bridge Through the Window,* with the sun shining through raindrops on the glass; the dispersed and ragged abstract pattern of Lessing's *Hungarian Revolution;* Cartier-Bresson's *Matisse and Doves* —he is a photographer who is able to suggest in any subject, a political, editorial point of view; and Porter's *Sick Herring Gull,* whose intensely accurate textures to the very edge of the picture, make other photographs look journalistic.

The exhibition does not convince me that the organizations which submitted photographs to the jury are primarily interested in the art of photography. I would like to see work by Ellen Auerbach, Rudolph Burckhardt, Robert Frank, George Montgomery and Walter Silver.

Communication and

Moral Commitment

[*1961*] In a recent column in the New York *Herald Tribune,* John Crosby writes, "It does seem to me that the gulf between the public and the artists has never been wider, but this is one of those subjects that is unmentionable." He quotes Abram Chasins, the composer: "The average man is educated or bullied into thinking he has a responsibility toward modern art. But . . . the artist feels not nearly so obligated to reach this average man as the average man feels responsibility to reach the artist." And in his letter to *The Nation* on March 4,* Selden Rodman implies that a stand for artistic moral commitment puts one in the minority. These criticisms that modern art does not communicate and lacks moral commitment, go together. The first says that it is selfish, hence immoral, not to communicate; the second says that the only proper communication is a moral one. The first criticism assumes that the artist should be more guided by public taste. That is the theory behind public-opinion polls and market analysis. There are a number of objections to this. Market analysis informs one about the immediate past. And since "the public" is a generalization, "public taste" is either not concrete, or it aims at a preference for reminiscence, that is, a preference for the second hand. Insofar as "public taste" *is* concrete, it is against individual integrity. The second criticism, that modern art lacks moral commitment, usually contains a puritanical moral prejudice, which is that goodness consists in a concentration of attention on shortcomings, failure and disaster. This is called compassion. This was the moral motivation of Helen Schlegel in *Howard's End,* who, in order to confront Mr. Wilcox with his evaded responsibility, brought two starving people from London to the country estate he was visiting on the Welsh border.

The morality and the communication inherent in the nature of art is that it makes one aware of the connectedness between people and between things. Science does this too, with the difference that science explains, where art presents the wordless. When connections are explained, the form of

* A reply to Porter's review of Rodman's book *The Insiders;* see Chapter VIII.

the explanation takes the place of the original *gestalt*: science leads you toward itself, art goes no further than analogy. Science takes you away from the world, and art forces the world upon you. The "world" means anything that one may be aware of, objective or subjective. It can mean the artist's, which is to say man's, relation to work. Art has no rules to confine awareness. Because art is concerned with the ineffable—what cannot be translated—it will seem difficult to anyone who believes that explanation is the road to understanding. Artistic understanding comes from confidence in one's intuition.

The Castelli gallery exhibits nine oils by Jack Tworkov. Tworkov is one of the American painters chosen two years ago by the Museum of Modern Art for a traveling show in Europe. In that exhibition, which was shown at the museum, Tworkov's paintings stood out. His paintings have a quality that other American-type non-objective paintings do not have: though superficially just as broad and dashing, they are entirely conscious. This is apparent to anyone. The least accident, even the smallest white splinter between broad strokes of French-flag blue and red, which may look as spontaneous as an accident, has been worked out with the greatest deliberation after much redoing. At first sight, therefore, his paintings haven't the virtuoso impact of Kline—that enormous release of immediate energy. Tworkov's forms, tattered, banner-like, are endlessly calculated to simulate this all-at-onceness. On an almost hidden single or double H grid, a structure inside and relative to the carpentry of the canvas stretchers, he makes a transition to the specific torn looseness of the final painting. The stretched canvas is the form of general communication, as one talks to another person in English. The specific building up of strokes relates to some organization of experience that is more than visual, though visually presented. The titles indicate this: *West Barrier, Brake, Friday.* Tworkov's power, which gives his paintings their lasting effectiveness, comes from his never letting go of awareness. The scrupulosity, however, is always esthetically relevant to the concrete painting (which guides him), it always adds up to a coordinate force, a moral one, like the force of conscience. His conscience is directed toward the difficulty of achieving artistic integrity. His conscience keeps him conscious, awake and aware.

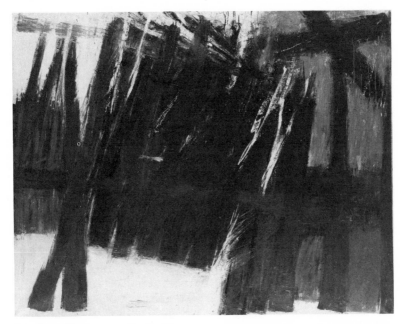

32. JACK TWORKOV: *Brake II*

Alex Katz's paintings at the Stable gallery are also relevant to the discussion of communication and morality. They are figures in landscapes, landscapes, interiors and portraits. The bright style recalls such unsophisticated commercial art as a Wheaties package (framing a full-length portrait of the dancer Paul Taylor), or of colored comics. Katz connects conscious art with art that was not consciously intended, and the articulate with the inarticulate. In the past his paintings have had in much of the daily press an attentive and classically condemnatory reception that recalls the blasts that first greeted Monet, Degas, Cézanne, Van Gogh and Matisse. I think these critics object to his connecting art with the unpretentious, as though he were betraying a social status. In the portraits the likeness does not "stop" the paint. The most ordinary and flattest gray, mixed only from black and white, has the radiance of violet. The green of a real, living plant in the gallery looks less alive than the actually rather abstract green of the foliage in his landscapes.

145

Other paintings now on the walls, or recently shown, that have given me a great deal of pleasure are the non-objective paintings of John Grillo and Patricia Passloff, and the representational painting of Robert Dash, Edith Schloss, Lawrence Campbell and Wolf Kahn. To me pleasure is both communication and a sign of moral commitment.

Experiencing Art

[*1960*] The audience for all the arts is growing. Probably not since the time when the populations of cities were organized into craftsmen's guilds, almost all of which participated in artistic production, have people been so open to art or wished so to experience it. And experience is the only way to know it. Art can be known best in its own terms, artistically. The experience of art is inhibited if it is considered as something to be "understood," something, like juvenile delinquency, that resists social control, but whose prevalence requires a sympathetic and tolerant attitude in order that society or individuals may manipulate it for social benefit or private ends. The worst and most mistaken way of manipulating art is to use it for malicious propaganda; a much less bad way is to understand it as part of a disinterested study of all society, without emotional involvement—as though emotion were an obstacle in the pursuit of truth. In this case, disinterest inhibits the experience. But between these extremes there are other common ways of regarding art that are inhibiting. One of those is to consider art as a natural phenomenon for scientific investigation; another is to think that it is a substitute for science, religion or philosophy in the revelation of profundities. It is still fashionable to explain Impressionism as an illustration of the theory of the physical nature of light. When I was at Harvard, Professor Sachs invited a physicist from M.I.T. to explain the nature of Impressionism to his class on the history of French painting. This man talked to us as one talks to very small children, but he patronized the Impressionist painters even more than he did us. He was not interesting because he told us nothing that we did not know, and this seemed all that he knew. He assumed that Impressionism was valuable to consider for its compatibility with science.

The sociological or historical approaches are more com-

mon. The first makes art as good as its purposes: if art contributes to the progressive liberation of the poor and exploited it is good; if it darkens people's minds with superstition, it is bad. The historical approach is usually relativist: art presents an image of society at any given time. If this does not inhibit experience, it is at least unnecessary. It is best when it works as an art parallel to the art it attempts to illuminate. Both of these pseudo-scientific points of view are inhibiting if they induce new prejudices to take the place of the ones they supersede. We think of Victorian prejudices as narrowly moralistic; but sociology may impose, instead of a prejudice for the suppression of sensuality, one in favor of the morality of material fact; or scientific determinism instead of religious determinism; impersonality instead of emotion. The question is not about the truth of any of these opinions or ideas; the question is about the experience of art. And a prejudice in favor of the relativity of values can inhibit by making one disregard one's own feelings, and consequently directing the experience in advance.

The large audiences for art make it less necessary than ever to apologize for art. People are open to it. But art is presented through the efforts of professionals, and these curators, dealers, printers, restorers and critics present art as something to be understood, as something that requires special competence to perceive. That also leads to the consideration of art in terms other than its own. The experience of art can be inhibited by the way in which it is hung, reproduced, restored and criticized.

Of course it is hard to see paintings and sculpture if there are too many examples in too small a space, but that isn't the whole problem. It is also inhibiting if they are presented in too precious a way, apart from ordinary life. Some years ago the Museum of Modern Art spotlighted every painting of an exhibition of old masters in an unearthly fashion that gave an illusion that the paintings had no material surface, that they were just images of light, made of colors that had not existed before this particular exhibition. It was like looking at sacred objects, or the crown jewels.

In order to show its need for more space, the Modern has recently hung its collection in a very crowded fashion. But the intelligent, tasteful and refreshingly irreverent hanging partly defeats its purpose by animating the works historically.

Another example is the lighting in the Guggenheim Museum, which makes each painting insubstantial and visionary. It makes art seem to pretend to be something more than it is, phony and tiresome. This hanging was the unfortunate result of the challenge presented by Frank Lloyd Wright's building. Wright seemed to consider his buildings in somewhat the way that a seventeenth-century Massachusetts divine considered his sermons: disdainful, spare and relentless. This museum is the last battle of Wright's war against art, which was a threat to his own ambition. Either you cannot see the paintings from far enough away, or if you can, they are cut off, from the top and/or the bottom, like yard goods. The snail-shell floor scheme limits the meaning of the paintings to their place in the sequence. People go in vast crowds to see Wright's fun house, but not the paintings, which could have been seen better in their previous surroundings. His house is fun because there is nothing in an architectural way to compare it with in a city without architectural tradition, but only an engineering one. As a museum, it very effectively expresses its architect's contempt for art.

The best museum presentation I know of in this country is at the Cloisters, housing most of the Metropolitan's medieval collection. It is a delight to millions. Also excellent is the new wing at the Metropolitan, with a room featuring a window on the best view to the south. And the Worcester Museum, ever since Francis Taylor's first term as director, has bought and displayed art for its intrinsic merit instead of for a name value. In May and June it exhibited paintings by Sir Thomas Lawrence, who is distinguished among all English artists as the most un-English, as the one who more than any of his countrymen dared to consider art quite unaffectedly on its own terms, for its own sake. Not only are no exhibitions hung with greater artistry than those of the Tanager Gallery in New York, but the large window makes each exhibition a natural extension of the life of Tenth Street. To present art as an actual part of life is quite a different matter from "understanding" it as part of society.

Because art restorers have much science, they are often tempted to take a scientific attitude toward the object being preserved or restored, as though the "immortality" of

art properly removed it from time. This puts into art a rigidity that does not belong there. And in their rationalizations of what they do, the restorers appeal to their knowledge against experience, which is a way of disregarding art in favor of craft. In answering criticism they seem to agree in reverse with the person who says, "I don't know anything about art, but I know what I like." The restorer says in effect, "I know a great deal about art and, in the face of that knowledge, what anyone likes is of little importance." Here, as so often, scientific principle has become anti-empirical and authoritarian. It does not take into account that art, whether realist or abstract, like the nature and experience of an individual, is not valuable so much for the general principles it embodies, as for its unprecedentedness.

In this country, certainly, when art is reproduced mechanically even by transplanted European technicians, it is done scientifically, and the spirit of the original is almost invariably debased. I have seen the phases that the reproduction of a painting goes through. In the effort to get accuracy, liveliness gradually vanishes. It should be remembered that reproduction cannot be exact, for that would contradict the nature of art as always unique. A reproduction can be itself beautiful, art itself, parallel but not equal to something else.

Historical placement, even such as insists on the uniqueness of art, will not contribute to the vitality of one's pleasure. Experience comes first, ahead of the morality of either the old or the new. To consider a work as good as, but no better than, the precedence of its appearance, is to be too coarse about individuality. Are children of no value if they resemble their parents closely? To ask the meaning of art, is like asking the meaning of life: experience comes before a measurement against a value system. And the question whether art has any meaning, like the same question about life, may not be answerable at all. It can be answered by each person for himself, and it is doubtful how well this answer can be communicated. What counts is personal experience, and therefore, what the critic can do, in fact all he can do, is to describe his experience as sensitively as possible.

V

The Past Today

Cezanne

[*1959*] The significance of Cézanne is something that the critics keep trying to explain: they repeat each other and their explanations overlap and insist, in the same way that Cézanne insisted on his contours. His parallel straight strokes overlap where they cluster around the contour, like too many adjectives modifying the wrong noun. Or there are gaps between the strokes where Cézanne ignored a passage that he was either sure of, or planned to attend to later. "The contour eludes me," he is supposed to have said. His repetitiveness is the stutter of inarticulateness. And except for a few famous remarks, he was also verbally inarticulate. The contour eluded him. As he went after it, and kept fixing it, it acquired greater and greater firmness and simplicity of shape.

His contemporaries who rejected him were repelled by his clumsiness. But it was also catching, so strong was the impression he made. Whistler, usually adroit and witty, was reduced by the sight of Cézanne's paintings to a kind of heavy, choked rage. He said, "If a child painted that picture, her mother, if she was a good mother, would slap the child." His contemporaries could not understand his deviation from Impressionism. Was this another revolution so

soon after the Impressionist one? But Cézanne did not want to rebel, he wanted to belong to the Salon of Bouguereau. He is supposed to have said that he wanted to make out of Impressionism something as solid and enduring as the art of the museums. He adapted Impressionism in order to bring it back into line. The Impressionists were not interested in the contour. Pissarro, their most articulate spokesman, said it was the interior color and value that counted, not the edge. Cézanne insisted on the reality of things, which the Impressionists denied insofar as for them there existed only sensation. But Cézanne, who criticized the Impressionist exclusive reliance on the eye, its substitution for touch, had trouble with things; the Impressionists didn't.

Cézanne classified the elements of art in an academic way into drawing, light, color, the object, the plan, character and style. He had a system for dealing with his nervousness. He was not open to the world; as an artist, it frightened him. People frightened him, they resisted him, he could not control them, he could not even get them to respond. Cézanne's people are treated like still-life objects, immobilized and abstracted. His apples have more instability, and they often look about to roll off the table. The leaves of his trees keep turning on the branches; they quiver in the still air like aspen leaves. Everything has motion, but contained, except only his people, unless they are the figures of art, like his bacchanalian lovers. Cézanne had a passion for fastening things down, a passion too neurotic to be called classical. The Classicists, who did not know that they were classical, believed in an ordered world, which they unconsciously expressed. Cézanne believed in the Church, because he was afraid of his own weakness. His weakness expressed itself in the opalescent quiver of his interior spaces, and his need for firmness expressed itself in the increasing simplicity of his shapes and in the clarity with which he contained everything inside contours, including that contour that is the edge of the whole canvas. At the same time everything also constantly escapes. The landscape of *Mont Sainte-Victoire* from the Philadelphia museum makes a revelation of the truism that earth and sky have different natures. But still the sky and earth so tightly and simply distinguished by their contour of separation, interpenetrate each other. The ground is airy and the sky stony, and both splintered like flint. The

portrait with most human individuality is of Henri Gasquet, but this reality, which must have threatened so timid a man as Cézanne is controlled by turning the sequence of the hat, the face culminating in a peak over the left temple, and the triangle of shirt front, into a sequence of geometrical shapes.

What is the appeal of Cézanne to us now, who no longer are unfavorably impressed by his real clumsiness? To us the stutter, the tentativeness, is itself charming. And it represents skill, the skill of combining a new understanding of uncertainty (the quiver of broken color and the elusive contour) with the insistent emotion of his contour lines. His formality fascinates us, the formality of violent feelings simplified in curves and straight lines to contain the uncertainty of what he knew, symbolized by the colors of nature. If certainty is not real, he will create it. Out of inarticulateness comes expression, and out of fear of contact comes his translation of tactility into a new visual language suggested by Impressionism. And as his forms are simplified, so is finally his color, which tended to become more and more a convention of orange and blue-green. All his broken color is still there, just as much as all his hesitation about the edge, but the edge that he hesitates over is a circle at last, and the many colors seem to have resolved into two. For color also eluded him. Finally, contour and texture contained most of his vision, and it was his contour and texture that the Cubists appropriated.

Whistler, Morisot, Corinth

[*1960*] The first major retrospective exhibition of the work of Whistler to be held anywhere since 1905 is on view at Knoedler's. It shows the true range of his work in all mediums, including the huge portrait of Carlyle; opalescent seascapes; an early use of drip in *Arrangement in Yellow and Grey: Effie Deans,* from Amsterdam; Japanese-influenced decorations, and the famous *Nocturne* that caused the law suit against Ruskin.

Whistler was born in Massachusetts in 1834, and educated from the age of eight to fifteen at St. Petersburg, where his father was an engineer in charge of the construction of the Petersburg–Moscow railroad. After 1855,

he never returned to his native country. Though Courbet praised his early work, he repudiated realism. He thought art should stand alone, and appeal to the aesthetic sense "without confounding this with emotions entirely foreign to it." His expatriate status and individualism are partly accountable to the American prejudice against art as decadent, like the similar prejudice against bathing which, until the Madison administration, was considered one of the causes of the fall of Rome. The English of that time thought of painting as an art of second-class countries whose cultures had succumbed to British domination over international trade. In England, Whistler's work also countered the current of Ruskin's identification of aesthetics with morality. The only place for him was in the avant-garde, in which he served as a link between London and Paris. Monet introduced him to Mallarmé, and an intimate friendship developed between them.

Like Mallarmé's swan, he is committed to the ivory tower, "immobilized in useless exile in the cold dream of disdain." But as the swan could not shake off "the horror of the soil in which his plumage was caught," so Whistler remained caught in his Americanism. His painting can seem as feathery as James's writing seemed to Whitman. Along with its large, simple arrangement, there is a thinness of substance and texture in the portrait of Carlyle, as if painting expressed not the wall, but the canvas. Whistler's favorite word, arrangement, describes an external quality of form. He could not shake off the American prejudice against art as slight and peripheral. Defiantly, almost petulantly, he accepted this idea. He chose art against engineering, for which he had talent, and slight or not, art was what he gave his loyalty to.

The art he asserted had the grace of integrity because it left out everything foreign to it and against it. It left out emotion and morality: its integrity made it shallow. His paintings are beautifully constructed boxes in which a few jewels rattle around. Eakins thought Whistler's way of painting cowardly. But Eakins gave up grace for the illusion that what is true is beautiful; and it is doubtful who was braver. Whistler let no idea come between him and his skill.

Grace as the essence of artistic form shows in another way in two exhibitions of Berthe Morisot: one, of her paintings,

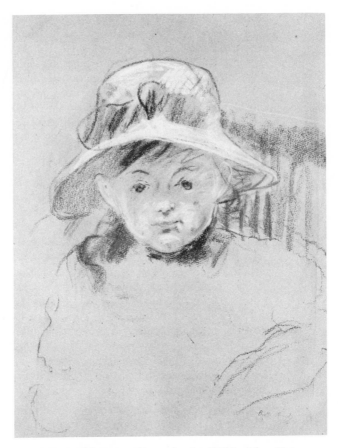

33. BERTHE MORISOT: *Portrait of a Child with a Hat*

at Wildenstein's, the other, of pastels, water colors and drawings, at the Slatkin Gallery. Berthe Morisot was born in 1841, and she too was a friend of Mallarmé. Her paintings are even more feathery than Whistler's, but her grace came from inside. There was no conflict between reality and ideality in the French bourgeois society of which she was a part. Morisot's range was narrow, but her views of art and the meaning of life do not conflict. She needed neither to arrange nor to organize. The singleness of her sensibility was selective, and saw what it saw as pleasurable, rather than good, right, aesthetic, or the reverse of these.

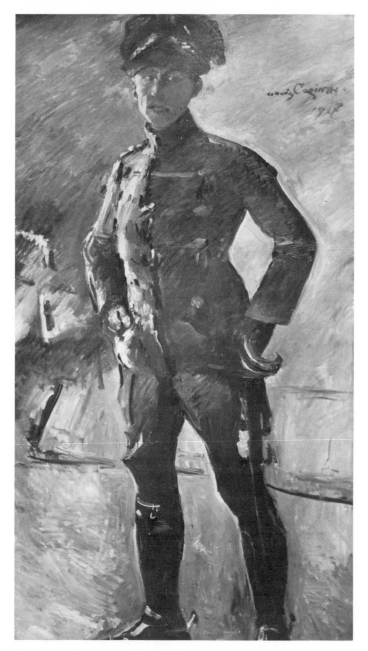

34. LOVIS CORINTH: *The Black Hussar*

Morisot's art celebrates. Her women and children and occasional men melt into the foliage, and her color became more and more a cool bluish-green and white. The stroke is crisp without sharpness, creating a tactile continuum like petals falling from overblown peonies. She loves, but in proportion, and she is perceptive without malice. She has the inner grace natural to someone gracefully brought up. Her world is like the world of Buddha's childhood, but it extends outside the palace garden, where a relatively successful society blurs the difference between work and play.

There are a number of portraits and one landscape by Lovis Corinth at the Frumkin Gallery. The landscape is like both Courbet and Soutine. Corinth was born in East Prussia in 1858, the year Whistler met Courbet, and saw his first Japanese prints. Corinth was one of the fathers of German Expressionism. The German Expressionists valued French Impressionism for its unprecedentedness and revolutionary glamour. As Prussian militarism rated the world outside Germany as organically real and very strong, calling for an immense native effort, so Corinth's military grace forcefully expresses the impact of the outside world. Corinth's portraits are usually larger and more sparkling than life, and they burst eccentrically from the bounds of the canvas. The art of the Expressionists of the Weimar Republic, retaining the largeness and oddness of Expressionism, had, like German militarism after 1919, lost an inner conviction. But Corinth's art kept this conviction, and his sense of the intense psychological reality of the subject even increased. This exhibition represents him at his best.

It is a mistake to think of Expressionism as expressing the artist. Rather, it expresses an overestimation of objective reality. Corinth is like someone who gathers together all his strength to cope with a situation calling for heroism. But the other Expressionists used heroism where it was not called for, and their eccentricity was an overcompensation for inner doubt.

France and America
in the Nineteenth Century

[*1961*] The exhibition, at the Whitney Museum, of American painting between 1865 and 1905 was organized by the Art

Gallery of Toronto, in collaboration with Lloyd Goodrich, director of the Whitney. It omits artists whose careers began before 1865, such as the Hudson River School, and it leaves out the realistic movement of the beginning of this century of Henri, Sloan, and so on. There is a feeling of enough space on the walls and between the various styles, and that there exists a great deal more of this painting in reserve. One is neither sated nor frustrated by the exhibition, and one leaves it with aroused interest and a desire to know the artists better.

These painters were the contemporaries of the French Impressionists, whose feeling of life was closer to ours today than to that of the Americans of three generations ago. The French had a delight in ordinary life and nature and the outdoors, which these Americans lacked. One of the most surprising paintings I know is of a battle between a Union and a Confederate ship that Manet watched off the coast of Brittany. A propaganda version of the difference between American and French society that one might imagine from reading Mark Twain or Henry James gives to America the role of a new country full of the freshness of youth and to France the role of effete and temperamental instability. But French Impressionism expresses solid pleasure in simple things, joy, and a stable life. American painting of the same time looks stunned and dreamy. Do Eakins' starving boxers stand for athleticism and his exhausted women in murky rooms for frontier simplicity? At the same time, the effete French had pink cheeks, they were in charge of nature which they had transformed into a garden where they did a lot of picnicking on the grass; they were completely at home in the country and city, whose streets are a background for a perpetual parade.

The French were social, the Americans solitary. The French hunted to enjoy the beauties of the woods and the deer, the Americans hunted to kill. The French went on boating parties, Americans took exercise. Light dominates French painting, while in American painting even outdoor daylight is dim and artificial. And Hassam, Chase and Mary Cassatt, who adopted Impressionist theories, produced a muddy grayness. The American painters seemed fearful of nature and man. In her mothers and children, Mary Cassatt sees a sum of features, instead of integral people. Whistler made the pre-Raphaelite identification of beauty with illness. Even his landscapes celebrate weakness. Thayer

seemed to see women the way a baby sees its powerful mother. All of the people in Homer's paintings are one lay figure. His *Snap the Whip* (one of the few paintings in the show with natural light) shows the same boy, six times over, against a background of autumnal hills as monotonous as the ocean.

There are four Ryders in the show. Two marines have Ryder's pat arrangement of clouds around the apex of the sail: the pathetic fallacy of the painter. *Weir's Orchard* is less typical; it is one of hardly more than half a dozen paintings that justify his reputation as a great artist. In this picture, he understands, as few artists ever have or do, what "value" is. Unless "values" express more than correspondence to a black-to-white scale of tonality, unless they are about weight and substance, they are meaningless. The meadow below the trees bulges more substantially than the foliage that overlies it, which in its turn is airy. And the boulders in the field seem to be floating on the heavy waves of earth, as indeed they do, pushed up by winter frost. This is painterly imagination, which Ryder had supremely, though he also had a romantic and literary one, as in *Roadside Meeting,* with a Poe-like atmosphere. The imaginary nature of his subject is realized by the materiality of his means. Blakelock was as romantic, though seldom as successful, as Ryder. *Ecstasy* shows an oak forest in unearthly light. The black leaves are set into, not on top of, the bone-colored sky, in front of a porcelain-blue distance. The ecstasy of the artist was the clarity and peculiarity of his vision that saw the shape of the leaf as the determinant of the shape of the forest. Both these romanticists seem to have chosen a deliberately unhealthy vision, nervous and narcotic.

American painting is full of false feeling. Whistler could not escape from it by expatriating himself. Neither could Mary Cassatt. Success made Sargent fall into it. It is very easy to choose a bad Sargent: in this exhibition they are all good. *Portrait of a Boy* is best; it has an un-American brilliancy of light and handling. Homer's *Autumn* is a good choice: his waves against the rocks of Maine became machines. Most of the artists in the show seemed unaware of how separated they were from nature and themselves.

Eakins pointed out a way of making a connection with

American life. What was necessary was to face up to false feeling. This is done by attentiveness, as long as this attentiveness is not sentimental, as it is when the artist does not dare to make decisions. It took all of Eakins' energy to face falsity of feeling; all of his attention, and it was very hard for him to dare to decide. He had the puritanical belief in truth as an extra-human value. Truth is everything, indiscriminately, and one must not monkey with it. This puritanism is the cause of the darkness of American painting. When the artist cannot allow himself to choose, he makes a proportional version of natural values. He believes there is nothing subjective about them. But the only way to get light is to choose and to decide. It is as though a writer thought that accuracy was to be found in adjectives and adverbs instead of in nouns and verbs. Eakins needed an explanation for every step he took. But in *The Pathetic Song* he found his form in the reality before him instead of having also to impose intelligence upon it. He was willing to make decisions. He decided in favor of the light on the singer, which saved him from obsessive concern with the details of the wrinkles in the material. He decided to silhouette the piano accompanist by an almost arbitrary variation of the light on the wall behind her, which maintains the flatness of the wall. He observed her expression of listening sympathy, and the listening nose of the cellist.

Sargent, Eakins and Ryder look best. But all the artists seem connected by their Americanism. They believed in nature and identified art with artifice. Whistler promulgated the idea of the separation of art from life. Eakins despised artifice, but in order to appease his conscience, he could get to nature only through the detour of science. Painting was easy for Sargent, and he was not very ambitious. Ryder's tenuous craftsmanship barely carried the load of his originality.

Italy and France
in the Renaissance

[*1961*] Continuing the series of national exhibitions that we have been privileged to enjoy since the war are the two magnificent exhibitions now at the Metropolitan Museum of Art, New York. One is a survey of Italian drawings from the

fourteenth to the eighteenth centuries, selected by Dr. Giulia Sinibaldi, director of the drawing and print collection of the Uffizi. The other is a survey of French paintings, drawings, tapestries and sculpture from 1600 to the death of Louis XIV in 1715.

The largest corpus of art in the West was produced in Italy, the second largest in France. The seventeenth century saw the Italianization of France. French civilization of that century is not nearly well enough known to us, who, as Theodore Rousseau, curator of paintings at the Metropolitan, says, tend to see history through English eyes. We are too little aware of the similarities between Louis and Cromwell. In both England and France an absolute state, modeled on Italian despotism, forced a social revolution that destroyed the power of the aristocracy in favor of economic domination by the middle class. English Puritanism was matched by the puritanism of the Counter Reformation.

All this had previously germinated in the North Italian city states. The Italians, surrounded by the ruins and survivals of Hellenism, had never been entirely convinced by Gothic inventions. Italian Gothic architecture is airy with Roman spaciousness; Italian sculpture never deviated so far from Greek origins as the medieval sculpture of the North. Though Italian painting until the fifteenth century had elements of Gothic naturalism, it was also based on conventionalities of a decadent Hellenism, as one can see in Sienese painting. The Gothic man left wholeness to God; society was called Christendom. Man's province was the details of nature. No one man is responsible for the coherence of a Gothic cathedral; it is a group effort whose totality is beyond the comprehension of a single person's imagination.

Today we call the logic of its form organic, which is to say, like nature. Secular humanity is expressed in the carved details of animals and plants, as well as in humorous irregularities. This naturalism shows in the fourteenth-century animal drawings of the school of Giovanni de Grassi. Both the surviving conventions of Hellenism and the medieval artist's assumption that wholeness is too large a matter for a single person's concern, show in the drawings of Parri Spinelli, where the features and drapery are vaguely Greek, but the connections limp. The spaciousness of Italian Gothic shows in the copy after the Giottesque fresco of the Visitation.

Italian drawing is like a distillate of the Italian visual

160

arts. It follows the essential development of Western art up to the eighteenth century. Medieval naturalism that leaves wholeness to God, implies security. One concerns oneself with things, and with the plurality of the world. Then questioning begins. What are things? Italian art developed through attention to those facts which are man's province: first, anatomy; next, appearance, how things look, which leads to perspective; then, what do we see, which leads to a questioning of the assumption of wholeness, for if the natures of the parts are questioned, so will be questioned what they add up to.

There is Uccello's perspective study of the *mazzocchio,* the wicker frame for the doughnut-shaped Florentine headpiece; in this, and in the studies of anatomy from Pollaiuolo up to Leonardo's and Michelangelo's mastery of anatomy, there is a continuous questioning of medieval materialism, a redoing of aspects of art, a new look at experience, and therefore at reality. In Pontormo's schematic anatomy and in Tintoretto's abstract laying out of a figure on co-ordinates, we see this new specific knowledge applied to a new sense of the whole—the whole, now, as man-made. In the fourteenth century the wholeness, like the detail, was unquestioned; it was organic, natural, only for God to understand. The new wholeness is artificial, human, inorganic, within man's province. Art is no longer continuous with nature: it has acquired an independent existence, pretending to equality with nature.

From mastery of detail follows in the seventeenth century the assimilation of detail into composition: even when the parts may seem to fly outward, the whole turns inward on itself, instead of presenting a parade of relations, such as is characteristic of Piero or Perugino. In the wash drawings of Guercino, Lodovico Carracci, Tiepolo and Guardi, the detail can no longer be separated from the picture; its significance is partial to the composition. Light unifies. Pollaiuolo's anatomy does not add up to so firm a totality as in the later anatomists; as Dr. Sinibaldi says, his drawing, which trembles with uncertainty, "is completely traversed by an overt and embattled search for something." It is wholeness that is sought, a wholeness attained later by Raphael. For Raphael, art is beautiful, not because it looks like nature, but because it makes a model for nature. Raphael's work parallels nature, a human totality that lies, as imagined by writers of science fiction, in another dimen-

sion outside the world of nature. But this wholeness is not the last one. There comes the new Venetian naturalism, as in Jacopo Bassano's drawing of rabbits, or the studies of Titian, denying line, as Goya did later on, and for this reason denying drawing as a separate art form.

Critics who find non-objectivity anti-traditional, do not see that tradition is a process. It leads to non-objectivity like this: first, acceptance of nature as including the artist, who is, like one of the details of his painting, an equal part of creation; next, a questioning of what things are, of what we see; then a questioning of how we see; from here to a consideration of vision itself; then to the one who sees, the artist as part of a duality of nature and recipient; to the artist in introspection, and a denial of objectivity.

In seventeenth-century France, Descartes proved existence by his own existence, which he knew introspectively. Here is the germ of the artistic present. At the same time the French took on the Italian role of responsibility for the continuation of classicism. Learning their art in Italy, the French artists of the seventeenth century, like brilliant pupils, saw behind their teachers, they saw through Italianism to its classical beginnings; they started a Roman revival. This is the conscious side of French painting. This is the significance of the Academy of Le Brun, and of such an intellectual expatriate as Poussin. Poussin could not relax in any way: his anatomy was unvaryingly perfect; color, atmosphere, everything that he could learn from the Italians, he would not allow himself to take for granted. As an outsider, he was too much aware of its value. It is as though he carried on his own shoulders the whole burden revealed by the Renaissance, as though he were personally responsible for maintaining the completeness and the culmination of art. There are two styles in Poussin's work. One, represented by the Metropolitan's *Rape of the Sabine Women,* is all intellectual, consciously fabricated, leaving nothing to the quality of the medium. This painting is the work of an esthetic puritan, guided by will, education and a ferocious conscience, held in heroic balance. The other, represented by the liquid *Entry of Christ into Jerusalem* (as to the ascription of which there is some doubt), is full of painterly surprises and a reserve strength showing in inexplicable formal intuitions, as a variation between softness and crispness, and a crazy split between different colored draperies

on the same figure, as if they were at different distances from the spectator's eye. But because one accepts these illogicalities as inevitable, they make for charm and vitality.

The Metropolitan exhibition contains the grandest Poussin in this country, *The Death of Germanicus*, recently acquired by the Minneapolis Institute of Arts. There are also a number of Claude seascapes which indicate the genesis of Turner; but Claude's sea has a restrained atmospheric limpidity that draws you hypnotically into the painting, into its world, as though you were there, by the shore. Turner's speech, when he describes the sea, is as coarse as his perceptions are sharp. Claude intoxicates, Turner is drunk. The conscious side of Italianization shows further in the academic paintings of Le Brun, the Caravaggio-like Valentin, La Hyre's *Adoration of the Shepherds*, with a Bellini-blue sky, and Vouet's mastery of many styles, from his early imitation of Caravaggio in the self portrait, to the graceful lightness and purity of color in the *Three Marys at the Tomb*. These imitations of Italian styles are hardly inferior to their models, and the leadership of art went from Italy to France, notwithstanding the greater genius of specific painters in Spain and the Netherlands. Italian was the language of Europe in the seventeenth century, French in the eighteenth.

But this is half the picture. The other half consists of the bourgeois painters, especially Georges de la Tour and the brothers Le Nain. La Tour's paintings almost all featured an interior light from a candle. *The Woman and the Flea* as well as *Saint Irene with the Wounded Saint Sebastian*, prefigure Balthus. So does *Venus at the Forge of Vulcan* by Louis and Mathieu Le Nain. In La Tour it is the rectangular combination of blandness with something shocking, and the spell-like stillness. In the brothers Le Nain it is a self reliance, perhaps the self reliance of the new managing class, or of persons whose good manners come from natural sensitiveness more than from rules of behavior. *The Trictrac Players* of Mathieu Le Nain looks ahead to Cézanne's card players, and it and *The Card Players*, also by Mathieu, to certain early de Koonings. As Descartes proved existence by his own existence, validated in introspection, so these bourgeois artists proved art by their own practice, validated less by comparison to Italian precedent than within the paintings themselves. Where the aristocratic painters mas-

tered foreign precedent, the bourgeois painters assimilated tradition at a less conscious level to a new naturalism, as thirteenth-century French sculptors had assimilated Hellenism to Gothic naturalism.

Americans have been too little aware of the French Renaissance. That is because, where the Italian Renaissance attracts us with its suggestions of youth, adventure and the opening of new possibilities, the French has suggested to us duty, heroic responsibility, an almost joyless splendor. French splendor had a high price. In winter, in the new palace of Versailles, the king's wine froze at the table. By comparison the Massachusetts Puritans were well prepared for their camping out, and they carried no white man's burden. The French court carried the whole burden of reason, individual responsibility within a Catholic framework, and of civilization. They chose to do so. And this exhibition proves that their *tour de force* was a magnificent success.

Restoration

[*1959*] The Metropolitan Museum is now exhibiting downstairs, along with its other El Grecos, its newly acquired *Vision of St John the Evangelist,* painted at the end of the artist's life for the hospital of St. John the Baptist in Toledo. The painting has just been restored, which was presumably necessary, although Theodore Rousseau, curator of paintings, says that the original paint surface was in good condition. "During its long life, its genuine glazes had not been eroded or damaged, though it had been cleaned at various times. It had, however, been previously restored, and considerable repainting had been done in the process" which showed in a discoloration in the repainted areas that no longer matched the original paint. Every age has its own ideas of the value of the past, and sees the past differently. It is probably not out of the way to say that the present restorers of this painting understand El Greco in terms of twentieth-century Expressionism.

Mr. Rousseau illustrates his article in the June *Bulletin* of the Metropolitan Museum with a photograph of the painting before restoration and with a color version of the

present state. Before the most recent restoration, the values had both more unity and more variety, and the effect of these photographs is that the "before" version was masterly, and the "after" version is an interpretation by a talented pupil. For instance, in the picture as now shown, the face of St. John is modeled from a light tone to a dark tone that makes the dark half separate from the head; the same is true of the darks and lights in his sleeves and draperies, which become a series of lights and darks that do not connect with the figure as a single entity. This criticism holds also for the red drapery at his feet; for the ground, in which substance is lost, making the foremost part a hole, where it seems not to have been so before. The movement of the sky, which formerly had a rhythm and a flow, is now jerky and abrupt. There is a similar change in the lights and darks in the row of seven nudes: the one nearest St. John and the second from the right have lost opacity and that diminishes their physical presence in the rhythm of the composition. The darks are now all more like one another and the lights are too, which reduces the resonance of the composition. There is a coarsening and an emphasis of the obvious.

When one criticizes restoration, one is answered in scientific terms; or, as follows: "Would you want arms put on the Venus de Milo?" Restoration today leans on science and disparages intuition. This has its drawbacks, as well as its good points. It seems to imply that everything is understandable in the way that a proposition in high school physics is. Or if not, then it is suspect. And there is a strong tendency to estimate the value of paintings in terms of what is familiar, to judge the past by present fashions, like the remark of an English critic in praise of the cleaning of the Titians in the London National Gallery, that one can now see that Titian is another Renoir. So this El Greco is shown to be like an Expressionist painting, with the implication that that is one of its significant merits. The flatness, the black outlines, the paint put on for its own sake are qualities that do exist in El Greco, and are like Expressionism. But I doubt that for El Greco the end was included within the means of painting—rather the means of painting contributed towards a whole that was not first of all aesthetic. And if for a modern painter the means are the ends, it is not at all necessary to use El Greco's means rather than, say, Raphael's, as an example. I base my

opinion on what El Greco was from his paintings in the Escorial outside Madrid, which like all the paintings there have retained a freshness unseen anywhere else in Europe. This is a place free from industrial smoke, with a dry climate favorable to paintings. I doubt that they have been restored.

My criticism of much restoration is that, for all its science, it is not artistic enough. Aesthetically the present restoration is less than one could wish for. The eccentricity of El Greco's style actually expressed more vividly than his contemporaries the Baroque that it seemed to deviate from. The restorers see the vividness as if separated from its ambience, and their over-emphasis diminishes this vividness. They make him into a mannerist. A principle of Baroque composition that El Greco exploited is the question-and-answer motion of curved forms against and in continuation of each other. This restoration tries to separate him from the Baroque and place him among the Expressionists.

VI

The Short Review

The Short Review

[*1958*] The members of the Artists' Club speak of their purposes, their integrity and originality. Who is most part of his time? Who is most honest to a personal vision? Relative claims are presented in this spoken art criticism, which is the competitive function of these discussions. An artist says that the critics do not understand him, to which the critic would answer that he does; that either there is nothing to understand or that what there is is inappropriate or immoral according to certain rules; he might say that this is not art. The abstract painters are against representation, which the realists find necessary. There is in all this written and spoken criticism a more or less suppressed implication that other people are phonies and their work trivial. Who is most important? Who most deserves the admiration of other artists and of the public?

A short review is thought to denote small importance: the critic evaluates by the inch. At the Club are discussed the common stupidity of critics and public, and the competition that artists have with each other for attention. This makes for a verbal self-assertion, different from the self-assertion of an exhibition. Artists and dealers are attentive

to criticism, they read what is written. The critic is important to them, and they are sensitive, and on the lookout for slurs. But most published criticism is literary criticism, and it happens that the artist and dealers are most attentive to literary criticism. Editors of avant-garde magazines assert their leadership in the intellectual world, and their conviction of leadership is convincing, or at least very persuasive; and so artists and dealers are much influenced by the philosophical and sociological fashions of the literary critics, and look for guidance there. "Where do I stand? What is my place in the world?"

A review can describe as vividly as possible the quality, the look, and implication of an exhibition. Naturally a reviewer does not like everything and his understanding and taste is limited. But it is his taste that is most limited, and that by education rather than by innate capacity. People in general do not trust themselves enough. A genuine and ordinary reaction to paintings and sculpture, like one's first impression of a new person, is usually very much to the point. I believe that accurate impressionist criticism is the kind that communicates to a reader of a magazine what the character of a painter's work is—a remark of the following sort (de Kooning about Charmion von Weigand's paintings): "She makes little cushions." I do not much believe in criticism of contemporaries that estimates importance, because although some things are better than others, as Shakespeare is better than Shaw, this has too much to do with restricting, either morally, like a minister, or pseudo-scientifically like a social worker; and it makes art and art criticism competitors of ethics, which they are not. Some art has a very open meaning, and can be written about in terms of this meaning; but the chances are that if the meaning is the most interesting thing about it, it does not stand alone, it does not assert itself. It leans on what it means. An implied meaning is richer. And the evaluation of the critic is most interesting when it is implied rather than explicit, because if it is explicit, something is almost unavoidably left out. A review can be at best a parallel creation, its subject being the nature of the painting or sculpture. Criticism creates an analogy, and by examining the analogy you see what the art essentially is. Criticism should tell you what is there. A long criticism may have irrelevant observations, and almost surely lacks the intensity of say, Wallace Stevens' description of Ver-

rocchio's *Colleoni*.* The point is, whether it is successfully done.

Painting and sculpture are made to be seen and touched; they are sensuous things; even if they are about ideas (dramatic, like Orozco), rather than about the sensuous world, still these ideas are sensuously communicated. Realist painting, which has an obvious subject matter, can be most valuably discussed in terms of its form—how and how well is its reality presented? Abstract painting in which the sensuous elements are undisguised and obvious can perhaps best be written about in terms of its subject matter, which is largely the artist himself, that is, his character.

Reviews should be short. Who likes to read art criticism? One likes to read it if it is worth reading, as Ben Shahn said. But this has nothing to do with the correctness of its evaluations; nor with the painting to which it refers; just as it is not what painting or sculpture refer to, but what they present, that makes them worth looking at.

Vuillard, Bonnard

[*1954*] Edouard Vuillard is being shown at the Museum of Modern Art in his first big retrospective exhibition in New York. Along with the exhibition, the Museum and Simon & Schuster are distributing Andrew Ritchie's illustrated book on the artist. Because his fame started early in his life, it is sometimes surprising to learn that he was of the generation of both Toulouse-Lautrec and Matisse. This reviewer does not agree with the usual American estimate, shared by Ritchie, that the early, small arabesque paintings, influenced by Gauguin, were his best. The exhibition seems intended to prove that after 1900 the Symbolist influence began to disappear under a mass of detail. It also emphasizes the indoorish side of Vuillard, "the fustiness of Symbolism" as Georges Duthuit put it. And Ritchie says, "His park scenes have a curious quality of the indoors about them." But this is not true of the landscapes, not included in this exhibition, painted after 1900 in Normandy, and *The Park at Les Clayes,* painted in the '20's; nor of *The Arbor* (1900) which is shown. Another serious

* In *The Necessary Angel,* Chapter I.

169

lack is the oil painting for the fresco *Comedy,* a landscape mural which it would be good to compare with the glue paintings for the Comédie des Champs Elysées.

The paintings in this exhibition which seem to this reviewer closest to Mallarmé are the interiors painted after 1899, one as late as 1910, and *Annette at Villerville* (1910) with details disappearing into the unity of the artist's awareness. In both Mallarmé and Vuillard "the metaphor is detached from the object" as Edmund Wilson put it; their art is concrete in detail and abstract as a whole (which is opposite from Cubism) and the existence of both the artist and what he looks at is doubtful: the narcissist's difficulties about his identity becomes the subject of art. "The Idea is an absence of Idea," says Duthuit. Painter and poet seem to have this atheism in common. For this reviewer Vuillard's significance is double; first, he did what Cézanne wanted to do, made of Impressionism something solid and enduring like the art of the museums, by unifying the Impressionist shimmer into a single object, instead of like Cézanne denying the essence of the shimmer by changing it into planes to express solidity. Secondly, Vuillard was the artist who most profoundly expressed in visual terms the Third Republic. We have not yet caught up with the extreme sophistication of his successes. He is thought of as soft and private. Privacy is also the essence of bourgeois life in France. And there is his sense of humor: on the side of illustration, the Frenchman who reads his newspaper in an environment whose beauty only the artist is paying attention to; on the other side (and related to the problem of identity), a humility or sense of proportion. As his paintings became less "intimate" he gained in his remarkable ability to put together everything before him, including the jar of Vaseline that the Countess Anna de Noailles asked her maid to remove, because "the master is likely to paint it." When he failed, as perhaps in this very portrait, it was—as Bonnard pointed out—that he made jewelry. It is the old women who count, he says, just as for the Renaissance it was the condottiere. Only Vuillard could make a masterpiece that in all superficial ways resembles a magazine illustration, in all ways except in everything. He had a greater range than his contemporaries, with an ability to construct that surpasses the abstract painters, and a diversity of material that the realists have not attained, united by a sensitiveness that

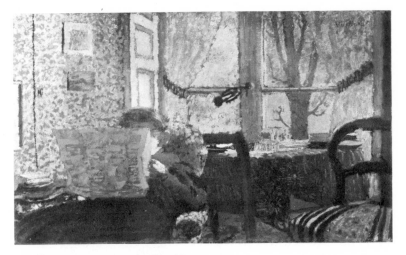

35. EDOUARD VUILLARD: *The Newspaper*

is more personal than that of the Impressionists, and therefore more human.

[*1956*] Pierre Bonnard was more original than he was credited with being. If Cézanne is really the primitive of the way he started, then it is doubtful whether Bonnard does not more truly continue it than Picasso. "The way" was Cézanne's use of color to describe the turn of planes: color is drawing. The Cubists could have learned everything they did from black and white photographs of Cézanne. Bonnard's originality is further shown in his departure from literalism; his spatial organization, esthetically consistent, does not repeat the consistency of actuality—the woman in front melts into recession, a shadow or the sky is palpable. He was intellectual and erotic; he liked to see things in an unusual light; in discussions with his friends he had a reputation for being contradictory and argumentative. The pleasure that his paintings give comes from the love affairs that he observes. Dishes of fruit are not likely to overlap, they are more likely to just touch. A chair back caresses the frame, another the chair rail. His paintings are full of the tenderest tangencies. Or if two dishes do not touch, the table cloth between them is an area to which he pays most at-

171

tention: he searches out the separation with thorough pathos and sympathy. His color has its delights beyond that of Matisse, that is, it holds you longer; because with his interest in "savor," he pays the same erotic attention to colors that he does to relatedness. Unlike Renoir or D. H. Lawrence he did not object to thought, but though he was an intellectual, he had no Idea. He was an individualist without revolt, and his form, which is more complete and thorough than any abstract painter's, comes from his tenderness.

Rodin, Matisse

[*1959*] Rodin was a sculptor whose drawings could only have been made by a sculptor. The reason for this comes from Rodin's painterly interest in the momentary which required him to get the form down so quickly that he had no time to take his eyes off the model, but had to translate what he saw as a sculptor, namely the feel of the modeling, into a tactile language of the pencil. These "blind" drawings, blind because he could not look at the paper, because he could not look at the result, are among the most direct in art: hardly anything intervenes between nature and the drawing. His hurry to get the figure on paper eliminates its relationship to the ground. There is no context beyond Rodin's record. The feet are too small for support (like the feet in Mannerist painting), the hands and heads function only as parts of the figure, the arms are very long; a curved wrist is not seen in perspective, but felt in the dark. He presents the felt turn of the chest, the measured width of the waist; the edge of the body is an imaginary line in so far as it is a real surface; all in tactile disproportion. The eyes are lids, the lids are cuts or wrinkles. Everything turns, but the felt turn is more vivid than the seen gesture.

Sculptors habitually think of their drawings as working drawings, not as ends in themselves; while painters, who work in a two-dimensional medium, have more respect for drawings in themselves. Matisse had both points of view. As a sculptor, he did not always care about the accuracy of his rapid line: the sculpture would fix that. As a painter, he often made patterns and tone of equal interest with the line

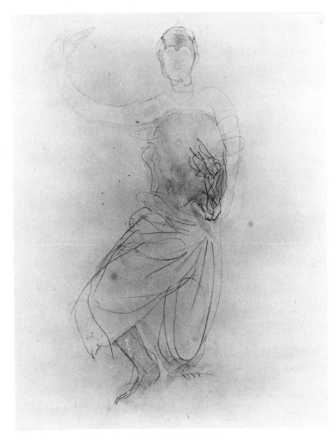

36. AUGUSTE RODIN: *Cambodian Dancer*

that shows a change of direction in the plane. In Matisse's small-size bronzes the scale is not conventionally monumental. The proportion of head to body is about one to six, which means the heads are proportionately large, and heads, breasts and buttocks count as equal; so, too, the arms are often equal to the legs, even upper arms counting as equal to thighs. This makes for an understatement, not of modeling, but of proportion. His sculpture understates the monumental, it understates the heroic. He sees the figure from a mean proportion, neither grand nor petty. This is a peculiar achievement, especially as he is not even a

173

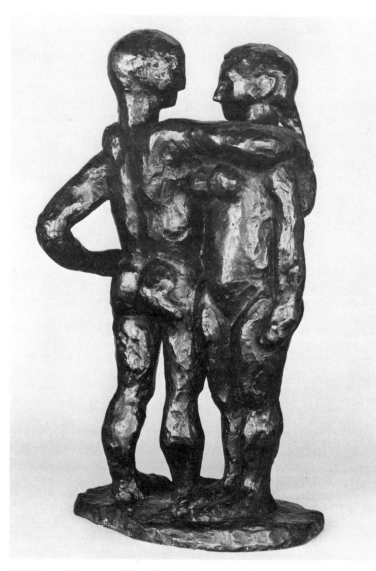

37. HENRI MATISSE: *Two Negresses*

realist like Degas, who concentrated on gesture. This understatement of the human figure in Matisse is like a view of human nature seen in a just relationship to the world as a whole. Matisse says neither that man is small in the im-

mensity of the world, as a romantic might, nor does he say that man is the measure of all things; he says instead that man is measured by all things. He arrives at Classicism from the outside. Thus he loses the grandiloquence of Rodin, and is saved from Rodin's pomposity; he loses the irony of Degas, but is saved from his dryness.

Dufy, Pougny, Berend

[*1953*] Beginning in the 'twenties Raoul Dufy's own style was established, which continued to be such a delight until his death. Though he did not attain the heights that Matisse did, still even after his illness he retained the easy gusto of *The Mediterranean,* 1923, in which a few ships and sail boats, a swimmer and figures on the beach are arranged against the vertical wall of sea. No other modern painter can make blue both so intense and so warm. In Dufy's work the difference between a finished painting and a sketch is slight. To ask why he did again and again what he had succeeded in once is to miss the importance of a pleasure repeated, like orange juice for breakfast every day. His method was to select once, like a caricaturist of the scene, what stands out. Then he did not select again, but made a record, using color and line, and colored lines. His painting and drawing were the same thing. Because of the uncritical, or perhaps unthoughtful nature of his selection, his successes were a matter of performance, like the successes of a dancer or actor. And his training and taste caused these successes to become firmer and to occur more frequently. It is only in his treatment of people in crowds, at the race track, at the yacht club (they seem to hold his interest less than the straight lines and curves of an iron gate), that his weakness is apparent, for it is hard for us to see people as of less or equal importance with things.

[*1952*] Jean Pougny belongs to a tradition of painting which is apparently still alive in France and has not been mastered outside of France. The subjects are people outdoors in parks and on the beaches, done in broken patches of cool mat colors that vary precisely in value (and with minimal chiaroscuro) according to their imagined places. To express

it in another way, the drawing is entirely interior, not a matter of edges nor of modeling, except of the painting as a whole. This relationship of color values is almost all there is to his pictures, making them, though representational, in a deeper and more important way, abstract. Hardly a painter today relies for his structure so completely on color relationships. Better than Prendergast's, these paintings are not all-over pattery, and though they resemble Vuillard's size paintings, Pougny's contain only one rectangle, the rectangle of the whole. Hardly a painter today makes paintings which though so varied inside, are such single wholes. Like a sonneteer, Pougny shows how rich a microcosm can be.

[*1952*] Charlotte Berend, widow of the famous German painter Lovis Corinth, exhibits watercolors made last summer in the Austrian Alps. An Impressionist of the air first, and secondly of light, she is sensitive to the way qualities of air change qualities of light: to the way the thin air of high blue passing above the timber line is more transparent to ultra violet, to the special thinness of mountain fog, and the heavy still heat of the valleys. There is something like Corinth in her round, wet, friendly drawing of fir trees, and something like Marin's watercolors of the 'twenties— a light grey scratchiness in the wash. Her watercolors restore and maintain freshness in a medium that has lately been losing some of its popularity. Such lightness is not easily won; it derives from that grace which is a quality of character, which has to be practiced and truly desired.

Two Primitives

[*1956*] Sophy Regensburg is a deliberate primitive. A primitive paints what he knows, instead of ignorantly what he sees, or as he sees. A primitive accepts prejudice, and this very decision in advance produces its shocks or surprises, for the conceptual clarity does not reproduce appearances, but competes with them, and the appearance of the painting is brighter (when the painting is as good as Mrs. Regensburg's) than the appearance of nature, and it is independent of temporal things like light. It says that reality is a

38. LOUIS VIVIN: *Le Palais de Justice à Paris*

fact. Mrs. Regensburg, who is sophisticated about modern art, is most vivid in still-life, and weakest when she introduces active human beings. Painting interests her, not social or illustrative ideas, and this reviewer does not know of any better primitive painter of today than she.

[*1954*] Louis Vivin, who died in 1936, was described as a "popular" painter, which means unsophisticated and of the people. His work shows a development from *The Farm,* 1880, to the Parisian paintings from the last five years of his life. In the earliest and latest paintings there is an insistent atomization of the countryside into leaves and of the city into stones. The pattern is stubborn and ungracious. It is the sort of painting (comprising some of the best sophisticated painting as well) whose first impact is ugly, but which can grow to look beautiful. With its many defects, it has character. The defects include the cars in *Le Palais de Justice* all of which are stalled, the motion of pedestrians ineffectively expressed by a longer and immovable front

177

leg, the train on the viaduct drawn in a perspective contrary to its direction. His paintings have the quality of their defects. The defects have to do with two contradictory devices that freeze details into immobility. But the odd form has the firmness of masonry. He was innocent of clichés. It is the painting of a man who does not display to you his struggles in life, instead, with ease and patience and very directly, the gnarled effect of these struggles. It is the painting of a strong man who never had time for egotism.

Dubuffet, Klee

[*1952*] Jean Dubuffet at his first appearance seemed anti-aesthetic, like the Dadaists, except that his revolt against art was expressed by means of, and within the terms of, paint. The shock of the impact of these disgusting paintings should have indicated what a fine artist he was. Now either he has become acceptable because we are used to him or because he has himself mellowed. He is as much as ever interested in the earth and in obscene roughnesses of texture. By throwing quality away, quality is what he attains. He has more than enough in reserve and to spare, and he bursts through the division between art and a shameless complete expression of his own sense of life. A downward division gives the landscapes a high horizon; his table tops, seen from above and the side, are like the earth in microcosm. In the heads the outline does not matter much: it is rather a texture of warm blood-filled living flesh. The skin is imaginatively transparent, hence *Ruddy Complexion.* But in pictures like *High Society,* as well as *Natural Histories,* and *Table with a Glass with a Necktie on,* he adopts a childish mischief and wonder, and here Dubuffet the anti-aesthetic comes close to Klee the aesthete.

[*1955*] Paul Klee had a passive appreciativeness toward everything that happened to his material; the paint surface, the texture of the canvas, including a torn edge, which seemed, with humor that admits unimportance, to interest him more than the subject and gradually to replace the subject, insofar as it is described in the title of the painting. For instance, though *Betrothed Couple in the Autumn of Life* shows two

people, still the pleasure one gets from the title is different from the pleasure one gets from the painting alone. His pleasure in surface for its own sake is the aesthetics of a serious dilettante, and it is in Klee that you find the beginning of the contemporary trend toward naturalism about the material of a painting, combined with no subject matter of the old kind. Compared to those modern painters who are in a way his descendants, Klee is better natured and more nostalgic about the past and wittier about the trivial, worn and discarded.

Inness, O'Keeffe

[*1953*] George Inness was a practically self-taught original with a vision similar to that of those present-day Americans who make large textural abstractions. His emphasis was on texture, too, but then he used texture to show an interest in light and air, instead of forms, which seemed to bore him. An orange sunset and the dusty fall, an ever-present haze, the softness of the leaves and grass in which separate blades do not show, sometimes cows, a suggestion of frozen weeds through the snow, hardly a person, or one who is unoccupied or there for an accent, bored and lonely; all these things create an atmosphere of truly American sadness and emptiness. This one kind of light and air with this amorphousness is still an aspect of North American landscape, dominated like the ocean by a gigantic monotony, in which no wave counts alone, but only has significance as a part of the whole.

[*1955*] It has been pointed out long ago that Georgia O'Keeffe is a realist, and what made this statement original at the time was that it was made when she was painting abstractions. Now that she is not painting many abstractions, it may be valuable to point out the abstract quality of her realism. This quality comes somehow in the blandness and precision of her surfaces which is a quality less of the outside world than of the mind of the observer. As Marin's work was a preview of the New York School, so O'Keeffe's gave us the first examples of the "Californian" school. *From the Plains,* which represents a huge expanse of red

and yellow sky, and which is only the latest of a series beginning in 1919, has the scale of emptiness and Romanticism that is seen in different ways in the work of such native Westerners as Still and Reinhardt. And her division of space in *In the Patio* has in it some of the design of Rothko. These painters may or may not have been influenced by O'Keeffe, but she did come first, and our present familiarity with these painters should help us to see O'Keefe's work freshly again, with its sense of the immensity of space.

De Kooning

[*1955*] Willem de Kooning's work is full of paradox. First, there is the discrepancy between the extent of his influence, and his relatively few one-man shows, of which this is only his fourth. The *Pink Woman,* dated 1943, in pink and greenish-blue, has a quattrocento look. In the 'forties, when he especially admired Ingres, painting was for him a matter of color-value relationships. In the later paintings, in which critics have seen a connection with Delacroix, the texture contributed by the brush, and drawing especially, predominates: color values count for less, and often the areas of thickest paint are transparent and insubstantial. The paradox here is that he seems to have gotten from Ingres an appreciation of color, and it is as if Delacroix's influence led him to demonstrate Ingres's dictum that "what is well drawn is well enough painted." His spaces are most substantial and fullest when he is able to use bare canvas, or flatness: it is in the most "painterly" pictures that areas of thick paint and strong brush strokes look as though he were unsure of how to bring the painting to the frame, as if the painting had stopped before he could let it go. To this reviewer, the energy in the large abstraction is not concentrated, and its roughness does not communicate strength. One often hears the complaint that his figures of women are monstrous in their distortions, which leads to the paradox that it is when his distortions are most twisted that he makes the most vivid similes between women and the commonest beauties of nature, like those in the song of Solomon—not just *Woman as Landscape,* but also *Marilyn Monroe,* like a peony, or *Two Women in the Country,* like

a garden of tulips. Here is that shock or surprise that is so often the sign of original creation.

Leslie, Ferren, Schueler

[*1952*] Alfred Leslie, born in the Bronx, worked as a model since he was fourteen and later as a professional hand balancer on the stage. After the war he studied art education at New York University. His first one man show presents a fresh, romantic, reckless expressionism—romantic be-

39. ALFRED LESLIE: *Christ the Door*

cause his paintings seem violently revealed. Three enormous paintings are on unsized canvas, one is on masonite and many oils are on paper, some made of scraps stapled together. *Christ Dead,* 6 by 7 feet, has an original asymmetrical decorativeness, with a horizon slanting down a little to the right dividing the painting into two equal sides, the top white over orange, the bottom black, with the white body of Christ slanting a little more steeply, and a green head. Or is it abstract? It is all closed in, making the simple white top half equal the weight of the bottom. One portrait has colors (and color). As none of the predominantly black-and-whites have "that grey that is the enemy of good painting," they seem also to have color. A case could be made for these paintings as being "a return to nature" in the sense of a new directness that makes much vanguard painting seem tight and prim by comparison.

[*1953*] John Ferren exhibits non-objective and abstract paintings all of which look as though they were about nature. These pictures are as much concerned as Monet's with what the eye sees, the difference being that Monet went outdoors

40. JOHN FERREN: *Untitled*

and looked and painted, while Ferren goes outdoors and looks and remembers, too, while he paints. He synthesizes memories and perceptions and uses flashes of intuition, projecting them in a flash of paint in which the touch counts. Some of the paintings done in the woods in California contain shapes of vegetable growth, some rather suggest them, and the latter are the more naturalistic. When nothing can be surely identified is when nature is most surely there, as trees, or stones, or flowers, and it is there just as surely as it has been well translated into a language of paint, and is there also as paint, with the character that only paint can have. What makes these paintings good is the same thing that makes any so-called realist paintings good—the very slight and very important difference between a developed dexterity and a lack of this quality. Perhaps the most concise name for this quality is maturity.

[*1957*] Jon Schueler studied in California under Still. His show is dominated by a huge triptych, *A Walk in the Country.* In the center panel, the largest, the yellow sky is just a strip above a mound of rust and dark blue dust in the middle; the leaves, the dust, the complicatedness of nature remembered as a sensation more than as a sight, nature as it smells to people absorbed in each other or to one person self-absorbed on a walk. It is nature in the autumn, when nature obtrudes, when it forces itself on your consciousness not as an object of admiration but as a process that interferes (you have to rake leaves); one side panel is called *Yellow Sky,* which is what it mostly is. His other paintings also have much to do with the piling of detail independent of oneself—an answer to Coleridge's inability simply to appreciate—"I see, not feel, how beautiful they are." Whether it is beautiful or not, it is really there. His subject is nature as a challenge: storms, a river, a lake, an island; not human, not garden-like, nor even necessary in the phony way of the Romantics. His nature has not yet been assimilated, he respects it and he is not so vain as to be sad about it.

41. LEON HARTL: *Flowers*

Hartl

[*1958*] Leon Hartl, who was born in Paris, was trained a dyer and
has lived in America for more than forty years, is, for
some painters, very much of a painter's painter. He
doesn't fit current American categories. The lack of nega-
tive elements in his sweet subject-matter, which shows only
the prettiest aspects of landscapes, still-lifes, and girls,
goes against the grain of the existentialist cult of sincerity
that values violence, ill-adjustment and awkwardness. It

also goes against the grain of those who think of art before they think of painting. He invites the disapproval of those intellectuals for whom "pretty" has a pejorative connotation, and who may admire in, say, Arnold Friedman (whose work it is relevant to compare to Hartl's since there is a superficial resemblance between the two) the sour color, repetitiveness and insistently inaccurate line. Hartl does not give himself away. Private emotion is presented in its public aspect. He is not like those abstract painters who are interested mostly in nature, or in the subjective nature of the subject. For Hartl, the subject has the importance that the canvas has, it is a background for making a painting. He takes the subject for granted: it is his occasion. He is not romantic. Therefore his painting is "pure" (but not academic). Hartl's occasions are appropriate to a society without hierarchies, for they are the public (and common) aspects of private enjoyments. He uses Seurat's Pointillism esthetically, which Seurat did not entirely achieve, not having lived long enough to take his own manner for granted. More than other paintings today, for a painter, Hartl's paintings are supremely about spaces and volumes expressed in the colors and textures of paint. Their double appeal, both extremely professional and very ordinary, give them a quality of endurance.

Freilicher, Kahn

[*1952*] Jane Freilicher is a young New Yorker with an M.A. in art education who has taught primary-school children. This is her first exhibition. The weakness of traditional painting in America is that it is also provincial and imitative. If the painter avoids this he may become eccentric and shallow. Jane Freilicher seems to be trying to rediscover first principles. Her painting is traditional and radical. She is consciously imitative of the masters of the Renaissance, but in a first-hand way. Nature is what she is, perhaps more than what she sees. When she paints a reclining figure, she may lie down to see how it feels. Her models include along with the outside world, art and herself. These paintings are broad and bright, considered without being fussy, thoughtful but never pedantic. The subject may be immediately obvious, or, as in *Figure on a Bed,* at first sight apparently

something else. Reading from the top down, the figure looks like clouds in a greenish-blue sky, the bed like the opposite banks of a river landscape, the floor and dog below like the river and near shore. Though this double image

42. JANE FREILICHER: *Early New York Evening*

43. WOLF KAHN: *Dead Bird*

may not be intentional, it adds to one's enjoyment, as the underlying depths in a friend's character makes the relationship richer. When, as in *Football,* she has to choose between the life of the painting and rules of construction, she decides to let the rules go. The articulation of some of the figures is impossible and awkward, and though this is a fault, it is a smaller fault than murder.

[*1953*] Though her new exhibition shows an advance in skill, this advance is not at the expense of her love for life that grows as fast as her control. The clumsiness, the blunt puppyish forms remain and mean what they meant before—a deep affection for all bumbling things.

[*1953*] Wolf Kahn was born in Germany and studied here under Hofmann. He teaches shop in a private elementary school. Because of the high quality of his landscapes, imitative of

the manner but not the feeling of Soutine, previously seen in group shows, the excellence of this first exhibition of energetic, sometimes wild and always genial drawings, watercolors, pastels and oils comes as no surprise. Everything is first-rate. The Soutine manner is giving way to a more generalized French manner. Though an influence from France is practically universal, many painters seem to wish to be superior to it as quickly as possible. Probably Kahn started with the same happy pleasure in color and light that delighted the Post-Impressionists, and so he studied these things very hard, with an unusually successful result. His pink, violet, orange and green paintings made in various parts of the country do not indicate that he pursues picturesqueness. He was in these places for other than painting reasons, and painted what there was. And being the sort of man he is, the deadness of his dead birds and fishes is an entirely unimportant fact about them.

Noguchi, Armitage, and Kohn

[*1954*] Isamu Noguchi shows ceramics made in Japan during the summer and fall of 1952, along with sculpture that has been seen before—stone and wood carvings made in this country. This makes it possible by comparison to assess the growing Japanese influence on his work, which to this reviewer looks like a happy one. For one thing, working directly as he did, and working with Japanese clays in the regions where they are found, the vases, plates or figures have the spontaneous and improvisational character of sketches; he has had to work fast and second thoughts were ruled out. For another thing, he seems to have gotten away from the Western artist's concern about the place in the world of what he makes. His objects are his surroundings quite literally. There is no nonsense about use of objects because apparently in Japan art does not exist apart from life, but is a form, a ceremony of daily existence. He says of things that could be considered flat dishes, "sculpture may lie down." The vases do not have to have water in them, they do not have to contain grasses or flowers. There are frogs and centipedes and Japanese figures expressed in the terms required by the language of curved sheets of clay, that have an ease, grace and appreciation and respect for the earth, for the mineral as well as animal and human

44. ISAMU NOGUCHI: *Dish*

world that this reviewer has not seen in modern Western
ceramic art, including Picasso. All the careful calculation
that was needed in his stone carving has turned into some-
thing that, because it includes and admits and loves actual-
ity instead of an ideal, has an elegance that is of the sort
that is looked for in what passes for perfection.

[1954] Kenneth Armitage, well known in England and to collectors
here, has an English unconventionality toward the lan-
guage of a plastic medium. As Turner had the originality
to make light instead of space the material of painting, so
Armitage thinks of sculpture not as volume, but as space.
His sculpture is like a bas-relief seen from all sides. Much
modern sculpture following (but excepting) Gonzales is
concerned with space before volume. However the other
moderns use their lines to define an empty space, while

189

for Armitage the spaces between, made of curving sheets of bronze, are what is most solid. His space is also that space found in English domestic architecture and gardening, as well as in Turner—a matter of internal organization, of something the spectator is inside of instead of something he contemplates; a matter of sequences instead of limits. It is like the drowsy feeling of not being quite sure of where, under the sheets, one's feet are. De Kooning remarked that all the space he needed to know was where his elbow was. Armitage is not quite sure how far away one thing is from another. This is the cause of his distortions. His membranes are not stretched, for this would mean certainty. And uncertainty, too, perhaps more surely than certainty, can lead to truth. His knowledge is ambiguous and poetic. And his subject as well as his point of view is English: like a family going for a walk, the wind, listening to music; an Englishman's seriousness about daily life.

[*1959*] Gabriel Kohn's sculpture is made of heavy carpentry planks doweled together. They could be assembled from building blocks for a Brobdingnagian child. One sculpture ends in a shoe-tree-like shape. Another is a cradle for a giant twig. The largeness combined with bland good workmanship and polish contributes to an air of clumsiness like that in a child's room not yet picked up before bed time. A child makes a man out of blocks, and so does Kohn. There is something figurative about many of these constructions. The balance of huge pieces, tipping, accurately fastened one on top of another, makes their fascination, and is the reason why the child wishes to keep them overnight, and why the logic of art dominates the logic of neatness. They insist on their precedence over the convenience of the cleaning-woman. When one is a child dominated by adult-imposed routine, the block constructions must be disassembled every night, but when one is grown up, the even larger constructions are fixed together, and it is sculpture, and it dominates you.

Lichtenstein

[*1952*] Roy Lichtenstein, a young newcomer who teaches at the University of Ohio, shows a group of semi-abstract, hu-

morous, unpretentious, easy paintings. The subjects, *Death of a General, St. Macarius before the Monastery* (from a Russian icon), *Bronco Buster, The Death of Jane McCrae, The Knight, Indian Mother and Child, Her Hero* (who is also a knight on a horse with a humanoid face), imply the diverse interests from scholarship to folk art and folk humor of a young intellectual. *Very Important Person* is a self-portrait as a knight. Rich earth reds and browns predominate. Black is used as one of the colors. There is the clayey quality of direct oil paint. He spreads one flat color next to another and lets it alone. It always works. He does not force the textures nor torture the paint: when a roughness appears, it is in the right place, as though he were unfailingly lucky. It almost seems that he has done it all before, in another life perhaps, so that now it is no trouble at all. He is a natural.

From the Short Reviews

[*1951–1959*] Clay is the original medium: as Freud pointed out, God made man of clay.

Apparently a drawing by definition is either (1) on paper, or if not on paper, then the medium is (2) not oil, or if it should be both oil and on canvas then (3) it must be monochromatic.

Skin is as like sky or wall as wall or sky are like each other or skin.

A metaphor is small, while an ambiguity may have no clear limits.

It may be less an augury of innocence than of sophistication to see the world in a grain of sand. When one is pleasantly dazed and blinded by a day in the sun, the scale of the sand and the little things in it loses its first value, and one doubts whether this is the beach or the Sahara.

It may be that to separate pleasure from an object is too hard a thing to do, and that abstract pleasure, like abstract taste or abstract love, is not for ordinary mortals.

In any made thing a repair that is thoughtfully done adds a pathos that a new object or one that has fallen into disrepair cannot have.

Discipline is sweetened by compromise.

The value of conservatism is in direct relation to the sophistication of the artist.

It is as though when he painted, his influences were polished windows giving an extra clarity to his vision.

He cares about indifference. He is fanatically cool headed.

His light shows why Impressionism began. At a distance across the room the color vanishes, and what remains is tone.

He has a certain red that has the airiness of blue. (This is something that occurs in flowers.)

They have presence, though nothing stirs and there is no sound; they have the aliveness of mushrooms.

Probably this aesthetic passivity and respect for the nature of the woodblock, familiar in the West since Klee, originated in Taoism, whence it came to Japan, then to France and America, and now back to Japan again.

The close connection between writing and painting gives Chinese painting on one level a very abstract look; for the characters are no longer pictures and the pictures are not yet ideas, and both are made of similar kinds of marks.

In African sculpture, though we may not know the beliefs that animate it, there is conveyed to us the power of the belief, which seems more satisfying than much Cubist sophistication.

The fixation of a style is certainly one of the essentials of Byzantinism.

Piranesi in the eighteenth century is more deeply nostalgic even than Klee in the present.

Boucher and Robert with their developed conventions were not bothered by doubts about reality.

Perhaps in all English painting that goes directly to nature, contour is emphasized, for contour is the last thing to disappear in a fog.

Gainsborough used light, Raeburn had a conscience about it. Lawrence summed up Raeburn to make light a means again. Turner created the light of the world, a light without shade.

At his best Copley surpassed his British contemporaries with a clarity that sees below convention. At his worst he was wooden and muddy—he was a native of a colony founded by men who believed in individuality and were opposed to distinction.

American nineteenth century landscapists present something over which they have no control and for which their artistic training seems to have been inappropriate: a hostile or indifferent world rather like the colored pictures one sees today in magazines of encampments on the moon or Mars.

Raphael Soyer is interested in a certain kind of reserved, shy and rather proud young person who appears in variations of facial type, from the sad to the resentful.

In Cubism color expresses neither light nor matter but an incomplete consciousness of in and outness, where motion is across the surface like reflected light. (Reflected light is light at second hand.)

Kandinsky's logic is external—his Expressionist paintings show no helpless urge—and he was finally at his best when he contrived most thoroughly.

The German flag colors seem to have crept into everything painted around 1914.

A Picasso drawing differs from a Picasso painting chiefly in that it takes him less long to make it.

Picasso's humor is composed of parody (including a parody of art) and cynicism.

Léger's reserve force is the alibi for his inattention.

Ensor was terrified by calmness before cruelty; by the fact that the scream makes no impression.

In Arthur Dove the earth and air and water are jellies of different consistencies, with a possible minimum consciousness.

O'Keeffe is an artist whose smallest detail seems to refer to a nirvana where all distinctions vanish.

In Moholy-Nagy there is no quality except the quality of order—the picked up desk.

Kay Sage has a disturbing ability for making nothing look like something else.

In Kenneth Hayes Miller, dustiness takes the place of shade, and glassiness of light.

In Vlaminck, the charm of the slippery, broad knife stroke and the acid brown skies look like energy and have passed for dash.

Severini's paintings that employ the Futurist devices for showing motion uses the fact that lines not parallel to the frame move against it, as lines not parallel to each other move against each other. There is little more to it than that.

German twentieth century painters use modern mannerisms for stale ends; they come in beyond the limit of the painter's imagination, like burnt porridge.

Though Franz Marc summarized all the separate details, he left none out, and there are as many too many boring parts as in the production of the most abject realist. Black and blue, green and red, all look alike, they cramp each other's style, like brothers at the same party.

On playground sculpture: This is all very well, but isn't it a little sentimental to suppose that the ecstacy of swinging is enhanced by such a kid-stuff setting?

The feeling of travelling through the country in a car takes precedence over the feeling of the country that one gets when one stays a while in one place. Perhaps this is a modern kind of sensibility: what we see is moving past us, and what is relatively still is the motion itself.

These paintings represent the sort of thing that for an Easterner is wrong with California. The streamlined improbable trees, like eucalyptus trees, have no character. The colors are bright and without savor. The weather is dramatic, but no one has to cope with it. Each painting is like a stage setting ready for actors who have confidence and health but no feeling.

The faces in *Faces* all have an archaic pout, as if the heads from an Italian sketchbook accepted only sullenly their reappearance in the twentieth century.

There is a *Woman* with an aggressive face and scolding swollen tongue, like a drawing of teacher by her most talented and rebellious pupil.

The profiles of the watchers in *Yacht Race* have the innocent seriousness of people for whom fun is no release from tensions never felt.

About *Grief,* a nude in grey and white, the Red Queen might say to Alice: "I could show you grief compared to which this would be elation."

The Edge is the edge off which, if you have not fallen through before you get there, you finally fall off.

VII

Portraits of Americans

Homer

[*1958*] The name Winslow Homer is like the name of a nine-
teenth-century New England farmer: the Christian name,
which is personal to him, is a family name, unspecific and
anemic. The last name suggests the Greek Revival. Such
Yankee names disguise individuality under anonymity.

Homer's training was as proudly deprecatory as his name.
After three years' apprenticeship to a lithographer, he never
again, he boasted, had any master, although he did briefly
study drawing in New York and Brooklyn when he was
already established as a successful magazine illustrator. He
is quoted as having said that the only way to learn to paint
was never to look at a picture. If he had in mind the pic-
tures one could see in New York and Boston exhibitions,
this was a good enough rule, because it meant avoiding
looking at paintings that, like second-rate literature, were
composed of official and conventional sentimentalities. Or
the theatricality of the landscape painted by the Hudson
River School contrasts painfully with the meanness of the
artists' personal gesture. And Homer's total body of work
was also like his name: an ashy surface that did not quench
nor entirely cover his burning originality. The drama of his
more official paintings is not in the painting, but in the

disastrous story they tell. *Fog Warning, Eight Bells* and *The Fox Hunt* (in which a fox is pursued over the snow by crows emboldened by hunger) are about terror and danger in nature. *On a Lee Shore* implies danger to the schooner sailing past. The sea pictures painted in the last half of his life at Prout's Neck, near Biddeford, Maine, show more than the surface form of the sea; they represent, in a way no other painter quite did, the inevitable motion and force of tons of water against the rocks. The individuality of art is disguised under the anonymity of nature.

When these paintings do not quite come off, it is not only because of the overwhelming corniness of the storytelling subject, but also partly a technical matter and partly a result of Homer's lack of artistic background. Technical difficulty was the rule in the nineteenth century. The American Revolution verified the nonexistence of any traditional system on this continent. It also verified the physical break with the European background. Colonialism had stimulated Copley (and Madison, and Jefferson), but when Allston came home, he stopped painting. Morse gave up painting to invent the telegraph. The end of Colonialism meant also the end of the social system that gave painters patronage. To Allston, being a professional painter meant identification with a tradition that didn't mean anything in Boston. For Homer, as for Whitman, to be trained as a professional meant to be trained as a reporter: journalism provided patronage, background and function.

Homer began as an illustrator for *Harper's Weekly* in 1858, and during the Civil War he was their artist-correspondent at the front. During and after the war he made paintings from these drawings: he started painting at about the age of twenty-seven. These paintings are tight and conscientious: he is concerned with impartial accuracy of appearance, and this remained his conscious aim all his life, for at Prout's Neck he said that he wanted to paint nature exactly as it appears. In painting, as in drawing, he was a reporter. There was no art beyond that of a reporter. These prosaically literal early paintings are no less bright than his later oils; they do not seem to have faded or cracked. They are rather uninteresting, but not from technical failure, but because, having no artistic background, he let his conscience be his guide. An American Protestant, who has no experience of art, and consequently no artistic standards, finds his artistic standards in what to him is clos-

est to art, and a little less strange, namely religion. (Perhaps this is also the reason why esthetics is often confused with ethics in America.) He fills the artistic gap with a humorless attention to boring detail. He paints as if he were Abraham Lincoln walking miles to return three cents change. The weakness of these paintings is that they are based on the naïve belief that art is rational, and that this rationality is not visually based. *October Evening,* 1865, is one of Homer's first paintings with light as the subject.

In Europe the French Revolution separated the nineteenth century from the past. In America the Revolution separated this continent from its past, but the difference was that the American separation was not only a matter of ideas, but verified a geographical displacement. The monuments of European history remained around the Europeans, as Classical monuments remained in Italy at the fall of the Roman Empire. In Europe the pre-Revolutionary social structure partly survived the Revolution, but in America there never had been any to survive. The American Revolution established, among other things, the unprecedented nature of the artistic profession. In order to understand different ideas, an American artist had no artistic prejudices to overcome. His lack of background was a potential source of strength as well as weakness. The extraordinary thing about American nineteenth-century art was not whether it had merit—the extraordinary thing was that there was any at all.

The Industrial Revolution is at the beginning of Homer's career, here and in Germany, and it went on with equal intensity in both countries. But the Germans were not geographically displaced as were the Americans in the seventeenth century, and pre-Industrial ideas survived to influence those Americans who studied in Munich. They brought back artistic values that closed their minds to Impressionist and Japanese influences. Homer did not study art in any school, and so in his ignorance of any standards, it was perfectly possible for him to be open minded about new movements when he visited Paris in 1867.

In the introduction to the catalogue of the retrospective exhibition of Winslow Homer at the National Gallery, Washington, D. C., Albert TenEyck Gardner proposes the theory that, although all previous writers maintain that Homer was unaffected by his Paris trip, on the contrary, he was influenced both by the Japanese exhibition at the

Paris Fair of 1867, and by the controversy that was raging over the paintings of Manet. Gardner maintains that his Paris trip was the most important event in Homer's life. Certainly after 1867 his paintings have a light and an asymmetry that they did not have before. The beach and country scenes of the late sixties, seventies and eighties were the best oils he painted. And they are the most masterly oil paintings by an American of this time. He had the advantage over Eakins of not having received any artistic ideas from his education that were inappropriate to the audience. He did not need Eakins' strength to persist as a painter. Eakins had a terrible and life-long struggle with the values of industrialism. His social impulses were so strong that he was just able to maintain himself against an inner doubt that he should have been a scientist. His career was a long argument to prove that art is not inferior to science. The academicians trained in Germany withdrew into an isolated world of sentimental artistic values, but Homer's sentimentality came from journalism, not from art. Homer did not have to withdraw like Ryder into an esoteric world of idiocy. He did not have as much native talent as either Allston or Whistler. But at the beginning of the century Allston succumbed to the indifference of his environment, and at the end of the century Whistler was an expatriate. Homer compares to Whistler as Mark Twain compares to Henry James. There was always something unsophisticated about him. His best work is unique and raw.

In 1875, Henry James, reviewing an exhibition of the National Academy, wrote about Homer: "He has chosen the least pictorial features of the least pictorial range of scenery and civilization . . . and to reward his audacity, he has incontestably succeeded. . . . Mr. Homer has the great merit moreover that he naturally sees everything at one with its envelope of light and air. He does not see in lines, but in masses, in gross broad masses. . . If his masses were only sometimes a trifle more broken, and his brush a good deal richer—if it had a good many more secrets and mysteries and coquetries, he would be, with his vigorous way of looking and seeing, even if fancy in the matter remained the same dead blank, an almost distinguished painter. . . it occurs to us that the best definition of Mr. Homer. . . would be, that he is an elaborate contradiction to Mr. La Farge. In the Palace of Art there are many mansions!"

As Gardner proposes the theory that Homer's trip to

Paris was a most important and liberating event, so I think that the retrospective exhibition at the National Gallery demonstrates further that his best oil paintings were painted while his memories of France were still fresh. He had helped found the American Watercolor Society in 1865. After his return from England, and after he was finally settled at Prout's Neck, a split widened in his work between the anonymous and official oils painted for exhibition, and the natural and personal watercolors painted for pleasure. Castagnary, writing about the Salon of 1868, had defined naturalism as a liberating force. "Naturalism, which accepts all the realities of the visible world and...all ways of understanding these realities is...the opposite of a school...it suppresses all barriers...it says to the artist: 'Be free!' " The oils of which Homer painted only two or three a year in the last third of his life, grew dustier and greyer. They either tell stories, or they are abstractly naturalistic—about the weather, about the waves, like recent Californian non-objective paintings. In these oils he presented to the world the ashen cover of the fire of his originality, which, however, burned openly in the watercolors that he painted more and more and that he preferred to paint. His watercolors are carved as if out of obsidian in the blue-black, knife-like light of the American east. They are his most Japanese performance. He saw more deeply into the peculiarity of Japanese art than Whistler did, who used what he found there to create politely sarcastic decorations. Under Whistler's hands, Japanese asymmetry became damp and wooly. Homer emulated the elastic, steely materialism of the Ukiyo-e school. It is as though Homer combined Ruskin's science with Hokusai's empiricism. Prof. Arthur Pope believes that even the watercolors of canoes in rapids and of sailboats heeling over in the wind were painted on the spot. The intense and speedy attentiveness that this required carried him beyond himself: the discipline gave them life. Compare the oil *Breezing Up*, 1876, with the watercolor from which it was made, *Sailing the Catboat*, 1873.

There are no holes in Homer: his failures are ones of inappropriate interest—the sentimentalities of ship and weather. The fact that he finally concentrated on his watercolors showed that his instincts were a painter's. With the confidence gained from successful selling, he almost let "exhibition" painting go. But he never gave it up com-

pletely. The split between his instincts, that expressed un-controlled by thought and compressed by the necessity of speed and exclusive attention, the radiance in the world exactly as it is; and his conscience, which expressed a false notion of his social role, widened, until he almost, though never quite, accepted the role of being entirely, and without apology, a painter.

Sargent

[*1956*] The Boston of the end of the nineteenth century was created by Sargent as an Anglophile Boston that considered itself a province of London, while Copley's colonial Boston, created one hundred years before, was an alternative London, the London of the complete Puritan Reformation.

John Singer Sargent's ties to Boston, his warm feeling for it, must have had a great deal to do with the Anglophile aspect of Boston, which felt itself to be (and with some justice), certainly the equal, and possibly the superior to any other American city as a capital of culture. The Bostonians who admired and lionized Sargent identified themselves with English civilization: they had no awe of France. They were like the Dormer family in *The Tragic Muse,* who in the beginning of the book, being at an exhibition of the Paris Salon, make comparisons between French and English art to the advantage of England and the disadvantage of France. In Boston there may have existed a small climate of opinion as to artistic standards that did not exist in New York or Philadelphia. Neither Eakins nor the Hudson River School expressed any generally held standards of quality: both fought, rather, against a general indifference to art. They succeeded or failed in asserting themselves in an indifferent environment. In Boston, Winslow Homer succeeded in asserting himself. Sargent had sophistication, along with a very deep modesty even to a lack of sufficient conviction about his own abilities. He was hurt by French criticism, but he was a friend of Monet. Mary Cassatt, who identified herself with French art, criticized him severely and she is reported to have said that Monet remarked, "Sargent is a good fellow, but when he lunches with me, I do not talk painting." (*Sargent est un brave type, mais quand il déjeune avec moi, je ne parle pas la peinture.*) He was an early admirer of Velázquez and El Greco.

201

Sargent was born in Florence. His first visit to America was in 1876, when, at the age of twenty, he came with his mother and sisters to the Philadelphia Centennial Exposition, especially for the purpose of establishing his American citizenship. His father's father, a native of Gloucester, Massachusetts, moved all his family to Philadelphia in 1830; and his father after a short and successful career as a surgeon in Philadelphia was persuaded by Sargent's mother to retire permanently to Europe, where they never acquired a fixed home, moving every year from Rome to the Riviera to Switzerland and the watering-places of Germany. When Sargent was twelve and thirteen he worked in the studio of Carl Welsch in Rome; when he was fourteen he studied in the Accademia in Florence, and when he was eighteen and nineteen, in the studio of Carolus Duran in Paris. When he returned to Europe after his first American trip, in the same year, he showed his first painting in the Paris Salon, a portrait of a friend and neighbor in Nice, Frances Watts. At the age of twenty-one he showed for the first time in America, at what was to become the National Academy in New York. At this exhibition, Whistler, twenty-two years his senior, also showed for the first time in America. Whistler had met Sargent in Venice three years before, and Whistler's encouragement helped to decide him in favor of a serious painting career. In 1884, because of French criticism, he took up permanent residence in England, moving into Whistler's former studio; and he kept this place all his life. He did not see Boston until 1887, when he was thirty-one, when he again came to America, this time to paint a portrait of Mrs. Henry Marquand, the wife of the president of the Metropolitan Museum. In 1890 he was engaged to decorate the Boston Public Library; in 1916, the Rotunda of the Museum of Fine Arts; and in 1923, the Widener Library of Harvard University. These murals were mostly painted in England, but he made the sketches from models in Boston. His ties with Boston were ones of friendship more than family: he felt at home there.

The self-portrait at the age of twenty-one is as good a portrait as he ever painted: it is very thin and apparently has its original freshness and clarity. There is a sort of abortiveness about Sargent's career; his success was early and thorough, but it did not go to his head, instead, it was as if he knew better. He always felt like an American, not one of the Europeans whom his parents admired so

much that they left their home in order to live among them. He refused a knighthood in 1907 in order to keep his American citizenship.

His painting was full of discarded potentialities. When he forgot himself in the unseriousness of some work that he may not have considered important to do, as in his oil sketches and especially in his watercolors, truly called dazzling, then his abilities showed themselves. What he did in these "minor" works was to present the light as no one had quite done before. The weakness of these paintings is their lack of form, which is like a lack of point, or of belief. It is as if you could say about his most dazzling painting: "Yes, it is amazing, but why do it, what is the purpose?" They are not part of anything—his sophistication made him aware of excellence but gave him no goal, his personality no shape, and his life no helpless mad direction. He was too sensible for madness and too modest to make the sort of artist that was implied by his dexterity and accurate vision. These minor works are full of a light that exists in no other paintings. Other Americans, such as Homer or Hopper, have a light in their watercolors, but it is not part of the terms of the painting; it is incidental to something else, such as the weight of water or some architectural comment. The Impressionists' light is subsidiary to their theory of color or of light, it is subsidiary to form, it is an artistic light, not light in itself, the light of nature. Their light is light interpreted. Sargent's light was one thing he understood and could give you his feeling for. And if you compare the best Sargent portrait with the best of Mary Cassatt you see that she had a conscience and sentiment, while Sargent had talent and was lacking in sentiment. His absence of sentiment made him a caricaturist, as a parrot may caricature, and it was this that made people say that it took courage to have your portrait painted by Sargent.

It was his lack of sentiment plus his absence of form that made him a bad mural painter. The sentimentality and the feeble form led to Berenson's comment that the murals in the Rotunda of the Museum were "very lady-like." The charcoal sketches have his light, the finished murals, without this quality and without his bravura, have nothing else to recommend them. And they were what he considered his most important work. It is the same with his portraits: the important ones are the deadest. In them the light loses its luminosity, as in the portrait of Mrs. Gardner which is

the last of nine attempts, eight of which failed; and his weakness with the sense of the whole shows up in the shadows in the painting of the Boit children, that fill in spaces between flashy details. This weakness was not present in the self-portrait at twenty-one in which the whole painting, both the lights and darks, has his luminosity.

In the 1920s, when Sargent was despised by vanguard critics who, probably basing themselves on Bell or Fry, thought of "form" as the most important and essential quality in art, it was pointed out that Sargent's paintings were full of empty bravura, passages of "just paint" which expressed no depth, no third-dimensional reality. These passages, in addition to his light, are the parts of his paintings that retain some interest—and especially today, when the American style of abstract painting is based on a formality (or informality) which is less three-dimensional than expressive of the nature of paint, or derivative from it. A passage of drapery in a Sargent portrait or a scratched background in a Sargent watercolor relates to certain American abstract painting more closely than do Cézanne, Picasso or even Monet. The abstractions of Franz Kline, for instance, have a quality of light that has not existed in painting since Sargent, nor did it exist in Sargent's contemporaries who resembled him most closely—Zorn or Boldini. It is as though contemporary American abstract painters had at last justified those potentialities of Sargent's which he was himself unable to believe in, because there was no place for them in the Boston-English world which tolerated painting, not for the sake of art but for the sake of the graces and refinements of an upper-class life.

Prendergast

[*1966*] Maurice Prendergast (1859–1924) was born in St. John's, Newfoundland; when he was two years old, his father's business failed, and the family moved to Boston. At 14, having completed grammar school, he went to work in a dry-goods store, and later was apprenticed to a painter of show cards. By 1883 he was supporting himself lettering show cards, and he spent his free time sketching cows and landscapes. All of his life was associated with that of his younger brother Charles, who also became an artist, but

whose chief interest seems to have been Maurice's career.

During all of Prendergast's lifetime, and until the end of World War II, an artist's position in American society was anomalous. But Maurice Prendergast's painting had an anomalous position within this anomaly. Like other painters, insofar as their work was not applied to illustration or advertising, he stood outside of society; but further, as an observer, an appreciator, it was as though this outside position was the only and obvious one for a painter to have, and in this position which he accepted uncritically, he worked within the field of sensibility, directly, like the French painters under whose influence he came in his early thirties, especially the Nabis, and later Cézanne.

This anomalous position of the artist was caused by the Industrial Revolution, and was most affected where industrialization was most rapid and made the deepest impact: in England, Germany, America and lately the Communist countries. One of the origins of the Industrial Revolution was painting, which is visual only superficially and indirectly; it refers to signs that refer to sounds that refer to meanings that finally refer to things. Like music, like sound, it is linear and temporal. Neither painting nor sculpture can be translated into lines of print. Two things resulting from industrialization have tended to segregate (as Sir George Stapledon put it) man's thinking from his sensuous self and to depreciate experience in favor of "understanding"—i.e., the ability to translate into words. One of these is that the Industrial Revolution leads through mass production to the ideal of the standard. The replaceable part is machined to standard tolerances loose enough (inaccurate enough) to fit a standard assembly. A hand-made part is more accurate (fitted to closer tolerances) than a standard part. Standardization separates the mechanic from the machine and weakens man's connection with the material world. But the specific is not made either through thought, or understanding (both ways of dealing with the general), but sensuously. The other thing that resulted from industrialization was that in order to control the machines the future machine tenders had to learn to read. This enhanced the importance of the word and the power of the verbally minded, who in their command over words were able to generalize, to translate; to substitute the inaccuracy of "understanding" for the specific accuracy of direct sensitivity. Words are understanding, and understand-

ing is control. It also enhanced the social importance of education, which is almost entirely concerned with translation, in short, with showing that things are not what they seem to the senses, but something a little different and more general; that reality is not the specific material but the replaceable generalized part. An interesting thing about this is that it is the people with the most industrialized outlook on reality who are accused of "materialism," and it is precisely these "materialists" whose connection with the world of matter and experience is weakest. Another interesting thing is that science in its beginnings was based on the importance of experience. Roger Bacon was an empiricist in the age of Scholasticism. But the modern "materialist" devalues experience in favor of explanation, and what counts with him is not the object, but its translation into language, as though language had a stronger existence than matter. It is characteristic of scientists to ignore or doubt the existence of a phenomenon for which no explanation has been found. Conant's *Modern Science and Modern Man* ends with the sentence: "A continued reduction in the degree of empiricism in our undertakings is both possible and of deep significance—this, in a few words, is the message that modern science brings to modern man."

Prendergast's paintings, which are direct and "empirical," contradict his background as that of no other of his American contemporaries: the work completely ignores its ideological setting: it is so far out that every succeeding revolution in the visual arts in his life-time made by comparison an ever stronger philistine affirmation—or, one could say, asserted another verbal translation. Only in France was there a strong tradition in the visual arts, and only there did the public accept to a certain extent the artistic condition that artistic logic justifies style. The lack of artistic assertion in this country made, as it were, a power vacuum which at least up until the Armory Show was filled by the logic and morality of the manipulators of the law and an iconoclastic clergy. The painter could try to adapt to this society by expressing its concerns, which have little to do with visual experience, and where an irrelevant conscience replaces an esthetic one. The potential patrons demand, in return for their attention, that art show their prejudices arising out of their disinterest in art. The artist finds it almost impossible to assert himself as a painter. Only Eakins made the heroic attempt to make art out of disbelief in art. The

expatriates Whistler and Sargent were directly visual, but each in his way was somewhat superficial: Whistler seemed to be saying always, "This is Art," and Sargent's was the polite sensibility of the *rentier*.

Prendergast's position was anomalous both in regard to American society, dominated by the word and separated from the material world, and to American art of his time. There seems to have been no pressure on him to accept the anti-art prejudices of this society, nor was he oppressed by a strong sense of the art of the past. The only pressure came from the necessity to make a living, which he managed later by carving frames in his brother's shop. His first experience of an assertive art-world came from the artistic Parisian milieu that he encountered after he was thirty; and he saw the art of the past on his trips to Italy shortly after that. In Paris he met Sickert and the Nabis, and he seemed consciously influenced by Bonnard. His watercolor and oil sketches made from nature have a spontaneous freshness; they are full of weather, the outdoors and the movement of crowds. He was naturally a painter rather than a graphic artist, and his "drawing" does not count for much, which further relates him to Bonnard. This lack of "drawing" was the chief cause of his lack of wide recognition in his lifetime by critics. Drawing is about contour, and this is the aspect of visual art for which writers have talent. Contour (drawing) defines limits, it separates the picture into identifiable parts, and the criticism of people bemused by the Industrial Revolution is about nothing else. It provides a framework into which intellectuals fit the visual arts in order to understand them, i.e., dismiss them, by making them secondary to speech and writing. But one's sensuous self is first of all aware of qualities, which distinguish painting from drawing and are much less accessible to verbal translation. The strong effect of verbalism on painters shows in Cézanne's remark that the contour eluded him. It is as if Cézanne were deploring that he was a bad talker. Cézanne, the conservative, wanted to integrate in his painting the intellectual with the sensuous. Prendergast came under the influence of Cézanne's work, and his later oils show an attempt to make this same integration, somewhat like Signac's effort.

Even as a member of the 1908 group "The Eight," composed of a plurality of artist-journalists, Prendergast's position was anomalous. The critics singled out his painting

from group exhibitions for special condemnation: "The show would be better if it were that of The Seven rather than The Eight." He did not "draw" well enough. Neither did he come into his own in the Armory Show, which as a member of the Association of American Painters and Sculptors he helped to organize. The Armory Show stirred up the American art world, but instead of starting the assertion of artists as visual artists, it simply made them conscious of different rationalizations for art. Cubism, Surrealism, Expressionism, Neo-Plasticism were all concerned with new concepts based on language, or with new ways of promulgating the primacy of the contour, to make art translatable into words. From the influence of such critics as Wilenski, it was not a long way to the influence, in the Depression, of literary criticism. Directness began to be deplored as "French," and sensibility confused with weakness. The indirect dominated.

Prendergast never quite integrated his thinking and sensuous selves, though he tried to at the end of his life, influenced by the example of Cézanne. There is a certain heavy weakness to the oils painted in the studio. The Boston painter Carl Cutler described visiting his studio and wanting to buy a particular canvas, and being put off by Prendergast saying that he was not yet satisfied with the painting. What he would do would be to add and subtract, a boat, a child, a tree here and there. Was he thinking in terms of objective parts, of the drawing? The "drawing" in Bonnard, who was the product of a society with strong artistic tradition, is not a matter of a detail here and another there, but of the division of the canvas as a whole. Like so many of his American contemporaries Prendergast excelled in watercolor, a less intellectual medium than oil. His watercolors at their best have a happy and mature innocence. His sketch books are recalled in those large non-objective oils of de Kooning which Stuart Davis remarked looked like big watercolors. Prendergast expresses the generalized moment as do the Japanese Ukiyo-e prints; his attempt to be methodical in the oils painted from imagination made him lose some of his sensuous openness without gaining much either in formal idealism or specificity.

Marin

[*1955*] More works by John Marin than have ever been seen at one time before are assembled at the Museum of Fine Arts in Boston for a retrospective memorial show. The exhibition, which will include work in all mediums, will attempt to introduce for the first time the whole range of the artist's oils, a medium in which he did much work subsequent to his large exhibition at the Museum of Modern Art in 1936.

Especially interesting is a group of thirty-one small sketches painted on the Weehawken cliffs in 1903 and 1904, for they reveal perhaps better than his watercolors and etchings of six years later the characteristic mark of his style—a syncopated tilt, an angular askewness. They are, however, painted in areas, without the separation into line and area that he later developed more and more. The color, without being fantastically bright, is Fauve-ish; and since he seems not to have been aware of modern French art until he saw it in 1910 at Alfred Stieglitz' gallery, at 291 Fifth Avenue, when he returned from France after six years in Europe, the color was all his own invention. He had no precedent for it. Whatever reservations one may have, and one can have many, the amazing thing in these paintings is their originality of vision. There is a new form for a new experience. This experience was something that Marin was always expressing, in his talk, in his gestures, even in the way he walked—the critic Paul Rosenfeld told of seeing him once without himself being seen: Marin was entering the subway, wearing a raincoat, going around a corner, tipped to one side, and Rosenfeld thought, "He looks just like his watercolors!" Not his face, which was Emersonian, but his gesture, expressed what Analytical Cubism also expressed: the jazziness and fragmentation of the twentieth century.

The lack of precedent is, in his work before the Armory Show of 1913, a lack of European precedent. For when he went abroad in 1904, he did not come in contact with any of the new movements in painting, but followed Whistler, literally and spiritually, going to the places where Whistler went and making Whistlerian etchings. But his watercolors were something different. There is especially the well-known and often reproduced *London Omnibus* of 1908, analyzed

into squares, where Impressionism begins to give way to the sort of abstractionism that followed after Mondrian; abstraction out of Impressionism without the intermediacy of Cézanne. There is also in both the watercolors and etchings a difference from Whistler, consisting in a freshness that Whistler did not have. It is very delicate, this vision, perhaps the private vision of a man who as a child was indulged by maiden aunts and a most lenient father. The next phase was a group of watercolors made on his return to Europe, of which *The Mountain Tyrol* is an example. These paintings suggest a liberated, tender Sargent; the bloom is all there, what he does is done as if the artist, like a man in love, had only recently hatched. There is no system. They look like the watercolors of the same subjects by Lovis Corinth and Charlotte Berend. And when he finally returned to New York he began the paintings of this city that are closer to the *nature* of New York than anyone else has achieved. (Sloan painted the *look* of the city.) Marin sees New York (and indeed everything) as a flux. The streets are channels of communication, and traffic dominates the structures. The buildings are going up and coming down. These paintings could be classed with what Gertrude Stein called the catastrophic school. For Marin, New York is a complex of functions. He had worked in an architect's office, and he had used the knowledge gained from this in his etchings of buildings, but soon the buildings became animate (*Movement, Nassau Street,* 1936) and the anonymous people have no less firmness than the pavement and the architecture. Paul Rosenfeld described a skyscraper in one of the watercolors as resembling a subsiding pudding. Marin saw that bigness is by no means the same thing as monumentality. The disorder which is there in his New York watercolors tells of the actual disorder of New York, and it is both the strength and weakness of these paintings. He has been quoted as speaking of wanting to "run away" when he started to paint downtown Manhattan; and the watercolor with the Singer Building that was reproduced in the *Dial* portfolio in the 'twenties has a kind of messiness that makes it a restless spot on any wall. *The Black Sun,* 1926, barely holds together the river, the white building, the sun—black because how else show the intensity of the sun when you have to use paint?—and the fragmentary tug. There are the watercolors and oils with a yellow splash of sun on the ground, like suicide. The New York pictures are

violent and journalistic and can be compared to those Cubist still-lifes using bits of newspaper or the words in newstype, LE JOURNAL. Marin suggests the substance of the news instead of the idea of it, the experience of reading the newspaper for its content instead of the experience of the sensation of the texture of newspaper—which is a large part of our everyday sensations, along with the texture (in Picasso's and Braque's still-lifes) of wallpaper and moldings and jam and glass. Marin's experience is of movement more than of things. And in this respect he is superior to the Futurists, for whom motion was idea, not concrete fact. The Futurists were trapped by their theory; Marin was empirical. Certainly he was much influenced by the Armory Show of 1913, especially by the Cubists.

In the 'twenties he continued to paint New York, and he had besides discovered the Maine coast and the White Mountains. Starting in 1914 he gradually moved east along the coast, to end at Addison, near Machias, beyond Mount Desert. By the 'twenties he was at Stonington, on Deer Isle. The paintings of the little granite islands covered with a neat brisk coat of spruces with lighthouses, between Stonington and Isle an Haut, though they look half abstract, are always immediately recognizable, appearing more like themselves than in anyone else's paintings of the same subjects, or than in nature. The landscape imitates Marin. He painted the freight schooners which were disappearing from the scene, and when they had quite disappeared he kept on painting them from memory. These landscapes of this period were the most imaginative. Around the edges, at first as part of his subjective feelings, were lines or an irregular dark polygon like the skull of the beholder out of which his eye looks. There are strange goings on in the sky, a wind in a tunnel of air, say, or who knows, perhaps smells or sounds. The sky and water are in huge blocks to express his awareness of "weight balances." "As my body exerts a downward pressure on the floor, the floor in turn exerts an upward pressure on my body . . . the air presses on the chair with a force of fourteen pounds per square inch, and the chair presses back again with the same force." The air is weighty and immense, in blocks moving in different directions, in *Pertaining to Stonington, Maine,* 1925. The ocean moves in these same huge pieces, and it is both transparent and heavy. His schooners are in motion, even if anchored, as is the land and everything. In *Ship, Sea and Sky Forms,*

1923, the lines of rigging of the anchored schooner are implied by the structure of the trees behind; in *Schooner and Sea,* 1924, and especially *Headed for Boston,* 1923, the sails have little more substance than the air that blows them, but are tight with the tension of a bounding surface.

These things are Marin's special qualities. His oils have their qualities, too: *Sea Piece,* 1951, has a transparent surface and weight; *The Fog Lifts,* 1949, abstracts this phenomenon to express one's feeling about it as if this were a very frequent experience which one did not look at any more, but knew. And *Movement, Boat and Sea in Grey,* 1952, with its strongest shape a triangle of black like a twisted Greek fret, tells you something about the boat and all the rest in the mysterious way of intuition. His mountains also have their quality, especially *Mount Chocorua* from the Fogg Museum. "These big forms have everything. But to express these you have...to enfold too the relatively little things that grow on the mountain's back. Which if you don't recognize, you don't recognize the mountain." The trees of the foreground, transparent to the air as

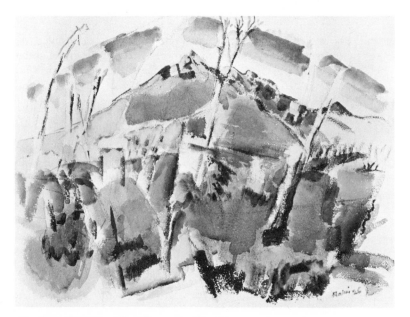

45. JOHN MARIN: *Mt. Chocorua No. 1*

in Turner, are broken in favor of the heavier bulk of the heave of the mountain behind. Turner precedes Marin in being perhaps the first Western landscape painter unable to overlook the fact that nature is larger than his pictures.

Marin's vision was of what could be called the world machine. It is in his vision that he is superior. Consider Léger, who also has a mechanical view. Léger's machine is frozen into immobility. But Marin falls down in his performance, and, in spite of continued successes to the end, did so increasingly after the 'twenties. Sometimes the watercolors have only their special and supreme sparkle. The oils and watercolors become in a way more abstract so that less is implied and more is insisted upon. The vision is graphically described more than it is painted, and he gives you a sign instead of a complete translation. His wash will seem to lack structure, for what is the structure of Becoming? How can you show this in a medium other than the film? He does not know how to stop, that is, spatially. The paintings analyze more and more into line and flat areas in another plane.

Like so many American painters of the twentieth century, Marin tended to relapse into graphic statement, with all the limitations this implies for painting. The angle in the sky and the angle in the ground became his mannerism. And his oils, which are today coming into their own with the growing unpopularity of watercolor, are often too grey, with the dull ring of clay not fired in a hot enough kiln. The largeness of his vision has something shy about it, a holding off; he does not touch things closely. The imprecision is only imprecision. Marin, once talking to me in admiration of Goya, said, "He was a man, he had twenty children. . . My paintings sometimes look to me like postage stamps." Marin's work may seem esoteric and reticent, and landscape contains his scope. In this he belongs in the category with Tobey, Graves and Gatch. In his special vision he foreshadows the New York School.

He said that he was more interested in the abstract painters than they were in him, and this is true. It is also true that even those painters who never looked at his work in his lifetime were busy rediscovering for themselves the vision of a functional world Marin was the first to find— one that does not contain objects.

Graham

[*1960*] John Graham once resembled an elegant Lenin, and perhaps the resemblance would still obtain had Lenin lived longer. With new acquaintances he may discuss Sadism; with acquaintances of longer duration his conversation includes magical speculations and moralistic concerns about esthetic worth. The absolute edges of his paintings and drawings frequently enclose one wandering eye, which he explains as giving life to the face. It is the life of a prisoner trying to escape. There is a conflict between life which escapes, and its contemplation, which is art. It is similar to the wandering eyes in the busts supporting the mantelpiece in Cocteau's film, *Beauty and the Beast*. It is life where life is not expected, as though the artist were a headsman, the effects of whose surgical task had not entirely run their course. And if the content of a man's work is the chief content of his life, it is obvious from Graham's painting that the chief content of his life is love of art.

He is an aristocratic Russian who served as a cavalry officer in the Czar's armies, then, with a Russian law degree, he emigrated to the United States and studied art. He comes to art the aristocratic way: through connoisseurship. He has an eye for quality. Wherever he lives, his home is a museum: its furnishings, from antique and second-hand shops and the five-and-dime store, reassemble a consistent workable house of no particular period in which each chair, painting or cooking utensil is set aside from such things by his recognition (which a visitor immediately senses) of a unique artistic or craft excellence. His houses illustrate a frame for civilized life. But he is not like a modern architect whose plan embodies his imagination of life as it ought to be, but never has been, lived; for Graham seems to imagine life as it has been lived. However, the life in his houses, where everything has its place as part of a whole, in spite of the ordinariness of the objects, or their uniqueness, is not life lived, but life contemplated, even when contemplation is contemplation-in-use. He is an appreciator who remains on the outside. He has a gift for imitation and for understanding things without losing his separateness.

His connoisseurship was expressed in his assembling of

the Crowninshield collection of African art. His eye for special quality showed in an exhibition that he organized in the early 'forties including work by the then unknown Pollock and de Kooning. His imitative gift was revealed in the Picassoesque paintings of the 'twenties. And, in 1946, his one-man show at the Pinacotheca Gallery presented along with some Ingres-like red and black ladies such as *Cave Canem* (whose content resembles that of a presumed Leonardo, *Lady with the Ermine*), imitations of early de Kooning women in green and brick orange. This constituted a sincere tribute to the originality of de Kooning, who, having not yet had a one-man show of his work, was still unrecognized by the general public.

Graham has verbalized his ideas in a book, *System and Dialectics of Art* (published around 1936). Written in a Stalinist dialectical manner of questions posed and answered by the author, it contains occasional Russianisms, such as the omission of the article, and an uncertainty about where to place it. Thus: "Artist creates for society," sounds more abstract than "the artist," as though not only were there a connection between all artists, but as though there existed further a generalized entity, "Artist," the god of artists. It may be that his taste for generalization and distaste for particularity which he expresses in this book come from the structure of Russian.

He places the understanding of culture before creation, as a necessary condition to creation. "Barbarians, nomads, are people of action. . . . Only after settling down do people begin to own objects. . . they begin to collect. With collecting the conquest of the outside world by action ceases and the conquest of the inner world by reflection begins."

He defines the artist's desire to create in the same words as the desire to collect, with the exception that he gives more space to the latter, expanding it far beyond the definition of the desire to create. He writes: "The desire to collect is the necessity to re-establish the lost primordial contacts and the need to arrest eternal motion and to contemplate." Similarly, "Artist creates because of (conscious or unconscious) desire to arrest motion and to contemplate. . .the desire to collect also comes from the painful fact that most people have lost contact with nature, with SPACE, with matter, they have lost contact with themselves, and are thus incapable of direct communication with other human beings. This is particularly true where Protestant civilization

has castrated people of their most natural elemental senses. As a consequence of irrevocable and drastic impairment of their ability to perceive, such people are unable to judge the specific weight of many matters. The impairment of any special sense does not end the matter, however. One of the instruments for reckoning being faulty the whole complement of instruments is out of gear and the concert action is absent. The reason men of high culture collect is that they have been disappointed at lack of understanding in present-day human society. . . .

"In collecting and classifying works of art one must realize that antiquity or age in itself has no meaning or value whatsoever. The things that matter are: a) plastic value [constructive art value in specified space] b) quality [care exerted] c) authenticity [belonging to the epoch or the artist] d) epoch [some epochs have more form significance than others] e) rarity f) state of preservation"— sometimes imperfect preservation is preferable, he says, as in Classical fragments, for Classical things "are overcrowded with irrelevant details. . . . Noses are superfluous because they obstruct the vision of the head. . . . There is only one infallible gauge in collecting, it is intuition perfected by personal, tactile experience. . . . One should never tamper with objects of antiquity, never restore, improve, polish, shine or paint."

The purpose of collecting is "to develop individual culture (source of general cultures)." Again about art, "The purpose of art in *particular* is to re-establish a lost contact with the unconscious (actively by producing works of art and passively by contemplating works of art), with the primordial racial past and to keep and develop this contact in order to bring to the conscious mind the throbbing events of the unconscious mind. . . . Conscious mind is. . . only a clearing house for the powers of the unconscious. The abstract purpose of art is to. . . establish personal contact with static eternity. The concrete purpose of art is to lift repressions."

Graham has an expatriate's ambivalence and an aristocrat's sense of status. He writes from the outside, as though the culture he admires were the activity of a class he respects and understands, even envies. But Graham remains aloof from the artist, separated by his understanding. He is separated first of all from Russia by his exile, and though he used to admire the Revolution, he does no longer.

He used to admire Picasso, and does no longer, probably finding in Picasso's eclecticism something too close to his own aloofness. He has beautifully expressed the nature of the Anglo-American culture of his adopted country, its strength and weakness, which have and do separate him again, not only from America, but from Western civilization, which seems to be going the American way. "Protestanto-Puritanism" "casts into discard ritual or form and substitutes subject matter—to the exclusion of form." And Protestantism "substitutes the particular for the general (detail worship), humor for joy, efficiency for aspiration, veracity for imagination, conscientiousness for honesty, cleanliness for beauty. . . ." It "has established subject matter as a paramount consideration and aim in itself, substitutes for real articles, thrift as a Christian virtue and thus laid the foundations of *capitalism,*" to which Graham added later in his own handwriting in the copy of the book I saw, "and consequently of communism." "In Puritanic culture the repressions meted out to the children are of an insidious character, *operating from inside,* disarming gently, depriving the young growth of a chance to rebel. . . . The result is a civilization deprived of the means of control and direction of instincts, deprived of emotional life, equipped only to move in the physical, subject matter, matter-of-fact, matter-of-action, brutal world. Human beings deprived of emotional life, hollowed inside like the trunk of a tree, are doomed to live in the *horror vacui* and contemplate the material world without being able to find any meaning attached to it, or have any access to it. Alongside. . . the negative aspects. . . there are crude but substantial virtues, such as:—ability to work, veracity, self respect, ability to endure [physical], poise, courtesy, eagerness to learn. . . . These civilizations coupled with the most advanced politico-economical ideology stand the chance eventually, so to say, of saving the world on these sound, rugged bases. Cultural refinements will come later and perhaps there will be no need for them. For the present these Puritanic virtues are deadly to the European (Western) culture and art."

Graham's art is the exact opposite to that of, say, Eakins, whose art is the epitome of these deadly virtues. Graham bases his painting and drawing on the art which expressed the West at its height. He went through a period of Picassoesque painting, which he has repudiated, but which has the same essential nature as his present Ingres- or Uccello-

like style. It derives from the paintings and drawings of the pre-Puritan, pre-Protestant West, it is not of the epoch to which he belongs. Neither does he believe that this epoch can have any significant painting. However at the same time he believes in art, and even more in a culture that expresses itself artistically.

"The edge ought to be absolutely spontaneous and final." And he says that volume and time are fictitious—in fact his greatest consistency is to perpetrate the absurd—that art "should lead humanity on to heroic action of no value." But today the "heroic action of no value" engaged in by humanity—the construction of vehicles for interplanetary travel, or of powerful machines of immense destruction— these actions would not seem to derive from art; but more perhaps from ideology, especially that of revolutionary states, which, for the end of independence from the central nations of the West, stimulate their populations to heroic and active starvation. Graham's painting illustrates what he understands about the culture he cares for, and when he creates, he makes objects like the most admired ones in the collections of his cultivated men. He wishes to create the contents of his museums. He competes as an artist with the historians who supply the dealers who sell to him as a collector. His beautiful decisive edges, clean as a surgeon's incision, imitate part of the impulse of Uccello. His Ingres-Uccello-Raphael type of feminine beauty embodies his idea of art as a ceremonial affair. "The value of the strange and the absurd lies in their suggestion of a possible unknown, supernatural, life eternal. For enigma is only a symbol of deity and deity is only a symbol of continuity or life eternal."*

The difference between Graham and Uccello, who Graham would emulate, is that Uccello pushed consciousness to its limits—perspective was a way of organizing and clarifying the experience of space; but for Graham the value of method lies in its potentialities for mystification. So in the end Graham goes to magic instead of to science. The magical elements in his women are their life in the fixity of his line; volume in flatness; the look of something that no

* Quotations from John Graham's *Systems and Dialectics of Art,* annotated from unpublished writings with a critical introduction by Marcia Epstein Allentuck. Copyright © 1971 by The Johns Hopkins Press.

longer exists, the dream of a more powerful past in which concepts come ahead of facts. The clarity of his space has the limitation of modern magic. The ceremony he believes in, is, like Houdini's, relegated to the vaudeville stage. For today magic is disappointing in its triviality and inconsequentiality. The face and bust of the lady in *Cave Canem,* and her dog, have a stony polish, and her hair and dress are brittle arabesques. The construction is in the cutting line, not in the bloody, morbid color. Graham's magic is papery; the paintings are like decorations for *The Mask of the Red Death.*

VIII

Books and Critics

Poets and Painters
in Collaboration

[*1961*] [Review of *Odes* by Frank O'Hara, prints by Michael Gold-
berg; *Permanently* by Kenneth Koch, prints by Alfred
Leslie; *Salute* by James Schuyler, prints by Grace Hartigan;
and *The Poems* by John Ashbery, prints by Joan Mitchell.
Tiber Press, 1961.]

These volumes are the first American example of extensive
collaboration between poets and painters that I know of.
They are slightly smaller and less bulky than the *Times
Atlas,* and they cost more than twice as much. However,
you get twenty original silk-screen prints in color which, at
$15.00 a print, is not expensive, especially when you con-
sider that at this rate the text, printing and binding are
thrown in free. The page size, 14″ by 17½″, is adapted
to the prints: it is they that make the price high for a
book, and it is only they that you can get nowhere else. A
recent collaboration comparable to this one is Edwin
Denby's *Mediterranean Cities,* with photographs by Ru-
dolph Burckhardt. Poet and photographer illustrate each
other, and in some cases the photograph preceded a parti-
cular poem. In the volumes reviewed here, the poems came
first, and the page design is the artists'. Frank O'Hara's

"Ode on Necrophilia" is included in Michael Goldberg's print, like one of Blake's engravings of his own poems.

The artists have more in common than the poets. They follow the school of de Kooning, which does something new in art. It takes as the subject matter for artistic contemplation, workmanship as such, good and bad, which is directly before the artist: the work, including the craft, of painting. It includes a contemplation of the work content of all art from the classics to modern advertising, and from skill of hand to the awkwardness of an amateur painting his boat in the spring. A spill, a blister of paint is as much part of the subject matter for artistic contemplation as the virtuosity of Frans Hals. Work is transformed into art.

The poets, who share an interest in this painting, partly do something similar in regard to all language from literary to inarticulate speech. Children do this soon after they learn to speak and paint. But these artists and poets are neither children nor primitives; they are radicals. They try to begin poetry and painting again.

The poets differ more than they resemble each other. Frank O'Hara's odes are an outpouring in the first person: a prophecy set adrift. Kenneth Koch's poetry all seems addressed to a second person as though part of a dialogue: this second person guides the poet. James Schuyler is contemplative and compressed; even when he says "I," the "I" is a third person, as though he were invisible in the presence of his object. John Ashbery's words which are separated from each other with the stiff lucidity of words in a primer, constitute a fourth, an impersonal person.

O'Hara's Whitman-like width of awareness dominates a dishevelled wealth of realistic details all somewhat altered by the stamp of the author's personality. His odes appear to exist in a continuous present that engulfs the reader, and all his references seem to be beside him while he is writing. His emotion is at a constant level: it begins and lets off, but does not rise and fall. The odes are like music. "Ode on Causality," in three movements, begins, as if each line were a separate instrument,

There is the sense of neurotic coherence
you think maybe poetry is too important and you like
 that
suddenly everyone's supposed to be veined, like marble

it isn't that simple but it's simple enough
the rock is least living of the forms man has fucked
and it isn't pathetic and it's lasting, one towering tree
in the vast smile of bronze and vertiginous grasses

and it ends, full orchestra,

> let us walk in that nearby forest, staring into the
> growling trees
> in which an era of pompous frivolity or two is dangling
> its knobby knees
> and reaching for an audience
> over the pillar of our deaths a cloud
> heaves
> pushed, steaming and blasted
> love-propelled and tangled glitteringly
> has earned himself the title *Bird in Flight**

This is the end of Koch's title poem:

> In the springtime the Sentences and the Nouns lay
> silently on the grass.
> A lonely Conjunction here and there would call,
> "And! But!"
> But the Adjective did not emerge.

> As the adjective is lost in the sentence,
> So I am lost in your eyes, ears, nose, and throat—
> You have enchanted me with a single kiss
> Which can never be undone
> Until the destruction of language.

His ironical language is the animating principle of his
emotions. His irony recognizes the childishness of ordinary
feelings which he shares with the reader, and this irony
washes away conventional sentimentality, until you are left
with the emotions of childhood again, seen now with an
innocence of maturity. This is reliable flattery, that as
you keep on hearing his mockery, and the ambivalence
stays, everything receives its due, and original childishness
is reinforced.

* Lines from "Ode on Causality" by Frank O'Hara reprinted
from *The Collected Poems of Frank O'Hara* by kind permission
of Alfred A. Knopf, Inc.

"Did you once ride in Kenneth's machine?"
"Yes, I rode there, an old man in shorts, blind,
Who had lost his way in the filling station; Kenneth
 was kind."
"Did he fill your motionless ears with resonance and
 stain?"
"No, he spoke not as a critic, but as a man."
"Tell me, what did he say?" "He said,
'My eyes are the white sky, the gravel on the ground-
 way my sad lament.' "
"And yet he drives between the two..." "Exactly,
 Jane,

And that is the modern idea of fittingness.
To, always in motion, lose nothing, although beneath
 the
Rainway they move in threes and twos completely
Ruined for themselves, like moving pictures."*

Schuyler contemplates and compresses:

Their arguing might be clarifying
to those who know them whom they do not know
as they know us who do not know them.

You see the poet's inventions, rather than the poet,
whose art is in the degree of disinterested attention with
which he follows them. He tends toward a deceptively
simple Chinese visibility, like transparent windows on a
complex view.

Within this head where thought repeats
itself like a loud clock, lived
the gray and green of parks before spring
and water on a sidewalk between banks of snow.

There is a stately gravity of tone, which he makes
colloquial, and he has an ear for ordinary speech that turns
it into art.

* Lines from "Permanently" and "on The Great Atlantic Rain-
way" reprinted from *Thank You and Other Poems* by Kenneth
Koch, by kind permission of Grove Press, Inc.

Past is past, and if one
remembers what one meant
to do and never did, is
not to have thought to do
enough? Like that gather-
ing of one of each I
planned to gather one
of each kind of clover,
daisy, paintbrush that
grew in that field
the cabin stood in and
study them one afternoon
before they wilted. Past
is past. I salute
that various field.*

Ashbery's language is opaque; you cannot see through it any more than you can look through a fresco. And as the most interesting thing about abstract painting is its subject matter, so one is held by the sibylline clarity of Ashbery's simple sentences, in which words have more objective reality than reality of meaning. One is back in first grade, about to learn to read. He spaces his words, but he does not separate the reality of art, such as a story by Hans Christian Andersen, or a crime movie, from the reality of nature.

Dawn breaks thousands of windows in the city.
As though a tear fell
From the eye of a smiling person.
The bathers are ready
On their platform;
The soldiers are parading
In furs, for it is a cold morning.
At this moment, butterflies
Fly over the city.
No one notices them,
Or that the street lights are on, as if it were not day.†

He has retained the clear but incommunicable knowledge of the child who was surrounded by heaven in his infancy, when a sense of wonder precluded judgment.

How genuine are these collaborations? For me, the most successful is the one between Ashbery and Joan Mitchell. She seems to treat her poet with sensitive understanding and respect. They are both abstract, and her graphic illustrations combine into page designs in which the illustration looks like writing, with Ashbery's lightness of touch. However the print preceding *The Poems* is almost monochromatic, though this poem is full of local color. She may have done this in the interest of total consistency. Though Schuyler is compressed and Grace Hartigan expansive, still she does get the luminosity of his language, particularly in the illustration that accompanies "A Head," where even her black spots have light in them. This collection has shorter poems than the others, and to make the volumes uniform in length (forty unnumbered pages) the print is correspondingly larger. It is primer size, though it is Ashbery's poems that have the most primer-like quality. Both Goldberg's and O'Hara's form is wild and windblown, though the artist is non-objective and the poet an epic realist. Perhaps the most beautiful, at once strongest and subtlest, is the page designing of Alfred Leslie. But it has no very close connection to the verse. The cover is rather ordinary, but the title page is very original, with transparent white over the printed title, and two kinds of black, shiny and mat. Leslie explores what ink can do, and his designs take in the whole paper, in a sensitive geometry that brings out Koch's occasional rather mathematical syntax. But one wonders about the whole series, is this done for the artists' or the poets' sake? Do the prints enhance the poems, or the poems glamorize the prints? For me, Denby and Burckhardt's *Mediterranean Cities* remains a more organic collaboration.

Rhys Carpenter
on Greek Sculpture

[*1961*] In *Greek Sculpture: A Critical Review,* Rhys Carpenter has written a history of the technique of Greek sculpture; he does not describe the personalities or lives of the sculptors.

The quotations from classical authors and mention of individual artists illuminate the general trend.

In his foreword, Professor Carpenter tells us that the Greeks "had no single term for Art, but obdurately persisted in referring to it as *technc,* which is to say 'skill of hand,' 'workmanship,' 'craft,' and even 'cunning,' but not what most men mean today when they say 'Art.' "

In the first chapter he tells us that Greek sculpture appeared suddenly, out of no native background; there was no "primitive" stage; and further, "the notion of free-standing monumental sculpture is so rare as to be almost an abnormality, even though we of the Western World, after so many centuries of familiarity with its production are apt to take sculpture for granted as a universal and inevitable form of artistic activity." Where did the idea come from? Apparently from Egypt. The date of the oldest surviving examples of Greek monumental sculpture is contemporaneous with the resumption of Egyptian trade. But motivation is something else: presumably the Greek traders were enthralled by what they saw, and became possessed by the desire to imitate the Egyptian example. But what made them keep on? Egyptian statues had a definite use-value, serving as a more enduring dwelling place for the soul after death than the embalmed body of the deceased. Greek statues had neither this use, nor any other. Without any word for art, could they have had an esthetic purpose? (In this connection, Nicholas Yalouris remarks that the Greek word for statue is related to the verb that means to rejoice; therefore we may assume that the Greek purpose was celebration, which is almost the same thing as art for art's sake.) We know that the Greeks took for granted the high value they placed on their sculpture. Such an unreasonable conviction of value is contagious, like the attraction exerted by a narcissistic person. Egyptian sculpture was useful, and its form hardly changed. On the other hand, in line with the uselessness of their purposes, the Greeks constantly perfected their techniques.

Carving dominated the development of Greek technique. Even life-sized bronze statues, which are nowadays reproductions of modeled clay originals, were in Greek times piece-cast from impressions made from carved wooden models. A carved statue communicates something different from a modeled one. A carver does not use his sense of touch so directly as a modeler. And though the spectator's

tactile sense may be equally stimulated by carving and modeling, modeling better satisfies his sense of the way things look. Modeling is more tactile and more visual than carving, and carving is more conceptual. A carved statue may seem to express a reality that is deeper than appearances can indicate. Carving begins at a cutting edge: it starts from lines. The Greeks used lines to make their form appear solid. They did this with an unsurpassed sensitivity. Archaic statues, following Egyptian practice, were cut from the four sides of rectangular blocks, like four reliefs at right angles to each other. Polycleitus' canon of proportion originated in the grid of the archaic sculptor which guided his drill and chisel on the flat faces of the stone. But both Polycleitus and, apparently, the architects of the Parthenon, who followed numerical canons, believed that the life of a building or statue lies in its deviation from numerical and geometrical exactness.

Verisimilitude was presumably the aim of the archaic sculptors. As they approached success, the aim seemed partly to change, and the appearance of solidity became more important. As sculpture got superficially to look more like nature, it grew more abstract. To give a more vivid appearance of solidity, the Phidian artists made the wrinkles of drapery fall counter to the underlying form, instead of paralleling it in the literal manner of the sixth century. This was one of the greatest artistic inventions of Greek civilization. Form was still described in terms of line, but now it was described negatively, in ridges, instead of grooves. By the second century, sculpture had freed itself from the squareness, for which Polycleitus had been criticized. The counter-twist of the pose of the *Aphrodite of Melos* is a device rediscovered by Michelangelo. And accompanying this lifelikeness of pose, the unfunctional drapery and impossible anatomy represent the height of abstraction attained by Greek sculpture.

In his previous book, *The Esthetic Basis of Greek Art,* Professor Carpenter shows that Greek architecture remained a two-dimensional art. Greek architects expressed depth by the precise edge between the strong Greek sunlight and the contrasting shadow. Also in architectural sculpture, depth was a function of the quality of the light. By the second century, partly influenced by modeling, sculptors tried to communicate a new kind of sense of the third dimension, but as sculpture became more pictorial,

more visual, its apparent solidity softened. It remained for the Romans, who created a three-dimensional architecture, to create sculpture whose three-dimensionality does not depend on shadow. Though solidity is not the same as depth, both solidity and depth express volume. Perhaps the two most three-dimensional sculptures in Rome are the equestrian *Marcus Aurelius* and the seated maiden of the school of Phidias in the Barberini palace. The Roman statue, one of the three most significant of its kind in the world, depends to a great extent on the continuity of surface and contour that keep always alive in the motion of their changes as you circle around it. The Greek statue is linear.

However, three-dimensionality remains something that sculptors barely, if ever, attain. In this connection Professor Carpenter says of the *Laocoön* that "in a very recent study of the problem, the frontal composition of the *Laocoön* has been ascribed to the pictorial notions of sculptural form current in sixteenth-century Italy when the dismembered fragments of the group were reassembled as we now see them, but not as they were originally disposed. Here the claim is made that 'the elder son was displaced as much as ninety degrees out of his original position, and the axis of the group shifted about forty-five degrees. . . . Freed from the relief-like composition imposed on it by the sixteenth-century restorer, the group now regains an extraordinary three-dimensional character.' "

Alberti and Leonardo
on Painting

[*1956*] Leon Battista Alberti's *Della Pittura* first appeared in 1435. His treatise on painting "was built on the means, the aims and the results of the art of Brunelleschi, Donatello and Masaccio." It speaks for the practice of fifteenth-century Florence as Roger Fry speaks for the practice of Cézanne. Alberti's treatise, which influenced Leonardo, is more general than Leonardo's fragmentary, voluminous and repetitive notes, whose interest is in their concreteness. The *Libra di Pittura* (Vatican Library Codex Urbinas Latinus 1270) is a compilation by Leonardo's heir, Francesco Melzi, from Leonardo's notes about painting. More than a quarter of the treatise corresponds to material in Leonardo's

surviving notebooks; the rest is not found in the note-books, which, however, contain observations not found in the treatise, especially some abstract and imaginative remarks on perspective (e.g., "The air is full of an infinite number of images which are distributed through it" and which "approach the eye as pyramids"). Both Alberti and Leonardo say that the painter is concerned with the appearance of relief. The pyramids that fill the air seem to be taken as facts. Leonardo's eye, "which transmits its own image through the air to all objects which are in front of it," is an active eye. The abstraction assumed by Leonardo and Alberti has to do with the grandeur of ultimate reality, which was to be understood by intelligence, through the medium of the senses. Alberti thought reality finite, and therefore the finiteness of art in no way diminishes its value; Leonardo, thinking reality infinite, preferred painting to the other arts because it is not temporally limited. Such conceptualism vanished with the empiricism of the Impressionists, who knew only sensation, and for whom the eye was passive. The Impressionists believed not in thought, but in ignorance before nature. The Cubists revived something like the Renaissance belief in intelligence, via Cézanne, who, a vicarious Catholic, missed in Impressionism the grandeur that he saw surviving in the museums. Like Impressionists, current abstract painters prefer passivity to intelligence: they keep themselves open to revelation; their search for directness leads to a complete denial of abstraction; they are opposed to using appearances because they separate the artist from his experience, which is his painting. These artists would find little useful in Leonardo.

Alberti's and Leonardo's discussions of the nature of painting stand between Cennino Cennini's book of recipes and modern esthetic theory. Both authors emphasize what to do over how to do it. Alberti, believing in the primacy of mathematics, begins with a discussion of perspective; but he failed to achieve the *tour de force* of expressing in words what a diagram demonstrates immediately. He uses for an example a triangle whose sides have the relative proportions of 1:2:3, which is an impossibility. He recommends looking at pictures in the mirror to find their faults, and at the same time wonders why things always look better in a mirror. Alberti's treatise has historical curiosity. Leonardo's treatise, too, like the writings on flight, the inventions, the geology, and so on, is a curiosity—though a great one. To

a painter who does not share the Renaissance reverence for men, but otherwise accepts the reasoned beliefs of the sixteenth century, his treatise on painting gives academic support. And as an investigation of nature from an artist's point of view, Leonardo's account has the sort of usefulness that the *Book of Knowledge* has; it answers many questions, though you do not know what questions may be brought up, nor quite where to look for them. Most of all, his treatise shares the value of the rest of Leonardo's production. It is an unsurpassed example of continuous searching; like the drawings, an inspired model for any artist. He meant to, but never did write the treatise on painting, just as he meant to build airplanes that flew, and paint the Deluge. The treatise is a sketch book. It is a more or less orderly compilation of his thoughts in words instead of pictures, and is another proof that he was naturally neither painter, sculptor nor engineer, but used these means to put down his thoughts about the world of which his experience was indirect in proportion as it was profound. Many of his verbal observations have the suffocating clarity and passion that his drawings have. He is at his best when he does not make judgments, for his wisdom was unworldly. His observations on the movements of the human body, on the way trees grow and the nature of clouds and wind, are the most valuable for a painter. When his point of view is based on mechanical intuition, then what he says is still definitive. The emphasis on observation was modern. When he observed painting in this unprejudiced way, his definition of it was most modern: "Painting is a composition of light and darkness, combined with the different variations of all the simple and compound colors."

Selden Rodman's Apology for Art

[*1960*] In his book *The Insiders,* Selden Rodman takes a moral stand against the dominant school of art and art criticism, in favor of art which calls "attention to the unspeakable degradation of the *individual.*" "In his search for values that give meaning to life, the Insider does not divorce man as an individual from man as a social participant." He believes that the "full development of man...requires the rational evolution of *both* thought and feeling." Camus is quoted on the title page as follows: "The error of modern

art lies most often, in giving priority to the means over the ends, to form over content, to technique over subject-matter."

The dominant school of modern art does indeed often express the idea that the end you achieve hatches out of the means you employ. Does the choice of art as a profession come from the special nature of the artist's experience, or from his desire to give form to experience? Technique is a petty word; I prefer style, which is the man, and which takes precedence because any subject will do. An artist who seeks subject matter is like a person who cannot get up in the morning until he understands the purpose of life. Subject matter is given: in his field and in his capacity as artist, the artist seeks grace.

Selden Rodman finds painting the dominant art of the West since the last war. He is sympathetic toward avant-garde painting and sculpture, and he seems unaware of any paradox in finding it both alive and lacking content. But in spite of its popularity and the fact that, as Rodman says, a great deal of talent has been attracted into creating it, he finds it dehumanized, contemptuous of the audience, contemptuous of the individual, formalistic and self-absorbed —all of which, in his words, causes the "Philistine" millions to identify art with irresponsibility. But what of the huge audience for this formalistic art? What does Rodman make of their interest? These thousands must have been reached, to be interested; and if, like Rodman, they identify art with irresponsibility, and still admire it, it could be because this irresponsibility seems more realistic than the phony responsibilities presented to them.

The Insider is someone "drawn to values outside himself strongly enough to examine them in his work." He is concerned with "the human condition" expressed in "some form of representational imagery, or ... in an aesthetic vocabulary evocative of that condition." Since humanism expresses "man's wish to be godlike in tragic conflict with his bestiality and mortality, the Insider steeps himself in tradition." Presumably respect for tradition prompted Lebrun, an Insider, to copy Goya's *Family of Charles IV*. A reproduction of this restatement is included among the illustrations. Lebrun has added some de Kooning-like lines over the composition of an artist who detested lines because he did not see them in nature. Rodman would like artists to look outside themselves and to respect

individuality, as I suppose he thinks Kearns does, whose drawing, *Seven Viewers on a Wall,* is reproduced. The subject is children observing the aftermath of an automobile accident, and it contains, seven times over, the standardized monster, four heads high, that is Kearns's creation. (Why do so many Insiders use this nineteenth-century cartoon convention?) It expresses a shaggy geometry. Rodman calls Cuevas the heir of Orozco. Cuevas' distortions show an adolescent disgust with the adult world. Often the distortions that are meaningful to Rodman look like affections to me. The bronzes of Baskin, "poet of death," have a beautiful and subtle surface, and his wood engravings show beautiful control—all for a subject matter that is so much camp. Do his fat bald men mean death, as their titles claim, or do they mean the murder, by making it repulsive, of the artist's sensuality?

Rodman opposes "art for art's sake." If art is not valuable first of all in itself—which is what "art for art's sake" means—it is valuable for a reflection of greater values. Orozco, "the first and still the greatest of the Insiders," was less interested in art than in the subject; art was what he used towards an end. But the lesser Insiders whom Rodman admires use morality to excuse art, as an apology for being artists. They deny art for art's sake, and use morality for the sake of their careers. Their "compassion" looks like self-pity for their denial of their natural sensuousness. Instead of being anxious about man's fate, they seem to be anxious about whether it is all right for them to have chosen to be artists.

Speaking of the divorce between the artist and his public in contemporary music, Rodman describes the motives of "formalist" composers in this way: "Contempt for the audience and withdrawal into esoteric forms are only symptoms, self-protective attire the artist assumes when he has already lost conviction in what he has to say." But are not the Insiders' distortions and visions of violence a self-protective attire assumed to convince themselves of their humanity and to hide artistic emptiness? Instead of being a sign of vitality, their violence looks like a measure of the incompleteness of their commitment. And maybe, what in the "formalist" avant-garde, looks like contempt for the audience, is a refusal to make irrelevant concessions. Maybe the artist who seems to be interested only in technique,

seems so because he takes his content for granted, his subject matter takes care of itself. The Insiders protest too much.

Clement Greenberg on "American-type" Painting: A Letter to the "Partisan Review"

[*1955*] I would like to comment on Clement Greenberg's article on "American-type" painting in the Spring (1955) number of *Partisan Review*. I agree that there is such a thing and that there are more good abstract painters in America than in Europe. But Greenberg does not describe "American-type" painting. He evaluates it too easily in a favorable light. He is very ready to tell painters what they may or may not do, without enough understanding of what they have done or are doing. Sometimes he says "we" when "I" would be more accurate. He speaks of "the easel convention" without being clear what he means. He says, "By tradition, convention and habit we expect pictorial structure to be presented in contrasts of dark and light or *value.*" This idea of value is widespread among, for instance, public-school art teachers.

Contrast of light and dark would be better called "chiaroscuro." It is no accident that there is the word, "value," which is synonymous with "worth." It is difficult to talk about it without the painting (and not a reproduction) before you. Adrian Stokes in *Colour and Form* tries to but fails, because he does not sufficiently realize that it is a matter of the art of painting, not of nature. But in reported conversations of painters, and in conversations I have had, I know that there exists here a true and I think very important concept that has not been written down, except inadequately by people, not painters, who talked with painters and may not have understood. What Greenberg calls in the case of Monet the suppression of value, is really an emphasis on value, through dissociating it from chiaroscuro. For instance, one color can vary in "value" but not in hue or chiaroscuro or intensity. Needless to say, it requires art to do this, and the effect may be of the greatest importance in the result. An area has, as it were, different amounts of substance, or weight, or opacity, or some such thing, and this variation may be the important thing in the balance of the composition, and in this varia-

tion the form of the picture occurs. Fra Angelico was a painter who was particularly sensitive about this aspect of "value." Velásquez and Vermeer used it; but it is most frequently seen in French painting, from the fourteenth century *Pietá* of the school of Avignon, through Chardin, Corot, Courbet, Manet, Matisse, Vuillard, to Bonnard, who uses it unrealistically, that is abstractly, as can be seen in his painting that often hangs in the Guggenheim Museum, and that (though it has a recognizable subject matter) is because of this, perhaps the most abstract *painting* (as distinct from art object) in this museum devoted to "abstract" paintings. The earliest examples of complete abstraction of this kind of value from chiaroscuro, after the Impressionists, that I have seen, occur in paintings by de Kooning and some by Reinhardt, where a red and green, or a red and red, or a yellow-green and purple, having the same (Greenbergian) value, as well as the same value in the sense of worth (unless it is the same color), make your eyes rock. Otherwise modern painting from Cubism to William Scott and Clyfford Still depends on chiaroscuro. Nothing much more has been done except to leave out a recognizable subject, a negative acknowledgment of the first importance of the subject.

Greenberg writes of the great influence of Kandinsky and German Expressionism on American painting. But Americans copied the faults of these models as well as whatever positive qualities they may have. For instance, Kandinsky, not understanding value, made paintings full of dead areas —usually the darks, which in both his early realistic paintings and in his abstract landscapes do not connect with the rest of the surface. These faults can be seen in both avant-garde painting and in the sort of realist painting that derives from Expressionism and is shown in the Associated American Artists' Galleries. The German Expressionists misunderstood Impressionism because they did not understand value, and this provincial school bequeathed its provincialism to Americans. Cézanne did not, as Greenberg says, try to bring back chiaroscuro—on the contrary, he understood very well the form implicit to the originality of Impressionism. The Cubists, in so far as they based themselves on a remark of Cézanne, put literary content into their as yet incomplete understanding of him. (To speak of a literary content in painting is not to disparage its painterliness.)

Greenberg says the term "buckeye" comes from Barnett Newman. I doubt this—I remember hearing the term applied to bad painting thirty years ago in Chicago, and frequently since.

Greenberg says that Still, Newman and Rothko started as "symbolists," which means they started by wondering what to paint instead of how to paint—their first concern was with the artist's social role, and their painting has a literary origin. The way to get away from literature (if this is desired) is not by being negatively literary.

Greenberg says Rothko's opposition of pure color makes him think of Matisse. But Matisse shows far greater sensitivity to an abstract use of color by attention to "value" (not as Greenberg uses the word) than Rothko has shown.

"American-type" painting has in some examples, this originality: it starts from painting as a way of manipulating pigment with a brush: that is, it starts very radically from the implied proposition that a painting is the result of moving pigment over a surface. It starts from nature—the nature of work done with paint. You start from this: if you are an artist, you make art from this. It starts from the contradiction of a rule of the critic Wilenski, who showed in comparing a Raphael detail with a detail from Sargent, that in even the smallest part of Raphael there was a "plastic" (whatever that means) form, whereas in Sargent there was just paint, which demonstrated the inferiority of Sargent. American-type painting starts from the inferiority of Sargent, with the notion that a painting is, after all, this: just paint, and not illusion. It does not express ideas as often as European painting, and in this sense it is "purer."

Greenberg seems to think that the artist today must give up the figure: the figure has been done and nothing new remains. It was also done by the Greeks, but the success of the ancients was imitated, not shunned, during the Renaissance. American painters have not been supreme in figure painting; perhaps from shyness they have felt more at ease in landscape. There is now figure painting being done by Americans, but Greenberg doubts its validity, telling them in effect to stick to their old provincialism; and this misunderstanding of value is also provincial. American abstraction is a development from American timidity, and it is original; for instance a difference between American abstraction and European abstraction is that in the American form "there is nothing to look at," no center; as of the

still-life on the table, the face in the middle, or the house on the hillside, which probably derives from one of the differences of American landscape, even American city landscape, from European landscape. However as a war is not won by brilliant retreats, so creativeness is not advanced by imposed limitations.

Rosenberg and Hess on de Kooning

[*1975*] [Review of *de Kooning,* by Harold Rosenberg, and *Willem de Kooning Drawings,* by Thomas B. Hess.]

The arts today are sufficiently justified by their enormous popularity. The public does not so much need explanation as accurate reproductions, which both books supply. Just as painters paint somewhat for each other, so do critics write for each other and for the painters, and criticism has acquired a popularity it didn't use to have.

Thomas Hess's text is longer and more accurate and scholarly than Harold Rosenberg's and his generalizations are carefully based on reliable and very thorough information. The Rosenberg book contains de Kooning's "What Abstract Art Means to Me" and "Content Is a Glimpse." De Kooning has great linguistic skill, using words with precision and artistic ambiguity so that everything he writes or says is a delight to read or listen to.

Rosenberg's background is Marxist, which is to say that his criticism bases itself on a materialist ideology of history. This is, of course, a contradiction. His strength is in ideas, like that behind his invention of the epithet "Action Painting" that has become as widely accepted as "Impressionism" or "Cubism." His visual sensibility is weak. He aims for a general and conclusive judgment.

He has been de Kooning's friend for about thirty years. In the beginning of the friendship it was Rosenberg who talked and de Kooning who listened; finally Rosenberg was won over by his increasing awareness of the authority of de Kooning's paintings, and by de Kooning's "astuteness in handling himself and his talents in relation to prevailing ideas. His canvases are permeated with intellectual character, yet never illustrative of a concept. They have the strength, surprise, emotional range, and, on occasion,

the arbitrariness of a temperament." In short, they refute an application of Marxian ideology to art criticism. "It is for each painter to bring painting to life again out of his own life," which must prevail over "the commands and prohibitions of vangardism" resulting from a surrender of artists to prevailing progressive ideologies that seemed so compelling in the thirties. It is as though Rosenberg's final judgment is about the Marxists rather than de Kooning. "...under the conditions of the ideological pressure characteristic of the past forty years, unbending adherence to individual spontaneity and independence is itself a quasi-political position—one condemned by Lenin, outlawed in totalitarian countries, and repugnant to bureaucrats, conformists, organization men, and programmers. Improvised unities such as de Kooning's are the only alternative to modern philosophies of social salvation, which while they appeal for recruits in the name of a richer life for the individual, consistently shove him aside in practice."

Where Rosenberg uses de Kooning to criticize the Marxists, Hess uses Marx's description of the three principal relations between man and the immediate world as a parallel to de Kooning's way of working. Hess's generalities are not, like Rosenberg's, social, but the generalities of de Kooning's materials, tools, and ways of working. He speaks of de Kooning's use of the liner's brush as contributing to the speedy look of the ink drawings on smooth surfaces, and suggests an association between these drawings and his having skated on the frozen canals of Rotterdam as a boy. He puts de Kooning in the context of his friends and fellow artists who influenced him and whom he influenced, like the poets of the "New York School," represented by the poem-preface by Kenneth Koch, with its characteristic colloquial virtuosity.

Hess has been a friend of de Kooning maybe longer than Rosenberg. As managing editor of *Art News,* right after the war, he was the first art critic to give serious attention to the new American school of painters, before they were generally accepted. He immediately recognized that they were first-rate. The text is based on an intimate knowledge of de Kooning's working life. Each plate is related in particular to what de Kooning read and what Elaine read to him, to his poverty and his earning his living during the Depression, and to the artists who influenced him, from Castagno and Louis Le Nain on.

Hess believes that in his desire to make paintings as natural, fresh and seamless as a flower, de Kooning reacted against the increasingly open revelation of method in the nineteenth and twentieth centuries, and started a return to a hiding of technique as in the Renaissance. (But what of Velásquez or Tintoretto? And what of Whistler, who wished always to cover up his traces?)

Actually much of de Kooning's painting techniques were learned during his apprenticeship at the firm of Jan and Jaap Gidding, whose methods went back without interruption to the medieval guilds. De Kooning doesn't like to reveal them, and since critics today do not particularly approve of attention to technique, it is regarded as of superficial importance.

But I think that this training has contributed a lot to one of the original expressions of his painting, which turns labor into art, not in the romantic sense of the studio academician in a painting smock and with mahl stick in hand, but of a journeyman who having become a master, can clown at work. Since America began after the guild system had finished in Europe, we have little connection with or respect for the professions of artisanship: we do not buy quality, but labor time. The professions we are most likely to respect contain verbalization: the abstract profession of the "intellectual," whose closest resemblance is to a member of the Russian "intelligentsia." We respect it and despise it at once. We despise it because professionalism contradicts egalitarianism, and we respect it because except possibly in medicine we have no tradition of craftsmanship other than ones requiring a gift of gab. The minister, the editorial commentator, the lawyer, the politician. These indicate no social status, only talent. Talent, of course, can lead to any kind of deceit and shyster tactics. One needs only to be clever, as any ignoramus might. Insofar as knowledge makes for privilege, it is suspect. And so de Kooning's craft knowledge is disparaged. But it is an important aspect of his art: it is what he brought from Europe. Here he combined it with American amateurism and shoddy workmanship—shoddy because it contained nothing but labor and cleverness. In his painting work turns into art as in a potentially classless society, where skills exist for their own sake and denote neither class division nor the division of labor between hand and brain. His art symbolically realizes the social aims of the I.W.W.

Wyndham Lewis on Picasso:
A Letter to the "Kenyon Review"

[*1941*] Your article on Picasso by Wyndham Lewis was very bad. I think that like many literary people you have an indirect understanding of the visual arts, and that since Lewis is both a painter *and* a writer you thought he must be an art critic.

The criticism shows about Lewis, first, that he looks at paintings through the spectacles of words, and without these spectacles would be blind. He does not know the difference between the pictures and his talk about them, and his talk is about many things that are quite true and relate to the pictures, but are non-essential. Professor Edgell said that women who look at pictures are likely to be hypocritical, and men likely to be lazy: for instance in looking at a primitive madonna in which the artist has painted six toes on the child, women might say, "What charming naïveté," and men might say the picture was no good because no child has six toes. Lewis says that Picasso paints three eyes, and this is not in accordance with nature. Second, the article shows that Lewis paints from a written program, concocted in advance. He is a manifesto painter. In the end of his article he compares Picasso with his manifesto, and finds Picasso lacking. Picasso is not a manifesto painter, and the end of the article shows that what is at issue is the manifesto by Lewis, nothing else. It serves as an advertisement for the work Lewis is planning to do.

Lewis says that it is "no longer a question of defending Picasso against the abuse of the ignorant...it is...a question of saving art itself." But Lewis' whole criticism is ignorant, and Lewis' former defense of Picasso must have been motivated only by snobbishness. Who wants to *save* art, anyway? Certainly no one who is creative. Is art something that Lewis is fearful for? Then it is Lewis, not Picasso, who is the antiquarian. Lewis will save art by a return to nature. What is nature? What nature is absent in Picasso, and what nature is present?

Lewis speaks of Michelangelo. Michelangelo used anatomy not as an end in itself, but as a creative means; and so Picasso uses antiquarianism as a creative means. To say Picasso is an antiquarian, not an artist, is to say that

Michelangelo is an anatomist, not an artist. What counts is what is made, not what is used. Anyone can see the anatomy in Michelangelo, or the antiquarianism in Picasso, and a sensitive person, or a person whose sensitiveness is not inhibited by personal ambition, sees the creativeness too.

Lewis is "disagreeably bored" by Picasso. This remark reminds me of the remark of an old gentleman at a "modern art" exhibition in Boston, who muttered over and over, trembling with rage, "I get *no* reaction! I get *no* reaction!"

Lewis ends with an attack on the abstractions. He remarks on his own "experiments" in this genre. Picasso does not experiment. His pictures are ends, not fragments of research. He says that Picasso is imperfectly abstract, or not abstract at all, and that the real abstractionists were in Holland, Russia, and the vorticists in England. Picasso's abstract pictures are half abstract, half purely naturalist material. Quite so. This inconsistency is the essence of Picasso's "abstractions," and if you deny them this, you simply have not begun to understand what they are about. Lewis *read* Cézanne's formula about nature being spherical and cylindrical, as Picasso did, but Lewis took it literally, and not being a creative person, could not go beyond it, while Picasso *used* this remark and made something on the basis of it. Lewis' boredom with abstraction is a boredom with the limitations of his own impotence, and his anger at Picasso comes from a sense that Picasso was not bound by this idea, but liberated by it as he is liberated by most of what he uses. To use a phrase of Blake, when Lewis painted abstractly, he painted in chains, and when Picasso paints any way he is free. I predict that Lewis will paint equally in chains as the leader of his back to nature movement, for liberation does not come from manifestos, but from inside the man.

Lewis says: "A street in Timbuctoo is always so much more interesting...than a street in one's home city." Again he reveals the cause of his own boredom as a failure of sensibility. He does not recognize the home street, without the most superficial obvious trappings. What Picasso positively does is to show hitherto unnoticed and essential aspects of the home street.

IX

Art and Politics

Murals for Workers

[*1935*] In 1928 it would not have been possible to write about "murals for workers" in New York. Beside the travel catalogue or romantic-allegorical decorations in banks, theaters, and office buildings (the Rand School decorations by Will Pogany belong in this category), there were only the murals by Hugo Gellert in the former Workers Cooperative on Union Square. They were the first murals of the city. When S. Klein expanded his store and the Communist Party moved to Thirteenth Street, they were painted out, and the Mexican influence and the influence of Benton superseded the French influence on all painting, but especially on mural paintings with a leftish political content.

By "murals for workers" I mean murals that are now in place where anyone can see them, and whose content has immediate meaning and application to the lives of workers. The ideas should be expressed well enough in painting terms so no description can be equivalent to the painting. In other words it should be good enough to require that you go and look at it. Workers murals in New York can be found at:

The New School for Social Research, by Orozco, and by Benton;

The Whitney Museum of American Art, by Benton;

The Thirteenth Street Workers School (Communist), by Jim Guy;

The New Workers School (Lovestonite), and the International Workers School (Trotskyite), by Rivera;

The I.W.W. Headquarters on Fifth Avenue, by Carlson;

Lenox Hill Neighborhood Association, by Stefan Hirsch;

Hudson Guild, by Laning;

Madison House, a cooperative fresco by Lucienne Bloch and Stefan Dimitroff;

Queens Labor Center (Socialist), by Haberstroh (formerly at Rebel Arts headquarters);

Queens General Hospital, by Palmer;

The New China Cafeteria at Broadway and Thirteenth Street, by Tomatzu.

There are many other excellent mural paintings that are in storage, in artists' studios, and so on, like Burck's of the Five Year Plan that were to be in the former office of Intourist, Ben Shahn's project for Rikers Island Penitentiary, Hideo Noda's panel that was exhibited by the John Reed Club at the Independents last year, and the Harlem Workers School project. These artists, some of them liberals, and some radicals, paint in various modes, according to their beliefs, and according to the place the mural decorates: propaganda paintings, paintings of ideas, paintings of things, and use paintings. For instance, Benton is interested mostly in things, the American scene; Hirsch paints ideas without propaganda; Rivera is a propagandist; Palmer's mural in the new Queens General Hospital on the functions of a hospital, and Laning's Hudson Guild fresco about the organized play for the children of the neighborhood, are use paintings. Of course these different approaches are not absolutely distinct.

Most effective of the propaganda murals is Bloch and Dimitroff's cooperative fresco. By comparison, Rivera, who obviously influenced them, is confused and negative. What does he oppose to the horrors of Fascist Germany and Italy, or to his picture of working class disunity? Bloch and Dimitroff present a picture of actual living conditions on the Lower East Side, and a plan for better housing. Nor is their fresco limited to specific conditions and immediate demands. They show the relation between the A.A.A. crop reduction plan and an East Side breadline. Only the relationship between capitalism and war is not clearly stated—if that is intended by the graphs and dollar in the middle, and battlefield landscape at the right. Bloch and Dimitroff tell their story entirely in pictures, but Rivera resorts to the device of labels and quotations held in the hands of his characters. In fact, Rivera at The New

Workers School has not solved the problem of putting his subject in painting terms.

Less sweeping than Rivera, and less realistic than Bloch and Dimitroff, are the enthusiastic murals of Jim Guy. He is closer to Orozco: both in his method of using organically the irregularities of the wall space and in his preference for dramatic ideas, he seems to have learned a lot from the New School for Social Research frescos. Other propaganda paintings are Carlson's hastily executed mural at the I.W.W. headquarters, full of cliché capitalists in silk hats and noble workers naked to the waist, and Tomatzu's gay painting of the success of the collectivization of farming in Russia.

The painting of propaganda and the painting of ideas often but not always go together. They go together in the work of Orozco, Guy and Haberstroh. Dimitroff said that the Madison House fresco creates an atmosphere that influences or encourages visiting speakers to be more radical, but Haberstroh's *Youth and the Socialist State* might not have such an effect. It presents an idea (which may be a kind of persuasion), but it does not exhort. Jim Guy's picture of the future Soviet America, or of Labor protecting the Soviet Union from imperialist plots of aggression, are in this category.

At the head of this class is Orozco. Whether or not he is a painter "for the masses" I do not know. He is quoted as having related how when in Mexico City his frescos were unveiled, two people were killed in the crush. But returning tourists tell you that the Mexicans dislike his frescos. Orozco is misunderstood as much by his admirers as by those who dislike his work. You are told that here is a man who paints from a kind of helpless, clumsy passion for art. The truth is that no modern painter is better educated in all things related to his craft. To his original intuiton for form relationships, he can bring to bear four years of mathematics at Mexico University, two years' experience practicing architecture, two years studying anatomy at medical schools; he has also studied agriculture. And his drawings of *Mexico in Revolution* attest to his wide experience of life and death and his personal courage in facing them.

Two things determine the quality of the frescos in the dining room of the New School for Social Research: the architecture of the building and the ideas of the mural. This sounds elementary: it is. The austerity of the inter-

national style is matched by the angular, bare-bone style of painting. The idea is the revolutionary movement. In the walls about Mexico, India, and Russia, the leaders are realistically painted in contrast to the masses who have group reality rather than individual reality. Gandhi, relaxed and yielding, is much bigger than the self-important British soldiers guarding the chained untouchables and white-collar workers. By the way he has stylized the bodies of the representatives of different races around the "table of brotherhood," he says, in painting terms, "Solidarity!" His knowledge of anatomy and form relationships are not ends in themselves to be displayed, but means to be used toward the end of greater expression. Orozco has brought back to painting something that had disappeared: dramatic form. First English and then French bourgeois society, the society of laissez-faire economics, expressed itself in Impressionist and Post-Impressionist painting, the painting of sensations and feelings. For Orozco, reality consists in a conflict of opposing ideas. In his frescos the conflict is resolved.

Another painter of ideas is Stefan Hirsch. He is not a propagandist. Like Orozco he believes in human dignity. He is now painting at the Lenox Hill Neighborhood Association a mural of man's place in the universe and his essential activities. One wall is about physical creation—building; another about intellectual creation; and the middle wall is the setting and the biological cycle. The symbols are extraordinarily simple, there is no doubt as to the meaning, and the result is moving. A childbirth represents birth, a burial death, and in these incidents he finds grandeur.

Of all the approaches, use painting requires the greatest objectivity. The personality of the painter and his artistic theories have to be subordinate to the purpose of the painting. Palmer's *Functions of a Hospital* serves the purpose in the entrance hall of an explanatory introduction for the patient or visitor. As clearly as possible and in as little space, the patient's course from diagnosis through operative and postoperative treatment is narrated. Less stringently determined by its use purpose, Laning's fresco at Hudson Guild shows a sober and unsentimental friendliness for the subject on the painter's part.

Benton has an entirely individual approach. He has the American's respect for facts, and a Missourian's suspicion of ideas. There is no reality beyond the reality of things.

The American scene is various, and Benton knows a good deal about it. He seems not to evaluate what he observes. To Benton there is little heroism or grandeur in the American scene. Laning says that the relationship that exists between women and little children is a good one. Hirsch says the common man is a hero, but usually Benton treats all his characters with a still-life impartiality. That is not to say that he has not got his sympathies and his dislikes, but it is hard to discover an attitude. He likes children, country people, and Negroes. He is ironical about the tie-up between business, politics and crime; between sex and religion; or about self-conscious intellectuality. He shows with the same amount of interest strikers being shot down, girls taking their clothes off, people in a subway, a chain gang, a bread line, or the working of a Diesel engine.

This might come from a lack of reconciliation between his interest as an artist, in form, and his interest as a man, in his environment. Or it may mean that life in the United States seen from inside, is chaotic and violent without collective meaning. We are a nation of individuals—a bourgeois democracy. His impression is like the impression you get of America from the New York *Daily News*. If he were a Marxist he would say that his painting showed the brutality and chaos of decadent capitalism.

The Purpose of Socialism

[*undated c. 1940*] The purpose of socialism is to end exploitation of men by other men. The greatest exploitation occurs in the totalitarian countries. They present a picture of the reverse of socialism. The trouble with theories of socialism is that they usually describe a condition of greater control over the population than has existed before. Their authors do this without meaning to. They cannot conceive of organized society without a separation between the controllers of production and the producers. This may be called a Plan for Production. If there is this separation, even if these controllers are called the Central Planning Commission, then just as now consumption both as to goods offered and as to their quality will be dictated. Also there will be no freedom of choice of occupation. We will be at the mercy of the controllers of production and manipulated by their

coordinated advertising. In effect there will be socialization of distribution, but production will be in the hands of a ruling oligarchy. This is like Plato's Republic, which is fascism. The difference between this society and private capitalism is that in private capitalism because of competition between different producing agencies the consumer and the worker have a certain amount of choice, and from this a certain indirect control over production. The program of the people who call themselves "progressives" is like this apparently socialistic but really fascistic program: they want to concentrate the control of production into the hands of a few people, perhaps the state, which is in turn controlled by the people. They are democratic and want to retain the parliamentary state. Their criticism of fascism is the same as Trotsky's criticism of Stalinism, i.e., that it lacks a democratic parliamentary structure. I disagree with Trotsky and the Progressives in this: voting power no longer is the same thing as control. The briefest illustration of what I mean is in the example of the divorce between ownership and control in the modern corporation. Bertrand Russell quotes some book by Berle and Means to show this. Another example is the emptiness of the interior democracy in a Bolshevik party. Fascism starts from Bolshevik actuality. The Bolsheviks and the fascists and the progressives all work in the same direction: they attempt to socialize production, they get the control of the total production in the hands of a small group, who then are able to dictate distribution. What Berle and Means spoke of as happening to the modern corporation, where the owners count for less and less, and the officers of the corporation for more and more, happens to the whole nation. The new middle class of managers and office workers and technicians assume control and oust from control the old middle class of stock holders, directors, rentiers and absentee owners. The bolshevik-fascist-progressive revolution is a seizure of power by the mayors of the palace, and the Carlovingian dynasty begins. German fascism uses anti-Semitism, "the socialism of fools," as a substitute for anti-capitalism.

The chief symptom of exploitation is the wage system. The state enforces this. Gorham Munson said, "The wage system managed by the party state is fascism." I think this is as good as so short a definition can be. The socialist revolution will abolish the wage system and abolish the state. It is not true that people will then not work. People

work on self-sufficient farms. Artists work and not for wages. The word worker under socialism will have the meaning that Stieglitz now gives it. All work will have the same nature that artistic labor has now. The control of production will be in the hands of each factory. It will be organized by workers councils. Consumers councils will keep track of the consumption of communities, and will hand over these figures to the producers councils who then determine how much labor time is needed to produce this quantity of goods. I understand that labor time accounting is used with complete success in many firms right now. A certain amount of time is necessary for reproduction also, which means replacement, both of the worn-out machines and of the workers who ultimately make everything. In short there has to be enough produced so that the workers can reproduce themselves. This is the bare requirement. The factory council might decide some years that the bare requirement was enough, that in the rest of the time they would like to lie on the beach in the sun, and other years that it was not enough, that they would also like automobiles, or ferris wheels, or violins. Then they work a little longer, or work less at certain other things. I am talking abstractly of course, but one can imagine details quite extensively.

The whole problem of the success of socialism centers around the bookkeeping. It is here that a new ruling class might develop. Therefore there must be local autonomy and federal rather than central power. The public school system in Illinois is a little like socialism. In Winnetka our public school is of course part of the state system, but the community elects a school board who chooses a principal who determines education. There is almost no interference from Springfield. I would criticize this as still too indirect. A socialist society is one organized around production in the simplest and most direct way. People will vote and take an interest because of the immediacy of the issues. To avoid a usurpation of power by the bookkeepers, all the population must be armed. There can be no distinction between an armed police and the population as a whole. This is parallel to the absence of all class differences.

The latest example of something approaching socialism was the Barcelona commune of 1936. After the workers quashed the army revolt, many businessmen left the city in a fright. Some stayed. Some companies were owned

abroad and the connection with the owners was cut off. Transportation and production went on. The capitalists were unnecessary. During a general strike when services are continued to the families of the strikers, there is a condition of partial socialism. A city under a general strike is a community half socialist-half capitalist. There it is apparent that not only the capitalists are unnecessary but also the unions and union officials, and the parties and their functionaries. The civil war is fought on two fronts, against the capitalists and against the people who in pre-civil war conditions were the leaders of the workers; i.e., their representatives before capitalism. This is what usually happens: the people who live by leading the working class find themselves unnecessary, first because there are not enough of them for the suddenly expanded activity of the working class, and secondly because new leaders come from the immediate situation, and workers also find that they can see plainly enough what to do, and don't need commanders. These former leaders, out of habit or cynicism or because they are honestly mistaken, think themselves necessary, and try to get control over the strike. They appeal to the necessity for a united front and use their acquired skill that comes from long political experience to get this control. This is equivalent to the defeat of the workers, for it is a renewal of rule over them. Union officials are also exploiters of the workers. When the strike ends with a return to capitalism, it is after the counter revolution has been carried out already by the leaders of the working class. When Franco won the civil war, it was only after half of his work had been done for him by the Loyalist government. The Bolsheviks gained power by a coup d'etat over a state that had already ceased to mean anything. They used the soviets as a means to get power in order to re-create the state as their organ. The October Revolution was the counter revolution.

The communist workers' party of Germany was organized like a socialist society. There was the following method of preventing the rise of a bureaucracy: a new central committee was elected each year from a different city and wholly from the membership of this city, and which sat in the city where it was elected, and subject, each member, to immediate recall by that local membership. No bureaucracy developed. From 1919 to Hitler, its enemies were never able to nickname it after a leader.

Class Content in American Abstract Painting

[*1962*] In international exhibitions of non-objective painting one notices a difference between the Americans and all the others. In general, if it weren't for the American paintings, such exhibitions would look like exhibitions of craftsmanship. European paintings seem produced by professionals. A professional follows a calling in which he claims to have a special skill or knowledge, used for the purpose of guiding others. He is trained, he is expert, and he may be hired. Outside of advertising or portrait painting, American painting looks non-professional. But this does not mean that it looks amateurish. The professional and the craftsman show conscious skill in attaining an end; the non-professional shows a love for his material and his act regardless of ends and regardless of skill. Skill may be acquired by practice; this love comes of itself from practice.

The essential content of any painting is its vitality, and when it does not represent any object outside of painting, you see the state of soul of the artist. Of course this is visible in representational painting, too, though the subject may distract you from it. The professional state of soul is manipulative. The professional thinks of an end, and skill is his means. The non-professional is lost in the process and his ends are not separate from his means. The non-professional acts like an artist for no reason at all; the professional uses art, and artistry may be his aim. The professional non-objective painter uses his talents partly to separate himself from others: the non-professional is contemplative. Contemplation is a mood of wonder and it is receptive. (To a religious mystic, contemplation means an experimental perception of God, that, like faith, is given; in contrast to meditation, which is willed spiritual exercise. Meditation is an activity of those who profess religion: contemplation is passive.) What the best American artist, say Willem de Kooning, is contemplating, is work, in the specific example of the painting; the scope of this contemplation extends beyond its aspect as an artistic profession.

The distinction between professional and non-professional carries over into children's art: for example the difference between the teaching of art in Russia and in the United States, as told by John Canaday, *The New York*

Times (February 4, 1962). I quote from Mr. Canaday's comments on his conversation with a Russian teacher, Boris Yusov, on the occasion of a review of an exhibition of Russian and American children's art: "One of Mr. Yusov's rules is 'Don't touch paper until you have decided on the form of the subject.' The child should be trained, he thinks, to identify upon sight an object with the means of representing it, whether the medium is drawing, painting, block printing or modeling, which are taught simultaneously. Everybody has imagination, Mr. Yusov believes, but you should be taught to have 'artistic imagination.'...The American child is encouraged to plunge in and invent as he goes, an approach adopted as the first imperative by many abstract painters also. The American idea all the way through trusts impulse and personal, spontaneous expression; the Russian contends that impulse makes sense only when it is subjected to examination and then expressed according to tested rules." Though what Mr. Canaday describes as the American method is not a part of the non-professionalism I mean, still it is evident that the Russians [like Mr. Canaday] believe art to be a profession.

The American content, where work is the subject of art, comes in large part from the example of de Kooning, who was trained in the Netherlands at the academy of Rotterdam, where he learned drawing, and in the firm of the commercial artists and decorators Jan and Jaap Gidding, where he learned the craftsmanship of painting, like a medieval apprentice. When he came to New York, he was appalled by the ugliness and lack of professional standards in American commercial painting; house painting by day laborers who did not respect workmanship; the ugly and junky utilitarianism of American construction, with no attempt to incorporate pipes into the walls and between the floors: on the other hand he admired the originality of the sign painters and letterers. He looked at these things with an artist's eye and ceased judging quality, and by contemplation turned the work he looked at into art. He saw painting done by workmen with no claims to special skill, no training and no social role, the workman himself his chief spectator, changing the work of his task into a kind of formal play; and a letterer doing the same thing, enjoying his skill, not like a professional, but rather like an artisan who does his own good job for its own sake, or perhaps for the love of God. A man paid for his labor instead of his skill, and

having no status to defend, may sing at his work, or make a dance out of it, for his own entertainment.

In part, American non-professionalism comes from the circumstances of history, from the nineteenth-century breakdown of craft knowledge caused by the industrial revolution when factories wiped out the remnants of the guilds. The end of the guild system ended the transmission of trade secrets that had not been written down. Guildsmen were master craftsmen. Shaw has the executioner in *Saint Joan* say something like this to the Earl of Warwick: "I am not to be addressed as 'fellow,' my lord. I am the master executioner of Rouen. It is a highly skilled mystery." Among the last American masters of the mystery of the craft of painting were Copley and West, both half Englishmen. Morse might qualify, though his European education was nineteenth-century—after revolution had almost finished guild monopoly of craftsmanship. As a master painter, Morse was an expatriate; at home he turned into the inventor of the telegraph. (Now, more than a hundred years after Morse's invention, an attempt is being made to give artists the same income-tax privileges as inventors.) Medievalism did not survive the transplantation of English and French craftsmen across the Atlantic; and after the Civil War released the full potentiality of the industrial revolution, native professionalism disappeared from the arts.

The isolation of the New England settlers forced each man to be an all-around technician; necessity valued work above special knowledge, and Protestantism exalted it as a virtue. One of the first "American" painters was Eakins. Though he learned painting in France, he did not have a craftsman's class consciousness. He honored his father, the writing master, less for his status than for his self-acquired wealth, the outward sign of work done, whose reward is independence. He remained dependent on his father, and he kept demonstrating that he believed art is worth the labor that goes into it. He suspected professional skill, as shown by his comment on Whistler: "What a cowardly way to paint!" Is truth beauty and beauty truth? If he thought so, he might have agreed with the comment of Bertrand Russell that the truth is usually dull. Eakins was a contemporary of Dostoevsky, who had Shatov (*The Possessed*) go to America to experience the hardest conditions of life. And until the second World War American culture was

predominantly the product of amateurs, while those artists who wished for professional status expatriated themselves. These could not carry the burden of native indifference and hostility: abroad their status alone commanded respect. Respected in Europe, they were on the defensive here against the popular suspicion that they made aristocratic claims. At home, the American artist could be professional at the cost of provinciality, like the American Impressionists and Cubists; or he might be an original crank. Ryder and Eilshemius were not provincials, but their isolation exhausted their energy, preventing Ryder from producing, and lowering the quality of Eilshemius' work to the level of what Lewis Mumford calls Italian restaurant painting.

Until the last war, the inferiority of American painting lay either in its provinciality, or in the fact that the painters did not know their profession. Why belong to an elite that is, on the whole, despised? The popular American suspicion that the intellectuals made aristocratic claims was correct. The European painter was a professional; and with the nineteenth-century decline of the aristocracy, the professional class became themselves an aristocracy of merit. This is the class to which the lawyers belonged, those masters of the mystery of social structures. The academic painters and the followers of Delacroix and Ingres identified themselves with the restored monarchy, or with the Bonapartists, but the Impressionists identified with the bourgeoisie. The Americans, Copley, West, Allston, Stuart and Morse, had studied with professionals whose place was with the new aristocrats of European society. There was no American counterpart. The Impressionists identified with a middle class that was not tyrannized by the idea of work—a confident society which saw France as a Garden to be cultivated for man's delight. Neither was there any American counterpart for this. But the Impressionists had an idea of art much more like that of present-day American nonobjective painters than any artists who preceded or followed them.

The Impressionists had to learn their profession from scratch. Guild techniques had ended with the guilds. In a sense the Impressionists started as amateurs—which was why the critics opposed them—yet the Continental regard for education gave them a status. With this encouragement, they turned their amateurishness into a new profession. In their passivity before nature, and in having to learn every-

thing by themselves, they came upon new qualities in pigment. They portrayed no ideas from outside of painting in their preoccupation with painting as a working of material. What does the paint look like, what does it do? They did not monopolize understanding, and they did not even know what nature looked like. Their Naturalism was based on ignorance.

Cézanne, who wished to "make of Impressionism something solid and enduring like the art of the museums" was an Impressionist until he left the company of Pissarro to go home to Aix. There he lost contact, and what he did was not at all what he thought he was doing, but instead, though he could never shake off its effects, he denied Impressionism, which he no longer understood. He became preoccupied with the contour, which eluded him, though one of the discoveries of Impressionism was that the contour was unimportant relative to the interior light, substance and weight of what it contains. The Impressionists did not so much discover the physics of light, as Seurat thought, as the nature of pigment in the representation of vision. Cézanne, impressed by the Impressionists, missed their originality. His critics seem to think he discovered modeling with color. But the Impressionists had begun to give up modeling as irrelevant to the way vision reveals reality. Nor did Cézanne model with color, except insofar as different colors have different tonalities: his modeling is tonal; it all shows in a black-and-white photo.

The artist who did make something solid and enduring out of Impressionism, was, as much as any other, Vuillard, who derives, via Sérusier, from Gauguin, who did not understand Cézanne. Vuillard organized Impressionist discoveries about color and pigment into a coherent whole. The difference between Cézanne and Vuillard is that for Cézanne as for the pre-Impressionists, form in art is a translation of the three-dimensionality of objective reality; the cylinders, cones and cubes to which nature "can be reduced," while for Vuillard the form of art is a form of the Impressionist interpretation of vision; it is not objective, and results from no reduction of nature. To believe that reality results from a reductive process, is like the assumption of the pre-Pasteur chemist von Liebig, that when a plant is burned up, all the solid elements essential for its life will be found in the ashes. Vuillard's ultimate reality is a form of vision, in terms of paint, plus the implied presence of the

artist who sees, realized in a more coherent and orderly shape than was attained by the eye of Monet. There are "realistic" Vuillards with hardly anything recognizable that have the over-all non-objectivity of present New York School painting. As Cézanne leaned on his sister who leaned on her confessor who leaned on Rome, so his art leaned on his "little sensation" which leaned on an idea about external objects. This is also true of his inheritors, the Cubists, and of the Expressionists. Expressionist exaggeration emphasizes the intractability of the outside world. Vuillard did not confuse art and the world. He did not compete with external objects. Since he only shows what he directly knows, and any interpretation is implied, the reality he gives is the one you bring with you. The circle of the pupils of Sérusier, calling themselves Nabis, thought of themselves as a spiritual and private elite, not a worldly one. They left the spectator alone.

Post-Impressionism continued the reaction against Impressionism. The Expressionists over-estimated the power of the outside world. Art protected them against an encirclement of enemies. A European Abstract-Expressionist turns Expressionism into an idea (the "abstract" part of the compound name) out of which he makes a career. Schneider or Mathieu resemble writers of ghost stories or murder mysteries. Either one is a Graham Greene of painting. In all of Post-Impressionism, the idea enters from the outside, guiding the painter. This is least so in Picasso, for his idea eludes description. Dada and Surrealism illustrate; and among the followers of the abstract schools of the Netherlands, Germany and Russia, the idea has radical and teachable lucidity. Ideas are the speciality of the intellectuals, who are etherialized professionals. Albers' belief that art should be infinitely reproduceable is one that makes the idea more real than its concrete embodiment. An intellectual is an "ideal" professional and abstract ideas are the preoccupation of intellectuals separated from the practical world. An art that finds ideas more real than things is attractive to the unemployed intellectual. As the economy contracted, there were fewer openings for professionals; but European society still held education in the highest regard, for the educated are masters of the greatest mysteries. And Existentialism, in the assertion that what ultimately counts is simple, existence, rationalizes a paradoxical situation where society has no use for the skills it values most.

It is also from the unemployed intellectuals that the Bolsheviki were drawn; in fact this is the class that contributes the membership of all revolutionary organizations of both right and left. The successful revolutionist is one who is able to force society to give him the place of command that society has taught him to believe he deserves. Constructivism was the art of the early days of the Russian revolution, but after the October seizure of control over the wage system by an organized group of intellectuals, the state could not much longer tolerate a movement that put the reality of an idea above the still uncertain security of party control—that tended to make people believe anything more important than the secret police. Social Realism is the art of the intellectual in control of the economy. It is the art of any state, the security of whose power depends on its ability to freeze the class struggle into immobility. Superficially the Social Realist artist pretends a partisanship with the wage worker. Underneath this he says something different. Even if his subject is a vase of flowers, he lets you know, by his manner of painting, that he has made himself a task, endured without complaint, for labor is the supreme value. Like the paintings of Eakins, Social Realism is the art of the most austere period of the industrial revolution. Art is turned into work: however when Eakins did this, he did so of his own volition: the artist in the total state is *gleichgeschaltet* into the economic plan for all production whose creator is a committee of professionals. The art of the professional not yet in control, is "social consciousness." It is the art for those professionals who envy their privileged Russian brothers, those engineers of the soul whose pay is commensurate with public esteem. Social consciousness devalues everything except revolutionary activity. It devalues itself, like those toys that destroy themselves. In saying that what is, is bad, it inhibits the artist's experience, and causes him to fall into the habit of using clichés from previous styles. The artist knows everything and uses his eyes only to keep his hand from slipping.

As Cézanne denied Impressionism and started the return to art as the expression of ideas outside itself, or, in social terms, art as the class expression of the professionals, so the New York School that arose after the war, denied Post-Impressionism. It is closer to Impressionism than to anything else. As the Impressionists passively contemplated nature, so these painters do the same to painting in all its

aspects and uses. They do not rate what they contemplate and for this reason they make art out of the work, that is, the activity, of painting. This is an unprofessional attitude, which on one hand gives this painting its popularity, and on the other has led many critics, educated to respect art as a skilled mystery, to dislike it.

The proletariat lives by work; this is all it has to sell, but when this work turns into art, it is no longer a commodity, nor any longer the activity of a proletariat. As soon as art is sold it becomes a commodity, and then it begins to lose its unprofessional status. But there is a lag between its first popularity and its professionalization. One of the reasons for the professionalism of French non-objective painting is that it looks like the latest thing: and French business remembers the way in which those amateur-looking Impressionist paintings gradually became expensive commodities. New York School art is still rather classless, and what one might expect to find coming out of a classless society. But the art of the Communist states and of almost all other countries is a class art. In England there is some of the unprofessional quality of American non-objectivity. America has had a long tradition against professionalism, and England was the first country in the world to industrialize. Intellectuals, who think that Marx was another Jonathan Edwards, like to say that events have proved Marx wrong: for didn't he say that Communism would come first to the most advanced industrial countries, and did it not instead come first to the backward countries? These revolutions, however, achieved by class means, resulted in class societies. The Menshevik Martov testified to the class means even before the Bolshevik-Menshevik split in the Russian Social Democratic party. He said that the greater number of Russian workers stayed away from the Social Democratic party because they were not allowed to have an equal say with the intellectuals. The chief symptom of capitalism is the wage system whereby the worker is denied the full return of what he produces. This remains; the only change in all the revolutionary states of right and left is in the quality of control of the system. In contrast to the anarchic, indirect and flexible control of the wage system in capitalist countries, there is the organized, direct and rigid control of the totalitarian states. Lenin said that political class consciousness can only be brought to the workers from the "outside," outside the economic strug-

gle; and this was because it was not their class consciousness, but that of the unemployed intellectual desirous of command. If the worker should control the wage system, it would at that moment vanish. In what country is it closer to vanishing? Who controls the wage system in America? Does the worker, the professional, the government, the investor? If the transport workers union calls for a strike that prevents the New York Central and Pennsylvania railroads from merging, who controls the wage system in the railroad industry? The late John D. Rockefeller, Jr., is supposed to have said, "In my father's day the man who controlled industry was the man who controlled money, in my son's day the man who controls industry will be the man who controls labor." Rudolph Sprenger, the author of the first analysis of Bolshevism pointing out its class nature (translated into English in the thirties), came to this country in the late thirties. He got a job as a tool-maker. He described the difference between the attitudes of American and German engineers toward their work. The German engineer separated himself completely from the factory. The American liked to work machines in order to experience directly the result of his designing. The American professional did not share the class consciousness of his German counterpart. This is an example, noticed by a German Marxist, of characteristic American unprofessionalism.

American conservatives maintain that in the United States we have a labor government. They base this conviction on the decreasing profitability of American capitalism to American investors. Is not the combination of abundance with decreasing profits a sign of a profound social change? Take the example of the bourgeois revolution that was two hundred years or more in coming to France, and that was organized by the alliance of the monarchy with the third estate against the nobility. Did it not finally come as a result of abundance (France was the richest country on the continent in 1789, in terms of national product) and unprofitability, so that the king had to call in the third estate to rule in name as well as in actuality? You can find out a great deal about society from its art. Was not this revolution foreshadowed by the seventeenth- and eighteenth-century paintings of Georges de la Tour, the brothers Le Nain and Chardin?

X

Art and Science

Art and Knowledge

[*1966*] Sometimes people ask for standards by which to measure art, in order to be able to say that one thing is art, and another is not. The psychologist E. L. Thorndike contends, "whatever exists at all, exists in some amount," implying that art is measurable, or that it does not exist at all. Being used to explanation, we expect that when we ask what something is, the answer will place it in causality. Art has so much variety that it is tempting to try to find a common denominator. But the denominator is vitality, whose logic is inside itself. You can follow inner logic: you follow your vitality, you do not tow it behind you. Something is either alive or it is not. You can measure an amount of energy, but not aliveness, which, like a chemical reaction, has the quality of wholeness.

The wholeness of life is neither the result of consciousness nor arrived at through decision. When New England was our western frontier the wholeness of life in Massachusetts centered on the individual who did almost everything for himself to live comfortably in the wilderness, like Robinson Crusoe on his island. He wished to exclude art from what he expressed, and being consciously anti-artistic, he could not see how artistic this life was, both in small

things expressing it and in itself as a whole. In the same period, life at the French court, with no regard for comfort, attempted the magnificent burden of an earthly imitation of the hierarchy of heaven. And in order to express this consciously artistic and disciplined wholeness, French seventeenth-century art was as systematic as the law. But only the breakdown of this discipline and control resulted in its greatest artistic expression, namely tragedy.

As the wholeness of life eludes control, so the wholeness of art eludes the control of the artist. The realist thinks he knows ahead of time what reality is, and the abstract artist what art is, but it is in its formality that realist art excels, and the best abstract art communicates an overwhelming sense of reality.

The true and the beautiful became identified in people's minds at about the same time that they became convinced that the scientific way is the best way to the truth. Science has two ends, a practical one and the truth. Since the first is controllable, why not the second, and if so, does it not follow that each is smaller than the controlling agent, man himself? Since art is truth, which science leads to, science should lead to art.

Like art, science has an interior logic, but unlike art this logic tries to correspond to the outside logic of the universe. Limiting itself to questions of causality, scientific investigation starts with particulars and goes on to the general, by looking for ways in which particulars are alike, for this leads to a useful generality. The process is reductive, from difference to likeness; chance leads from chaos to order. Science predicts the highest probability. This is the logic of chance: the most probable is the most reliable order, which in the end is uniformity. Arising from chaos, structure reduces to rigidity, and the ultimate reality is death. The ultimate reality of death is assumed by those of us who are so much impressed by the prestige of science as to think there is no certainty outside it.

The anthropologist Jaime de Angulo once lived among some California Indians who traveled through the woods in old cars, which they skillfully kept in running condition. At his remarking on this one of them answered, "You white people think everything is dead."

Now, as certain questions are not profitably investigated by science, neither is it profitable for the artist to limit himself to the guidance of science. The artist considers *what,*

which presumes shape. The scientist tries to find shape through following the path of cause and effect that leads to death. To insist that *what* derives from *how* is to require the answer to come from outside. And this leads to saying that a thing is not what it is, but something else. An artist cannot do this and still adhere to the inner logic of art. The search for meaning altogether in outside relationships cuts the artist's communication with wholeness to finding significance only in the partial.

Consider surveying, which follows a scientific method. Its purpose is to discover the shape of the land. If you compare a chart made by surveying methods from the ground to an aerial photograph of the same coast, the first noticeable difference between the two is that the map drawn on the ground is hesitant and awkward, and though this awkwardness can be diminished in a perfection of the methods, the map will still fall short of a sense of the whole in which there is no conflict between whole and part, while the photograph taken from the air has an immediate wholeness that the men on the ground do not get. There is a similar difference between "abstract naturalist" painting and photography. The painter who wishes not to be realistic and at the same time communicate nature, produces something that implies that the nature of nature is chaotic; but the photograph reveals unique shape, that is, wholeness. However imitation of either nature or photography will not get wholeness, for what is whole is unique and not reproducible, nor found in the pursuit of a comparison with something outside itself, which can only produce the partial.

Proof, the demonstration of repeatability, makes science valid; but following vitality, the consequences of which are never the same, gives art its validity.

Art was taught scientifically at the Bauhaus. At the beginning you were asked to reproduce your own signature, which is to attempt to prove the unique by the paradox of repetition. It was shown that what a color seems to be depends on context. This training makes the artist think of colors in general, while in painting there is no Red or Blue, but only specific pigments. The Bauhaus theory finds art valid insofar as it can be included within generalizations—in order to be used by industry.

In a scientific world, morality gives way to health. You express disapproval of an opponent's point of view by

saying that he is sick. The healthy man adapts himself to society organized around industry and becomes a propagandist for industry in the advertising business. Or he may reverse the industrial organization of society into the social organization of industry, as in the total state. First comes the artist as industrial designer, next the artist as social designer, last the artist as "engineer of the soul" who tries to redesign individuals into controllable statistics.

Art as social criticism is as good as one's agreement with its message. If art is communication of a message, then the message counts more than its presentation. Art is useful if it tells you something. Certainly this is not information. If it is an idea, then the message that counts is ideal, existing in some intangible place. The ideal can be explained, but presence can only be experienced. You can completely define the immaterial, but what is at hand escapes translation. Science explains—that is, translates and reduces—to give you a substitute for experience. The scientific prejudice dismisses the difference.

Science has come into art through criticism. Morelli used science to identify the authorship of paintings with such success that he was followed by Berenson and Roger Fry. In his translation of Mallarmé, Fry tentatively agrees with Goethe that "the fundamental quality of poetry is translatable into another language." This means that the actual poem is less real than some essence to which it refers, and that you can get equally close to this essential reality in any language. But a poem does not exist until it is written in a specific language, and its significance is larger than anything, including meaning, that can be abstracted from it. A translation remains a substitute, lacking the wholeness of the original.

Is art the way the idea is presented? Willem de Kooning in 1950 gave a talk at a Museum of Modern Art symposium, and afterwards someone asked him to explain something he had said. "Could you say it in other words?" His answer was, "It took me two weeks to find out how to say that, and now you ask me to say it differently." What is said differently does not have its original wholeness and artistically speaking it is different. You cannot separate the idea from its presentation.

You cannot separate them, but this does not mean that presentation is the essence of art; nor that presentation, being method, can be explained by analysis. Too much

is left out. I remember in some art book an illustration of Titian's *Entombment* with a triangle superimposed to generalize the shapes. The point was, by this means to explain the composition by suggesting that it was essentially a triangle. The presentation was idealized. But if you said that a triangle is essentially Titian's *Entombment,* it would be thought impertinent, for it is automatically assumed that geometry, being ideal, condescends to the actual.

Plato, who thought actuality was the shadow of reality, wished to honor the poets, and then banish them from his Republic. They were a danger to the State. Did Plato understand art to be opposed to the ideal? *The Republic* finds its closest approximation in the totalitarian states, which show, in a disguised fashion, Plato's attitude toward art. They want to use it, and in doing so they make it partial. If what is valuable about art is a reference it makes, then, socially speaking, it might better be replaced by this reference. Independence is a necessary condition of the wholeness of art. Art is a threat to a Platonic republic because it says there is something more real than the ideas that command loyalty to such a state. The totalitarian ideal is socialism, without tangible existence. In practice it is a more efficient control of the wage system requiring more rigid class separation than capitalism. Art says the real is specific, and as long as writers and artists assert the present and the actual they get into trouble with any group dominated by an idea. The artist can assert the reality of art without reference to anything outside art, or suggest that there are ways to reality that no organization monopolizes: in either case the organization, if it has social power, will interfere.

Science, in moving from the particular to the general, prefers to ignore that which there is no hope of reproducing, because such things cannot be generalized in a proof. It takes for granted that nature as it is first known has no form, and out of this the scientist induces form. He assumes distinctions and searches for wholeness, which he would rather not find unique. (His way of saying this is that he does not trust a hypothesis that cannot be disproved.) The artist takes wholeness for granted and searches for distinctions which are the form of wholeness. For example, the scientist will not take it for granted that the sun will rise tomorrow until he can abstract a proof that it will from his observations; but the artist tries to see the sunrise separated

from the generalizations of memory. The scientist looks for the useful, the artist for the unique. The scientist proves that something exists if by explanation he has made it smaller than himself.

There is another attitude toward existence, namely, respect. The scientist resembles the Platonic social theorist. If you make order important in a Platonic way, you have to close your mind to disorder, as Plato closed his Republic to the poets. There is a nervousness about the uncontained. As tragedy eludes the academician, wholeness eludes the pursuit of order. The inclusive esthetic values are found on the level of knowledge that needs no measure.

Artistic thinking is not the kind of civilized thinking that Robert Maynard Hutchins opposes to "scientific" thinking. Hutchins opposes "scientific" thinking because in its close attention to facts and details it seems to him to inhibit the ability to generalize, which is sometimes given as a definition of intelligence. Art is neither like the "science" Hutchins opposes, nor the generalizing he proposes. It is not details (the artistic counterpart of facts) that count in art, but an integrity produced by differences.

Standardization is the victory of the most probable; art is for the improbable and against the standard. The art critic who attacks disorderliness asks why the artist can't make an honest living, and like the judge at Josef Brodsky's trial, he wants him to be brought under the control of the wage system. He is looking for the most probable, the safety of familiarity.

How can you know what art is if it is inexplicable? The answer is that the most certain knowledge is untranslatable. People do not trust this kind because they have been misled into thinking that you only know translations. Education teaches you to prefer indirection. But the best art has the best connection with the state of mind in which the commonplace becomes original. This is the way one recognizes wholeness.

Where art is, there is a presence. Artistic excellence is proportional to its strength. The esthetic thrill is the recognition of this presence; you feel: *thus*. It reveals what our education suppresses. Since its validity depends on uniqueness, it cannot be proved. I know nothing more certainly than my own sensation, and I cannot be sure of the quality of yours. Yet communication is there already. People do not ask what something means because they do not know,

but out of fear of their unconscious knowledge; they ask in order to appease their education and to lift the pressure of a separate and immediate reality. They ask what something means so as not to have to attend to it.

One learns from art to recognize and accept diversity for its own sake. One experiences a connection with the deepest part of oneself, and one learns that formality thought up ahead of time is incomplete, and leads away from wholeness.

Freud said that education has made us discontented because it has damaged our self-love in three ways: first Copernicus taught that the earth is not the center of the universe; then Darwin showed us that man is only an animal among animals; and lastly psychoanalysis shows that we are not masters of ourselves. But I would say that the damage to our self-love comes from a suppression of a sense of wholeness resulting from our education. Freud says our self-love has been hurt. Yet why should self-love need the assurance of the self being at the center of creation, or especially separate from the rest of life, and why should it require belief in the possession of a divided soul one part of which controls the other? Is self-love intellectual? If so, it is because we have been taught that love needs conditions, that it comes out of respect (it is probably the reverse) and that respect is earned. Before education we love ourselves without outside help. We take wholeness for granted. The pleasure art gives us is in making us aware of what things are, including subjective things, and it shows us that these props to our egotism (that Freud thought we thought we needed) not only are unreal, but further, that we are not concerned about them. We do not earn our self-love through proving to ourselves that we are worthy of our own self-respect, nor does the outside world earn our love of it through causing us to respect it. Each one of us knows his own reality and that this is his integrity. Just as the questions "what" or "what for" have no meaning in science, so the aspects of our education that Freud found wounding to his and his patients' vanity have no validity from the point of view of art.

Wholeness is as close to you as yourself and your immediate surroundings. You need not pursue it, you have only to accept it. What is real and what is alive is concrete and singular. In a statement of esthetic belief Pasternak said, "Poetry is in the grass."

Art and Scientific Method

[*1969*] A good work of art can in its entirety be represented
only by itself.

—Tolstoy

In the nineteenth century it was commonly believed that
truth in art meant "likeness" to objective nature. In Eakins'
time science was empirical, and Eakins placed his trust in
an assumed projection from the object through the lens of
his eye to the canvas. Art was projective geometry. The
Impressionists relied more simply on seeing itself, without
reference to what it might be that they saw. Seurat had to
verify seeing by routing it through his conscious mind, as
Stravinsky says he has to do with his muscular activities in
order to be able to walk, now that he has reached the age
of 86. In the nineteenth century, science was empirical, but
the empirical element is being continually reduced in mod-
ern science. The ultimate realities of physics are expressed
mathematically, which is to say in ideal terms.

Twentieth-century esthetics comes from the reaction
against Impressionism and is supported by the tendency of
modern science to grow away from empirical fact and re-
duce the totality of everything that exists to essential and
manipulable ideas. Twenty years ago in the conversations
of those painters around whose talks the Eighth Street Club
was formed, it was common to disparage "illusion." The il-
lusory is what probably does not exist, you can see it as you
see a ghost. It may be a trick, a deceit. What is real enough
to place your confidence in? If it is form, what is form in
visual art? Is it order? Is it something which makes sense?
Is what makes sense an essence that can be extracted from
the thing? Is it a translation—an expression in other terms?
There is a school of criticism that seems to take off from
semantics, that tries for scientific objectivity, and is con-
nected with art education in colleges and universities. What
one can make sense of, to talk about, must be presented
logically, following the rules of language. I think this
criticism derives from the enormous prestige of science
consequent on its useful applications. Science looms over
us; it dominates education; and according to what an in-
creasing number of scientists increasingly say, in its practi-

cal applications it threatens within a generation or a century to make the planet uninhabitable for all vertebrates, bees and flowering plants. The threat is both enhanced and hastened by technological solutions. As Barry Commoner said there is something basically wrong with technology.

What is wrong is that the scientific notion of reality, which is at the bottom of technology, is inadequate. It is inadequate because it is limited by the idealism of the scientific method. The practical successes of science come from a reduction of the totality of "everything that is the case" to what can be used. Science uses facts as though they were the replaceable parts of a mass-produced machine: what counts is their similarity, their replaceability: that which recurs. The uniformity of nature is a scientific ultimate within which all events take place and towards which all processes return. This view of reality ignores the specific quality of facts, which are notoriously arbitrary.

The scientist does not go as far in the direction of ideality as the mathematician. The mathematician's facts, having no material existence, can be manipulated with absolute certainty. Science does not deal with absolute certainties, and a generalization from material facts can only be an approximation, and manipulations of these approximations can therefore lead only to approximate results. What in science is called proof is not absolute as in mathematics, but rather a demonstration of a very high degree of likelihood: it is assumed that what seems most likely to happen, will happen. Yet the connection with the particular and the arbitrary grows more and more tenuous. That modern science leaves experience ever farther behind is attested by Buckminster Fuller's reply to the (naturally hypothetical) question, "Where do you live?" with the proud banality that he lives on Spaceship Earth; and to the question who he is, with the equally proud and apathetic reply that he does not know. These questions, he seems to indicate, have no scientific significance, which to a layman is like saying that they do not exist.

When Bertrand Russell investigated the question of knowledge, he found that he could reduce knowledge to three principles, and from these principles build up again, first mathematics, next physics, then chemistry, presumably followed by biology. These principles come out of the theory of numbers, so they establish a mathematical basis for truth. They are: quantity, class and the idea of the

successor. But he could not derive from these principles an explanation for the way in which the weather never exactly repeats itself. He could not derive from them the fact of communication, that even creatures of different zoological orders, as for instance a dog and a porpoise, understand each other somewhat, without translation into some mediating logical system. The quality of communication is not illuminated by explanation: nevertheless it exists.

Art critics who have been impressed by positivism want their criticism to make sense in the way that Russell's logic does: they have the layman's disbelief in the existence of that which is without scientific significance. As in science, what has significance in this esthetic are events that recur, and recurrence is artistic form, which it is possible to talk about only insofar as it is logical, and can be translated or measured. This measure is its validity; it is what can be taught. The most formal is the most general, the most amenable to systematic translation. Wittgenstein had the idea that to know an event as one knows a proposition in logic, it is necessary to translate it into a picture of itself, according to rules of logic. In a way this is the reverse of the verification of art by criticism, for it implies the use of art to know nature. The picture reinforces one's belief in the reality of the existence of the facts to which an experience refers. What good is art if it has no connection with the truth, and what better way is there than the logical way of getting hold of the truth?

Logic is a criticism of experience. The ability to communicate implies the ability to manipulate, which is most complete when, as in mathematics, the terms of the communication are reduced to immateriality or the ideal; for in the material world one comes up against the intractability of fact. Since a fact is specific, as part of a generalization it will lose specificity: its integrity will be destroyed.

A scientific proposition which has to keep the connection with material fact requires, to persuade one of its truth, the assumption that what is almost certain (almost capable of truth) is true enough. It follows that a scientific proposition is almost communicable. But when one's concern is, like an artist's, with the arbitrary and the particular, there can be no "logical" communication at all, for the arbitrariness of the original experience will not survive a generalization that is necessary for logical communication. The question comes up, has the arbitrary got form? Is it real?

Material form is always arbitrary, and cannot be expressed by essence or elixir, and to know the arbitrary exactly is to know something that cannot be generalized. Wittgenstein came apparently to believe this, as indicated in his remark that "every sentence is in order as it is." The form of the arbitrary, the order of the material world of fact that is there as it stands, being insusceptible to depiction by logic, cannot be part of the world of either mathematics or science. It is a world in which what is certain cannot be repeated. I believe this is the world of art.

Art connects us with the material world, from which mathematics, science and technology separate us. It is concerned with the particular; it reconciles us to the arbitrary. Artistic particularity has no connection with technological generality. The concern of technology is to even out, to bring about that uniformity of nature envisaged by the idealism required by the effective working of its methods. The purpose of technology is, in effect, to hasten the process of entropy—in short, to destroy. Insofar as twentieth-century esthetics derives from the idealism of logical positivism, it serves the purpose of promoting, like technology, our separation from the world of material fact, and it is opposed to art. And so also are those artists allied with technology, such as most architects and industrial designers.

If a good work of art cannot be represented in other terms than itself, how does one talk about it? The answer is, in analogies. A description bears a family resemblance to its subject rather than reproducing it. An intelligent esthetic analysis uses the concepts of quality, relationship and the transition. Being outside of logic, these concepts do not "make sense," and since they are untranslatable they are not "useful." Art discovers a reality that human intelligence is not coextensive with and that cannot be manipulated. One understands material reality by experience. One understands art by imaginative identification, which is also the way the artist (or scientist, or logician) discovers his subject in the first place. Wallace Stevens said the aim of poetry was "without imposing, without reasoning at all, to find the eccentric at the base of design." This is both the artist's vision and his sense of order.

Albert York

[*1974*] Our present day wide-spread discontent seems to be caused by the feeling that nothing any longer is worth while. Why do we feel this? I guess it is the influence of the astonishing accuracy and success of the scientific method which, separating the scientist from his observations, precludes value and emotional involvement. All that is left is quantity. "Everything that exists," says the psychologist E. L. Thorndike, "exists in a certain amount." Does it follow that, unless you can tell how much, there is nothing there? Until recently what was thought to be the scientific method has

46. ALBERT YORK: *Twin Trees*

been accepted as guaranteeing the way toward a better, fuller, and more valuable life. Now we question this: we see that technology's application of the scientific method for these progressive purposes may very well finally finish us off.

The popularity of art today is a reaction against our disillusionment with an objectivity whose purposes are not ours. Albert York's paintings are popular partly because, as Gertrude Stein said of herself, he has a small audience; but, much more, as a reaction against the standards of a criticism based on the nineteenth century belief in progressive change. This criticism, for all its old-fashioned materialism, looks for precognitive talent, for an ability to foresee the next fashion. York's paintings do not look like the next fashion but, rather, old-fashioned. Instead of mural-sized and bland, they are small and intense. They are approximately ten inches off-square. They do not contain the hectic emotion of expressionistic paintings, in which the painter, separated from his experience like the scientist from his experiment, projects his emotions onto the outside world. York's paintings are without pathetic fallacy. They contain an emotion that he has discovered outside himself. Take the painting of two trees, with a pond between them, in which one of the trees is reflected. It is for him the source of his imagination of the trees' lifelong experience. These two trees could be Baucis and Philemon after Zeus, at their death, changed them into trees to grant them their desire never to be separated. He identifies with his subject, whether a tree, a cow, a glass of flowers, or the woods. But not only with the subject: he also identifies with his materials, and with the translation of the identification with the cow into an identification with the paint he uses to present the cow. His watercolors do not so much express a masterful technique in watercolor (which they do) as an identification with the nature of the medium. Certainly part of the strong emotional appeal of these paintings is that he is not clever, and in no sense superior to the nature of his medium or the nature of the subject, but that he is as one with both. It is his identification, his empathy, that attracts. He does not "know" anything better than you who look at the painting; rather, he is able to identify with the mystery of the world that our civilization tries to keep us from being aware of.

Technology and
Artistic Perception

[*Talk
at Yale,
April 8,
1975*]

The idea of progress is taken for granted. It is the ideological basis of technological civilization, which we also take for granted all over the world, on both sides of the Iron Curtain and in the "third world" for whose adherence communists and capitalists are competing. The idea of progress has also strongly influenced modern artistic production, for art, like all social activities, cannot help expressing the common basis of social life.

The progress of science causes the progress of its application, that is, technology. Science organizes knowledge. And to organize knowledge you have first to reduce it to common elements. You have to ignore the arbitrary and inharmonious—at least until they can be made harmonious and no longer arbitrary. Organization implies order. An order can be repeated and order implies control. But the arbitrary is very insistent and unavoidable. One ignores it at one's peril.

Morse Peckham wrote a book, *Man's Rage for Chaos* in which he said that the activity that finds the particular case which does not fit the theoretical organization of the facts is "the activity of artistic perception." Peckham therefore accepts the preconception of civilization that to upset the orderly basis of society expresses an urge toward chaos. Civilization means order, and art means disorder. This seems to have been Plato's belief also in regard to the poets.

I was once told by a professor of philosophy that the great and original contribution made by Bertrand Russell to philosophy was his contention that all of knowledge could be reduced to three things fundamental to the theory of numbers. These are the notions of quantity, of class, and of the successor. From these three conceptions can be built up again all of mathematics, then physics, then chemistry, and finally presumably biology and psychology. But one cannot reconstruct art from these three concepts. If you analyze aesthetic analysis, perhaps one of the notions on which it is based is the idea of value. This means the quality of something in its particular relationships to a context. There is also the idea of quality, which

271

is the particular nature of something, or perhaps the nature of something in particular. Then there are the notions of relationship and of the transition. In this connection it is interesting to note that Russell was awarded the Nobel prize, not for his original philosophical contributions, but for literature. He won the prize and was honored as an artist: that is, for his great sensitivity to the qualities of language, or the particularity of words and the way they relate to each other, and to the way he made transitions between words and sentences. He was honored for the way that, in practice, he refuted his own philosophical contribution.

George Maurice Edelman, on the occasion of his synthesis of insulin, was interviewed by *The New York Times* (April 15, 1969). The reporter, in order to make a story out of Edelman's being both a scientist and a poet as well as an amateur guitarist, asked him if he found any conflict between the two worlds of science and art. Edelman replied, no, that both were imaginative. Then he added: "Science is concerned with the general and it looks for recurrent events in a world that has one value at a time; poetry is concerned with the arbitrary and the particular and can look at many worlds at once." Instead of denying a conflict, Edelman's answer described the nature of two points of view about reality.

I believe, like many people, most of whom, at least most of those who articulate their beliefs, happen to be scientists, that the world today is in the most critical state that it has ever been in; that our activities threaten the continued existence not only of "civilization" but of life. The point of my talk is that the difficulties that threaten us come from our acting out the values implied in the first point of view about reality, and that perhaps the solution to our difficulties can be found in the second point of view. Therefore it is appropriate to say what I am saying to art students. When I decided to study art, art was considered of peripheral importance; the artist or poet was thought to be outside of the mainstream of life. I remember a neighbor whom I respected very much, who was disturbed by my decision, and told me so. This man was a businessman, and at the same time an inventor and a poet. He told me that his first reaction to anyone's wanting to be an artist was the thought that this meant deciding in favor of triviality. Then he thought of the Vatican

272

Torso, the piece of antique sculpture which Michelangelo said was his master. Triviality meant to him decorative objects.

Today art is vastly more popular than it was forty-odd years ago. I think the reason for this is that it answers a feeling of emptiness produced by our progressive and antiartistic civilization. It isn't enough to say modern civilization is against beauty, for that might be only sentimental. What is beauty in the face of the death by starvation of half a billion people? What is the significance of spiritual concerns to people whose physical survival is at stake? I believe that the popularity of art today is the result of a recognition that the flaw in our so-called materialistic civilization is that it is out of touch with matter—with matters of fact—and that we see in art the connection with the material world from which technology separates us. The progress of this civilization is progress away from direct experience and into an insubstantial world of ideas. The trouble with the idealism of technology is that it is necessary for technological success, and it does not fit the material facts. It is not that the activity of artistic perception sometimes discovers that particular facts do not fit theories, but rather that they never quite do. The particularity of a fact is its integrity, which any generalization has to overlook. The facts that science organizes are ideal substitutes for themselves.

Scientific investigation seems to vacillate between the activity of artistic perception and an organization of the harmonious aspects of facts. The organization proceeds logically and mathematically: Russell's basic philosophical concepts are mathematical. The statistician reduces the facts to numerical generalizations. The progress of science in the recent past has been based less on artistic perception than on logical deduction. James B. Conant, the former president of Harvard, who worked for the government in the First World War on poison gas, and in the Second on the atom bomb, wrote that the message of modern science for modern man was a continued reduction in the degree of empiricism in our undertakings. On the other hand, the astronomer Fred Hoyle wrote that scientists suspect a theory that cannot be disproved. Why? Isn't it because such a theory will have lost touch with the arbitrary and particular facts that experience connects us with?

According to empirical philosophy, experience gives us

no certainty of the existence of sequential connections. Heisenberg's uncertainty principle presents a generalized demonstration of the limits of empirical certainty in the microcosmos. The probability of progress is deduced from a generalization of our sequential experience.

The success of technology is the result of its idealism, of a necessary organized disregard for the particular, of dependence on the inaccurate and the probable. One of technology's more successful inventions is mass production, based on limited tolerances for the impossibility of exact measurement. One could almost say, on the impossibility of any measurement. Since there cannot be any standard way of dealing with what cannot be measured, the tolerances of mass production are a device for translating the immeasurable particular into a measurable standard. The success of mass production comes from a substitution of ideal recurrences for actual diversity. The organization takes the place of the infinite multiplicity of diverse events. The organization is true in an ideal world that doesn't exist except as a description. The more extensive the achievements of the organization, the more obvious becomes the inadequacy of the description on which they are based.

Whitehead expressed this in *Modes of Thought*: "We are presupposing an environment which, in its totality, we are unable to define. For example, science is always wrong, so far as it neglects this limitation. The conjunction of premises, from which logic proceeds, presupposes that no difficulty will arise from the conjunction of the various unexpressed presuppositions involved in the premises. Both in science and in logic you have only to develop your argument sufficiently, and sooner or later you are bound to arrive at a contradiction, either internally within the argument, or externally in its reference to fact." My point is that the disastrous state of technological civilization expresses this contradiction resulting from its present high development; further, that this high development was made possible by a method that requires at the beginning an evasion of the material quality of facts: and that if there is to be a solution it will come about through the activity of artistic perception. This is the activity that could save us from universal destruction and the end to all life.

It is interesting to note here that Whitehead's son, North Whitehead, was educated as a mechanical engineer, and

that later he gave up his profession because he found that it involved making bridges and locomotives and so on without ever asking, "Who wants these things?"

I could list here the failures of scientific technology, but perhaps this is not the place for an argument that is to be found at least in part in Barry Commoner's *The Closing Circle*. It wouldn't be very hard to show, for instance, that the epidemic of drug addiction has been caused by the advance of medicine, crime in the cities by the advance of architecture and transportation; that the destruction of a country in war comes from defense, that agriculture is being ruined and famine advanced by technology, that the building of dams to save water desiccates further the arid regions of the world, that the economic crisis comes from the large scale of the organization of production, and the wasteful use of energy and the energy crisis from more and more highly organized ways of making it. And on top of all this the rush to poison the world irrevocably by atomic energy and the advance of the chemical industry. What is the purpose of government? Isn't it to protect the health, safety, and welfare of the population? Yet the more government organization grows, the more insecure we become and the more it threatens our health, safety, and welfare. But this is hidden from us by our presupposition that the bigger the government the more effective it will be. Indeed it will: but to what end? for whom?

The theory of probability was invented to rationalize chance. It maintains organized thought in the face of the discrepancy between mathematical ideality and the unpredictable event. It proposes that what is most likely to happen can be taken as a practical equivalent to what will happen. This leads to the Second Law of Thermodynamics which states that what is most likely to happen, and therefore can be practically considered as what will happen, is that variety becomes homogenized, that the course of events is from complexity of organization toward randomness. It follows that however organized the world is now, it used to be more highly organized, and will be less highly organized in the future. The Second Law of Thermodynamics contradicts evolution. The reason for the cumulative failure of technological organization, and consequently for the breakdown of civilization, is that rational progress can consistently only lead to an increase of entropy.

In the same way, logical thinking leads to something less than its premises. For what follows from the premise is in a sense contained in it, and logic discovers nothing new. Once when Russell and Wittgenstein had worked out a difficult problem in logic, Russell remarked, "logic is hell!" To a theologian, hell, which is chaos, or death, means separation from God's presence, that is to say, from the creative principle, that is to say, from the activity of artistic perception.

Yet the activity of artistic perception may be the most important part of scientific discovery, and logicians engage in it and express it too. There is the example of Russell's artistic use of language. Another I can think of is that when Willard Van Orman Quine described what a logician does, he resorted to metaphor; he wrote, "The logician chases the squirrel of truth up the tree of grammar." He evidently preferred the singularity of this metaphor to analysis, as if it were superior to any translation of itself.

Discovery and composition in art and science, and of course in all acts of life, follow from holding oneself open to chance. It isn't the result of a rational plan—though planning may help to prepare favorable conditions of work. It is the result of attentiveness to things and to what happens. There are no rules to follow. It is important to be ready for and not to miss the opportunity—what I think Whitehead called a state of imaginative muddled suspense. Neither is discovery a matter of control, of putting oneself on top of events, or even of standing outside of them like the ideal experimenter who pretends that he is not part of his world. It isn't a question of mastery, which is a technical matter. Artistic perception perceives the significance of the contingent. Sometimes an art critic urges the inevitability of a good composition. I think this is nonsense. A good composition could be an infinite number of ways as good, an infinite number of ways better, or an infinite number of ways worse. Composition is contingent, which means that it doesn't conform to rules. The connections between the parts are *unscientific,* for one cannot isolate from them any system, rule, or connecting thread that adequately describes the whole work, which, as Tolstoy said, "can be represented only by itself." The shape of contingency is the shape of art. It is a matter of experience that one does not know what the composition is

until it has been made: the problem cannot be formulated in advance of its solution.

If one talks to a practitioner of the "hard" sciences about entropy and evolution, and suggests that evolution disproves entropy, the answer is that evolution, like the presence of life, is so minor an occurence in the immensity of the universe that it no more disproves it than a grain of sand in a field disproves the rotundity of the earth.

The law of entropy is rationalized by the theory of probability, which says that on the average what occurs is what will probably occur. Of course, the improbable occurs too. An example of the occurence of the improbable is seen in the *usual* evolution of the stars, where carbon atoms are formed from the collision and fusion of helium nuclei. Jacob Bronowski described this in "New Concepts in the Evolution of Complexity."* Two helium nuclei that collide do not stick but fly apart in a millionth of a millionth of a second. "But if in that splinter of time a third helium nucleus runs into that pair, it binds them together and makes a stable triad which is a nucleus of carbon. Every carbon atom in the universe has been formed by such a widely improbable triple collision in a star." Carbon atoms are of course the necessary ingredient of all organic molecules. Here the improbable is the "rule." Life, and the complexity that it represents, is the result of a chain of *stabilizing* accidents. If it did not represent a significantly different principle from the advance of entropy, the tendency of mutations to occur would on the average be equally balanced by their tendency to break down again. *"Evolution is an open and unbounded plan"* (Bronowski's italics), having the characteristic that the sequence of events that constitute it are invented moment by moment, and the outcome is not a solution, but a creation. Bounded plans have solutions, determined by the probabilities.

In the same way, the activity of artistic perception does not solve problems, but creates: which is to say that it causes the existence of what did not exist before. It is concerned with the improbable. And so Donald Judd's remark that painting on canvas is no longer credible puts painting in the category of the solution of problems; it makes it predictable and technological. Frank Stella repeats the canvas stretchers, which is credible, as it is available

* Published in *The American Scholar,* Winter, 1972–73.

to knowledge. Both Judd and Stella want to verify experience; they will not take it for granted. When Picasso criticizes Bonnard for relying too much on his sensibility, for not "seizing control," he is proposing that the artist behave like an engineer. Sensibility is what puts one in touch with the material fact. To repeat, to verify and to control is to separate oneself from experience, to substitute the ideal world of numbers for the diversity of things and relationships. Mondrian's divisions of the canvas are particular and experiential, but his color turns experience into knowledge in order to shelter him from the dangerous mystery of fact. Reinhardt's desire to reduce art to academic aesthetic principles is another attempt to take out of art the uncertainty of experience in the interest of verifiable rationality. Seurat, the favorite of rational criticism of Impressionism, tried to make a system out of what he considered the essential element in Impressionism, namely, broken color. American Impressionism of the turn of the century was also a substitution of a rational method of small equal strokes for the ragged directness of French Impressionism. The realism of the nineteenth-century academy was an idea of reality, implying that the reality of things is known ahead of the experience. In general, technology influenced nineteenth-century art by turning it into a systematic craft following a system of rules. Technology influences twentieth-century art most strongly in the case of those artists who are guided, not by the productions of technology, but rather by the principles behind it; who are guided, that is, by the idea that Conant said was the message of modern science to modern man: a continued reduction in the empirical content of our investigations.

In order to avoid misunderstanding I must add that this has nothing to do with "realism" versus "abstraction." Suzanne Langer has succinctly defined the difference between abstraction in science and abstraction in art. In science, she said, an abstraction is a generality, in art an abstraction is a particular. Art does not make repeatable things except in collaboration with industry. The photorealists substitute an idea of reality derived from the look of average photographs; that is, they take for models photographs far advanced in an expression of the thermodynamic process of degradation. Abstract artists who do not reproduce, like an industrial designer, a worked-out model, but whose productions grow unpredictably are

278

using their faculty of artistic perception. Good artists have used photographs from the beginning for the insight they offer into the diverse nature of the world of experience.

In this connection I would like to say something about this insight that photography offers. If you compare, say, an aerial photograph with a map of the same area, the difference is striking. No matter how carefully the surveyor follows his technical procedures, what he presents as the shape of the world will give a configuration well along in entropic degradation in comparison to the configuration revealed by the photograph. The photograph taken from the air shows relationships that one couldn't imagine exist. It shows an order to the sequence of bays, beaches, hills, and rivers in which, though nothing repeats, you have a sense of the integrity of the whole made out of the immeasurable diversity of nature. The surveyor puts in a logic that is the inevitable consequence of the rationality of his methods, and yet the whole configuration does not have the integrity shown in the photograph. Photography is a possible artistic medium because it puts one in contact with a formality too large to be contained by the human mind. A good photograph refutes, for this reason, the unconscious prejudice of positive philosophy that the human intelligence is potentially coextensive with reality. We can only get in touch with reality, and we can only do this through the "mystery of sensation."

From what I have said I think it follows that there can be no such thing as a collaboration of art and technology. The collaboration either corrupts artists into Quislings of the totalitarian tendency of technology, or substitutes for the idea that art is valuable for and in itself, a belief in technology for technology's sake. This is what the earthwork artists express. They see the essence of art in its uselessness, and at the same time are impressed by the scale of technology. They exploit the tools of technology to produce objects with the grandeur of technology and the meaning of art. It is as if one saw the meaning of athletics to reside in an overcoming of obstacles, which would give to a pie-eating contest the same value and meaning that a track meet has. The earthwork artists compete with the government's experiments with atomic energy, insecticides, defoliants, and, lately, the weather. These experiments serve to protect the Goliath of technology from the David of artistic perception.

Bertrand Russell as a logician tended to accept the conclusion of an argument if he could find no fault with its logical form. He directed his conscious attention to logical form. And if the rational form were contradicted by evidence, he assumed that the evidence must be mistaken. This is the basis for the habit of the apologists of technology of preferring the idea behind a new technique to the particular contradictory fact. The activity of artistic perception returns us to the evidence. It puts reason ahead of rationality. And evidence perpetually surprises us because of the perpetual novelty of the material world, from which rationality tries to protect us. The rationalist prefers his dream.

Artistic perception gives the only possible response to the question of how it happens that there is something instead of nothing, by presenting us with what Wittgenstein called the astonishing fact that anything exists. What is called the materialism of modern civilization is not materialism at all, but consists in our putting our faith in ideas that can only be connected to the immediacy of experience within limits of tolerances, inaccurately, like the replaceable parts of mass-produced machines. A rapidly mounting accumulation of inaccuracies that separates the world of technology more and more widely from the facts is the reason for the destructiveness of technology. Though it is called materialism, actually it expresses a disrespect, a lack of love for things as they are and a fear of matter. We are addicted to the illusions that are the consequences of technological ideas, which substitute manipulable statistics for arbitrary diversity. As long as we remain dominated by the illusion that the general is truer than the particular, and by organizations which society uses to protect its interests against the individual, we will, to our very great peril, even to the peril of our lives, become more and more separated from the inexplicable and immeasurable world of matters of fact.

Artistic perception can restore our connection to them. How? What can it do? I will quote, as a partial answer (for there can only be a partial answer), from two critics of the effects of technology on the human spirit. One is Bruno Bettelheim, who said: "Our modern infatuation with speed is a very real handicap. Our new yardstick of time, even in human affairs, tends to be the machine, not the living cell. Our image of time no longer rests on the slow growth

of trees, nor on the nine months it still takes before a baby is ready to be born. In to-day's affluent society, satisfactions are so immediate that children are less likely to have learned about delay as a natural dimension...Food comes precooked...photographs can be developed in an instant, the human fetus cannot. The same goes for inner controls. There are timetables in human development that can only be hurried (or delayed) at a painful and deadening cost." The other critics are Helen and Scott Nearing, who wrote in their book *Living the Good Life:* "The social consequences of turning the countryside into a vacationland are far more sinister than the economic results." (This is a consequence of the division of labor caused by modern industrialism.) "What is needed in any community is individuals, householders, villagers and townsmen living together and co-operating day in, day out, year after year, with a sufficient output of useful and beautiful products to pay for what they consume and a bit over.... Solvency of this nature is difficult or impossible except in an all-year round community."

So the answer is, first, let us forgo speed, let us regulate our activities by organic time; and second, we must replace our social organizations with a plurality of entirely new and small communities.

Two Statements

[*1974*] Whenever I make a somewhat different painting someone is likely to ask, "Is that a new direction?" They want to know what you are planning next. But I think this question arises from the misconception that what is interesting in painting is ideas it expresses. Painters are concerned with things. The most prominent things in the painter's experience are right in front of him, like the paint on the canvas. It is better if he does not achieve a plan, and that the painting eludes him, with a life of its own. The painting unfolds, gradually and with difficulty, and he doesn't quite know what it is even for quite a while after he stops painting it. Then it falls into place for him, or it doesn't; but for another person who looks at it it may have a peculiar character right away. So far as it has merit, a painting is a fact, arbitrary and individual.

[*1975*] For me, painting does not illustrate or prove anything; neither "realism" nor "abstraction" nor any of the categories invented by journalists. It is a way of expressing the connections between the infinity of the diverse elements that constitute the world of matters of fact, from which technology separates us in order to control it and control us. The more effective technological control is, the more destructive it is. Technology is essentially totalitarian, and artists who collaborate with technology are technology's Quislings. Technologists are often idealistic, clever and insane. Painters are usually stubborn and materialistic.

INDEX

(Page references to illustrations are in *italic* type.)

Abstract Expressionism, 36,
103, 107-11, 112, 254
Abstraction, 102-3, 278-79
Action painting, 236
Agam (painter), 66, 67
Agostini, Peter, 136;
Clothesline, 135
Albers, Josef, 66, 67, 254
Alberti, Leon Battista, 20,
228-29
Allston, Washington, 197, 199,
252
Analytical Cubism, 209
Angelico, Fra, 234
Angulo, Jaime de, 259
Anti-Art, 125-26
Appel, Karel, 59
Armitage, Kenneth, 59, 189-90
Armory Show of 1913, 109,
112, 206, 208-9, 211
Arp, Jean, 66, 74, 75-77;
Constellation, 76
Ashbery, John, 31, 220-21,
224, 225
Atget, Eugène, 141
Auerbach, Ellen, 27, 142
Auerbach, Walter, 27

Bacon, Francis, 59
Balthus (painter), 103-4, 163
Baskin, Leonard, 59, 60, 232
Bassano, Jacopo, 54, 162
Bauhaus, 37, 55, 57, 102, 105,
110, 260
Béguin, Albert, 50
Bell, Clive, 55, 103, 204
Bell, Leland, 131
Bellows, George, 72, 109, 112
Benton, Thomas Hart, 26, 70,
110, 241-42, 244-45
Berend, Charlotte, 176, 210
Berenson, Bernard, 20*n*., 25,
102, 203, 261
Bierstadt, Albert, 108

Bischoff, Elmer, 91-95; *Two
Figures with Vermillion
Light, 92; 93*
Bishop, Isabel, 87-89; *Subway
Scene, 88*
Bladen, Ronald, 85
Blake, William, 59-72
Blakelock, Ralph, 158
Bloch, Lucienne, 242-43
Boldini, G., 204
Bolotowsky, Ilya, 66
Bonnard, Pierre, 20, 28, 54,
130, 171-72, 207-8, 234, 278;
*Dining Room on the Garden,
129*
Botticelli, Sandro, 108
Boucher, François, 193
Bouguereau, Adolphe, 151
Brancusi, Constantin, 65
Braque, Georges, 54, 211
Brecht (artist), 139
Breitenbach (photographer),
142
Brodsky, Josef, 263
Bronowski, Jacob, 277
Bronzino, Agnolo, 51, 53
Brown, William, 130
Brunelleschi, 228
Burck (mural painter), 242
Burckhardt, Rudolph, 28, 142,
220, 225
Burri, Alberto, 55
Butler, Reg, 59
Button, John, 31, 126-27;
Warehouse, 127

Cage, John, 62
Campbell, Lawrence, 146
Campoli (sculptor), 59
Canaday, John, 249-50
Cantor, Moritz, 53
Capa, Cornell, 141
Caravaggio, 163
Carlson (mural painter), 242-43

Carpenter, Rhys, 225-28
Carracci, Lodovico, 161
Cartier-Bresson, Henri, 141-42
Cassatt, Mary, 72, 157-58, 201, 203
Castagnary (critic), 200
Castagno, Andrea del, 237
Cennini, Cennino, 229
César (sculptor), 59, 60
Cézanne, Paul, 20, 33, 54, 81, 95, 105-21 passim, 163, 170-71, 204-5, 207-10, 229, 234, 240, 253-55; Mont Sainte Victoire, 108, 151; review of 150-52
Chamberlain, John, 64
Chardin, Jean-Baptiste-Siméon, 234, 257
Chase, William, 117,157
Chasins, Abram, 143
Chinese painting, 64, 192
Chirico, Giorgio de, 50
Classicism, 175, 216
Claude, 108, 163
"Communication and Moral Commitment," 143-46
Constructivism, 65-69, 95, 105, 130, 255
Copley, John Singleton, 72, 193, 197, 201, 251-52
Corinth, Lovis, 156, 176, 210; The Black Hussar, 155
Cornell, Joseph, 49-53, 137; Ostend-Dover, 51
Corot, Jean Baptiste, 234
Courbet, Gustave, 107, 153, 156, 234
Crosby, Joan, 143
Cubism, 54, 64, 67, 94, 105, 117, 170-71, 192-93, 208-9, 211, 229, 234, 236, 252, 254
Cuevas (painter), 232
Cutler, Carl, 208

Dadaism, 62, 178, 254
Dali, Salvador, 50
Dash, Robert, 31, 146
Davie, Alan, 56
Davis, Stuart, 208.
Day, Lucien, 131
De Kooning (Rosenberg), 236
De Kooning, Elaine, 28, 30-31, 73, 123-24, 237; The Loft Dwellers, 123
De Kooning Willem, 20, 28-29, 31, 54, 59-60, 71, 73, 103-4, 107, 109-10, 163, 168, 208, 215, 234, 236-38, 249-51, 261; reviews of, 36-38, 180-81; September Morn, 39

De Niro, Robert, 131
Degas, Edgar, 63, 98-101, 107, 109, 113, 136, 174
Delacroix, Eugène, 20, 100, 180, 252
Della Pittura (Alberti), 228
Denby, Edwin, 28, 220, 225
Denis, Maurice, 117
Di Suvero, Mark, 85
Dickinson, Edwin, 117-20; Boyer House, Sheldrake, 118
Diebenkorn, Richard, 59, 60
Dimitroff, Stefan, 242, 243
Dinnerstein, Harvey, 85, 87
Doesburg, Theo van, 66
Donatello, Donato di, 228
Dove, Arthur, 54, 129, 194
Dubuffet, Jean, 59, 60, 178
Duchamp, Marcel, 137
Dufy, Raoul, 175
DuMond, Frank, 117
Duran, Carolus, 202
Duthuit, Georges, 169, 170

Eakins, Thomas, 32-33, 58, 72, 108, 153, 157-59, 199, 201, 206, 217, 251, 255, 265
Edelman, George Maurice, 272
Edwards, Jonathan, 256
Ehrenzweig, Anton, 22
Eilshemius, Louis, 112, 252
Engman, Robert, 95-96; Untitled sculpture, 96
Ensor, James, 194
Expressionism, 103, 109, 112, 165-66, 181, 193, 208, 234, 254. See also Abstract Expressionism; German Expressionism

Falkenstein (artist), 139
Fauvism, 209
Ferren, John, 182-83; Untitled, 182
Figure painting, 69-73
Fink, Sheldon, 85, 86
Fiore, Joseph, 31, 114-16; Medomak II, 116
Fishburne, St. Julian, 85
Follett, Jean, 65, 139
Frank, Robert, 142
Frankfurter, Alfred, 30
Freilicher, Jane, 30, 31, 97, 185-87; Early New York Evening, 186
Freud, Sigmund, 22, 50, 191, 263
Friedman, Arnold, 185
Fry, Roger, 20, 22, 204, 261
Futurism, 194, 211

Gainsborough, Thomas, 192
Gardner, Albert TenEyck, 198, 199
Gasquet, Henri, 152
Gatch (painter), 213
Gauguin, Paul, 54, 169, 253
Geist, August, 64
Gellert, Hugo, 241
Genre painting, 71
Georges, Paul, 31, 73, 98, 127-30; *Self-Portrait, 97*
German Expressionism, 62, 110, 112, 125, 156, 234
Giacometti, Alberto, 41-44, 59-60, 63, 115; *Figure From Venice VI, 43*
Gidding, Jaap, 238, 250
Gidding, Jan, 238, 250
Giotto, 36, 104, 108
Goldberg, Michael, 220-21, 225
Golub (painer), 59, 60
Goodnough, Robert, 31, 91-95; *Summer III, 93; 94*
Gonzales, Julio, 189
Goodrich, Lloyd, 157
Gorky, Arshile, 30, 110-11, 121
Goya, Francisco, 133, 162, 213, 231
Graham, John, 214-19
Grassi, Giovanni de, 160
Graves, Morris, 213
Greco, El, 54, 164-66, 201
Greek Sculpture: A Critical Review (Carpenter), 225-28
Green, Wilder, 113
Greenberg, Clement, 28-29, 30, 70, 233-36
Greene, Balcomb, 59, 60
Griffin, Howard, 32
Grillo, John, 146
Grooms, Red, 125-26
Guardia, Francesco, 161
Guercino, 161
Guy, Jim, 241, 243

Haas (photographer), 141
Haberstroh, Alex, 27, 242, 243
Hals, Franz, 221
"Happenings," 61-62
Harris, Paul, 139-40
Hartigan, Grace, 31, 220, 225
Hartl, Leon, 113, 184-85; *Flowers, 184*
Hassam, Childe, 157
Hatch, Robert, 32
Hawthorne, Charles, 117
Henri, Robert, 157
Henssler, Fritz, 27
Hess, Thomas B., 30, 31, 33, 113, 236-38

Hiroshige, Ando, 54
Hirsch, Stefan, 242, 244-45
History painting, 71
Hofmann, Hans, 187
Holbein, Hans, 100
Homer, Winslow, 72, 114, 158, 196-201, 203
Hopper, Edward, 203
Horst (photographer), 141
Hoyle, Fred, 273
Hudson River School, 157, 196, 201
Humanism, 103
Hutchins, Robert Maynard, 263

Impressionism, 33, 37, 55, 66, 79, 105-7, 109, 111-14, 146, 150-52, 156-57, 170-71, 192, 203, 210, 229, 234, 236, 244, 252-56, 265, 278
Indiana, Robert, 139
Ingres, Jean Auguste, 100, 107, 121, 180, 218, 252
Inness, George, 179
Insiders, The (Rodman), 230

James, Henry, 199
Japanese painting, 57, 192
Jefferson, Thomas, statue of, 132
Johns, Jasper, 30, 44-49, 96; *Two Flags, 47*
Johnson, Lester, 131
Jones, Carolyn Mason, 142
Jones, John Paul, 130
Judd, Donald, 277-78

Kahn, Wolf, 30, 31, 146, 187-88
Kandinsky, Wassily, 54, 66, 130, 193, 234
Kaprow, Allan, 61-62, 139
Katz, Alex, 30-31, 46, 73, 107, 113-14, 145; *Ten O'Clock, 90-91; 90*
Kauffman (photographer), 141
Kaufman, Stuart, 85
Kearns (painter), 232
King, William, 137; *Lady Godiva, 137; 138*
Klee, Paul, 178-79, 192
Kline, Franz, 55, 92, 113, 122, 204
Koch, Kenneth, 31, 220-22, 225, 237
Kohn, Gabriel, 64, 65, 190
Krushenik, Nicholas, 131-32

La Hyre, Laurent de, 163
La Tour, Georges de, 163, 257

Landscape painting, 71, 107-9, 187-88, 193
Langer, Suzanne, 20n., 22, 66, 278
Laning (mural painter), 242, 244-45
Lanyon, Peter, 56
Latham (artist), 139
Lawrence, Sir Thomas, 30, 148, 193
Le Brun, Charles, 59, 60, 162, 163, 231
Le Nain, Louis, 163, 237, 257
Le Nain, Mathieu, 163, 257
Léger, Fernand, 107, 194, 213
Leigh, Ted, 34
Leonardo da Vinci, 161, 215, 228-30
Leslie, Alfred, 30-31, 181-82, 220, 225; Christ the Door, 181
Lessing, Charles, 142
Levine, David, 86
Levinson (artist), 139
Lewis, Wyndham, 239-40
Lichtenstein, Roy, 30, 190-91
Lindner, Richard, 73
Lissitsky, Lasar El, 66

McGarrell (painter), 59
Malevich, Kasimir, 66, 68
Malicoat (sculptor), 65
Mallarmé, Stéphane, 20, 31, 113, 153-54, 170, 261
Manessier, Alfred, 55
Manet, Edouard, 199, 234
Mantegna, Andrea, 99
Marc, Franz, 194
Marin, John, 26, 176, 179, 209-13; Mount Corcorua No. 1, 212-13; 212
Maroger, Jacques, 29
Marxism, 68-69
Masaccio, Tommaso, 228
Mathieu, Georges, 254
Matisse, Henri, 63, 117, 121, 141, 169, 172-75, 234-35; Two Negresses, 174
Mattick, Paul, 27
Mediterranean Cities (Denby), 220, 225
Melzi, Francesco, 228
Michelangelo, 39, 161, 227, 239-40, 273
Miller, Kenneth Hayes, 194
Mitchell, Joan, 85, 220, 225
Moholy-Nagy, László, 50, 80, 102, 194
Mondrian, Piet, 66, 68-69, 74-75, 77, 95, 120, 210, 278

Monet, Claude, 79, 107, 109, 111-13, 153, 182, 201, 204, 233, 254
Montgomery, George, 142
Morandi, Giorgio, 81-82; Still Life, 82
Morisot, Berthe, 23, 153-56; Portrait of a Child with a Hat, 154
Morse, Samuel F. B., 72, 108, 197, 251-52
Motherwell, Robert, 121-23; Black on White, 122; 122
Müller, Otto, 59
Mumford, Lewis, 252
Munson, Gorham, 246
Myers, John Bernard, 31

Nabis, the, 205, 207, 254
Nakian, Reuben, 133-35, 136; Venus, 134
Naturalism, 200, 253
Neo-Plasticism, 106, 208
Nerval, Gérard de, 50, 53
Nevelson, Louise, 64
New York School, 48, 71, 73, 81, 101, 106, 110, 130, 179, 213, 237, 254-56
Newman, Barnett, 235
Nicholson, Ben, 68
Nodu, Hideo, 242
Noguchi, Isamu, 65, 188-89; Dish, 189
Non-objective painting, 71, 79, 92, 94, 101, 106, 108; American, 54-59; Oriental influences on, 114-17

Odes (O'Hara), 220-22
O'Hara, Frank, 31, 220-22, 225
O'Keeffe, Georgia, 179-80, 194
Oliveira (painter), 59, 60
Orozco, José, 169, 232, 241, 243-44
Ortman (sculptor), 65

Painting: American, 156-59, 233-36, 249-57; French, 156-64; Italian, 159-64
Palmer (painter), 242, 244
Paolozzi, Eduardo, 59-60
Passloff, Patricia, 146
Pasternak, Leonid, 83
Peckham, Morse, 271
Permanently (Koch), 220
Perugino, Pietro, 161
Photography, 79-81, 140-42, 279
Picasso, Pablo, 28, 54, 63, 70-71, 111, 113, 121, 137, 171, 189, 193-94, 204, 211, 217, 239-40, 254, 278

Piero della Francesca, 161
Piranesi, Giovanni, 192
Pissarro, Camille, 54, 151, 253
Plastic arts, 139-40
Pogany, Will, 241
Pollaiuolo, Antonia, 161
Pollock, Jackson, 28, 56, 59, 70, 103, 117, 121, 215
Polycleitus, 227
Pontormo, Jacopo, 161
Pop Art, 45, 48-49
Pope, Arthur, 25, 200
Porter, Anne Channing, 27
Porter, Eliot, 79-80, 142; *Sick Herring Gull*, 142; *142*
Porter, Fairfield: art criticism of, 19-24; biography of, 25-35; *Field Flowers, Fruit and Dishes, 24*; *Morning from the Porch, 33*; *Trees in Bud, 21*
Portrait painting, 71-73
Post-Impressionism, 37, 109, 111-12, 188, 244, 254-55
Pougny, Jean, 175-76
Poussin, Nicolas, 121, 162-63
Pre-Impressionism, 105, 253
Prendergast, Charles, 204-5
Prendergast, Maurice, 176, 204-8

Quine, Willard van Orman, 276

Raeburn, Sir Henry, 193
Raphael, 161, 218, 235
Rauschenberg, Robert, 62, 98, 101-2, 121
Realism, 72, 98, 102-4, 169, 179
Regensburg, Sophy, 176-77
Reinhardt, Ad, 66, 106, 114-15, 180, 234, 278
Rembrandt, 98-99; *Indian Warrior with a Shield Leaning on a Stick, 100*
Remenick, Seymour, 86-87, 124-25; *St. Peter's and St. Paul's, Philadelphia, 126*
Remington, Frederick, 72
Renoir, Pierre, 63, 136, 172
Resnick, Milton, 113, 114
Richier, Germaine, 59, 60
Ris (painter), 66
Ritchie, Andrew, 169
Rivera, Diego, 241, 242-43
Rivers, Larry, 31, 72
Robert, Hubert, 193
Robinson, Boardman, 26
Rodin, Auguste, 63, 136, 172, 175; *Cambodian Dancer, 173*
Rodman, Selden, 143, 230-33
Romanticism, 180

Rorimer, James, 140
Rose, Herman, 113, 114
Rosenberg, Harold, 49, 124, 236-37
Rosenfeld, Paul, 26, 209, 210
Roszak, Theodore, 59
Rothko, Mark, 70, 120-21, 180, 235; *No. 18, 119*
Rouault, Georges, 41
Rousseau, Theodore, 160, 164
Rubens, Peter Paul, 26
Ruskin, John, 20, 22
Russell, Bertrand, 246, 251, 266, 271-73, 276, 280
Russian painting, 58-59
Ryder, Albert, 158-59, 199, 252

Sage, Kay, 194
Salute (Schuyler), 220
Sargent, John Singer, 92, 109, 128, 158-59, 201-4, 207, 210, 235
Schloss, Edith, 28, 146
Schneider, Gerard, 254
Schuyler, James, 31, 183, 220-21, 223, 225
Schwartz, Daniel, 86
Scott, William, 234
Sculpture, 132-36, 188-90; abstract, 63-65; Constructivist, 95; Greek, 225-28; humor in, 136-37
Seley (sculptor), 65
Selz, Peter, 59
Serusier, Paul, 253-254
Seuphor, Michel, 66, 67-68
Seurat, Georges, 105-6, 185, 253, 265, 278
Severini, Gino, 194
Shahn, Ben, 169, 242
Shikler, Aaron, 86, 87
Sickert, Walter, 207
Signac, Paul, 207
Silver, Walter, 142
Silverman, Burt, 86
Sinibaldi, Dr. Giulia, 160-61
Sisley, Alfred, 79, 109
Sloan, John, 109, 112, 157, 210
Smith, David, 64, 77-78; Sculptures, *77*
Social Realism, 255
Socialism, 245-48
Soulages, Pierre, 55
Soutine, Chaim, 156, 188
Soyer, Raphael, 193
Spinelli, Parri, 160
Sprenger, Rudolph, 257
Stankiewicz, Richard, 38-41, 98, 101; *Playground, 40*
Steinberg, Herbert, 86

Stella, Frank, 277-78
Stevens, Wallace, 22, 38, 168, 268
Stieglitz, Alfred, 26, 247
Still, Clyfford, 121, 180, 183, 234-35
Stokes, Adrian, 20n., 233
Stuart, Gilbert, 72, 252
Sugarman (sculptor), 65
Surrealism, 49, 208, 254
Symbolism, 169, 235

Taeuber-Arp, Sophie, 68
Takis (artist), 139
Tapies, Antonio, 139
Taylor, Francis, 148
Thayer, Webster, 72, 157
Tiepolo, Giovanni, 161
Tillich, Paul, 59
Tintoretto, Jacopo, 26, 161, 238
Titian, 25, 133, 162, 262
Tobey, Mark, 213
Tomatzu (painter), 242, 243
Toulouse-Lautrec, Henri de, 54, 169
Trotsky, Leon, 20, 246
Turner, Joseph, 20, 25, 108-9, 163, 190, 193, 213
Twombly, Cy, 114, 115-17
Tworkov, Jack, 144; *Brake II*, 144; *145*

Uccello, Paolo, 161, 218
Ukiyo-e School, 200, 208

Valéry, Paul, 20
Valentin, Moïse, 163
Van Gogh, Vincent, 54
Van Hooten (painter), 29
Vanderbeck (artist), 139
Vantongerloo, George, 66, 68
Vasarely, Victor, 66
Vasilieff, Nicholas, 82-84; *Red Pitcher, 83*
Velázquez, Diego de, 26-27, 201, 234, 238
Vermeer, Jan, 234

Veronese, Paolo, 25, 26-27, 108
Vicente, Esteban, 113, 114
Vivin, Louis, 177-78; *Le Palais de Justice à Paris,* 177; *177*
Vlaminck, Maurice de, 194
Vouet, Simon, 163
Vuillard, Edouard, 20, 28, 31, 33, 111, 169-71, 176, 234, 253-54; *The Newspaper, 171*

Watteau, Jean-Antoine, 108
Watts, Frances, 202
Weigand, Charmion von, 168
Weinrib (sculptor), 64
Welliver, Neil, 29, 31, 34
Welsch, Carl, 202
West, Benjamin, 251, 252
Westermann, H. C., 59
Weston, Harold, 26
Wheelwright, John, 27
Whistler, James, 72, 114, 150, 152-53, 157-58, 199-200, 202, 207, 209-10, 238, 251
White, Robert, 86, 87
Whitehead, Alfred North, 26, 102, 274
Whitman, Robert, 139
Wilenski (critic), 208, 235
Willem de Kooning Drawings (Hess), 236
Wilson, Edmund, 170
Wilson, Jane, 31
Wittgenstein, Ludwig, 276, 280
Wonner, Paul, 130, 131
Wotruba (sculptor), 59
Wright, Frank Lloyd, 148
Wyeth, Andrew, 80

Xceron (painter), 66

Yalouris, Nicholas, 226
York, Albert, 269-70; *Twin Trees, 269*
Yusov, Boris, 250

Zorn, Anders, 204